PIERS *of* WALES

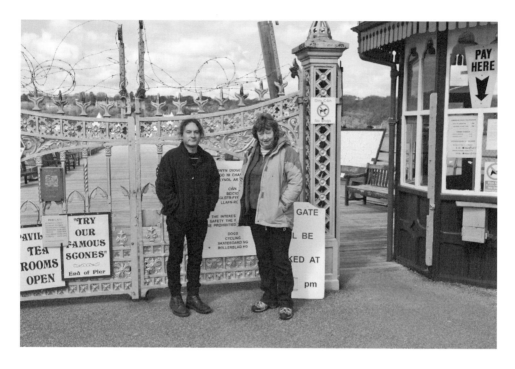

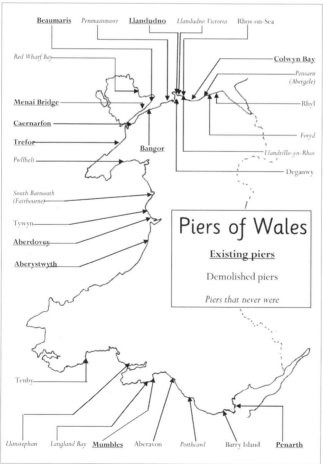

Beaumaris Penmaenmawr Llandudno Llandudno Victoria Rhos-on-Sea

Red Wharf Bay

Colwyn Bay

Pensarn
(Abergele)

Menai Bridge

Rhyl

Caernarfon

Foryd

Trefor

Bangor

Llandrillo-yn-Rhos

Pwllheli

Deganwy

South Barmouth
(Fairbourne)

Tywyn

Aberdovey

Aberystwyth

Piers of Wales

Existing piers

Demolished piers

Piers that never were

Tenby

Llanstephan Langland Bay **Mumbles** Aberavon Porthcawl Barry Island **Penarth**

PIERS *of* WALES

MARTIN EASDOWN *&* DARLAH THOMAS

AMBERLEY

Dedicated to John Anderson (1915-2003),
whose love of the pier at Rhos-on-Sea inspired our research.

First published 2010

Amberley Publishing Plc
Cirencester Road, Chalford,
Stroud, Gloucestershire, GL6 8PE

www.amberley-books.com

Copyright © Martin Easdown & Darlah Thomas 2010

The right of Martin Easdown & Darlah Thomas to be
identified as the Authors of this work has been asserted
in accordance with the Copyrights, Designs and Patents
Act 1988.

ISBN 978 1 84868 920 6

British Library Cataloguing in Publication Data.
A catalogue record for this book is available from the
British Library.

Typesetting and Origination by FONTHILLDESIGN.
Printed in the UK.

Contents

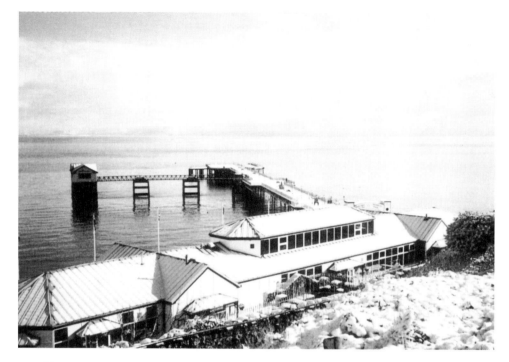

Mumbles Pier on a snowy day in 2005. In the foreground is the pier's amusement arcade and café and the lifeboat station jetty can be seen extending from the east side of the pier. (Marlinova Collection)

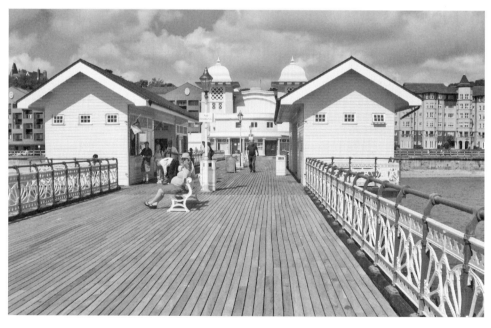

A photograph taken on Penarth Pier in June 2009 showing the mid-pier refreshments kiosks and toilets and in the distance the Pier Pavilion. (Marlinova Collection)

INTRODUCTION

The landscape of Wales is known for its green hills and valleys, narrow gauge steam railways and medieval castles, but not, it appears, for its pleasure piers. This is a shame, as the country has some of the finest surviving piers in England and Wales, with three particularly fine examples. Llandudno is known as the 'Queen of the Welsh Resorts' and has an elegant pier to match that title, situated at the foot of the imposing Great Orme headland. The pier is a superb Grade II listed structure that has retained much of its Victorian ambience, particularly in the section beyond the Grand Hotel. As a result, the pier is often used for film and television work requiring a Victorian pier setting. It is without doubt one of the finest surviving piers in the United Kingdom.

The pier at Bangor is equally impressive. Stretching across almost half of the Menai Straits, the pier looks almost exactly as it did when it was built in 1896, thanks to a magnificent restoration of the structure during the 1980s. The pier entrance boasts a handsome set of wrought iron gates and attractive minaret kiosks, and there are further ornamental kiosks on the pier deck. As an example of a Victorian promenade pier, Bangor is second to none.

Penarth is another fine Welsh pier: a neat and tidy structure with good ironwork and an attractive Art Deco pavilion, although this is currently in need of restoration. Alone amongst the Welsh piers, it remains in use as a landing stage and is a regular port of call for the PS *Waverley* and MV *Balmoral*, operated by the Paddle Steamer Preservation Society.

The pleasure pier was an integral part of the development of the great British seaside, which reached its apogee in the late Victorian and Edwardian periods. The foundation of seaside resorts during the eighteenth century was instigated by the enormous increase in national wealth during this period and the desire of those who benefited from this to maintain their well-being in the face of leading a rather unhealthy lifestyle. Spas had been used for centuries for medicinal purposes, and during the late seventeenth century towns such as Bath, Epsom and Tunbridge Wells were developed to meet the needs of the wealthy for health and leisure resorts. By the 1750s, the novelty of visiting the coast for the benefit of health by the bathing in and drinking of seawater was becoming increasingly popular for those who could afford it. Dr Wittie, at Scarborough, had advocated sea bathing for health at the spa town in the late 1660s, and by 1730, it was integrated into the spa routine at the resort. A print published in 1735 of Scarborough shows the earliest recorded bathing machines. Brighton, Margate and Weymouth were amongst the first English seaside resorts, assisted by closeness to London and other centres of population and/or royal patronage.

By the late eighteenth century, seaside watering places were also being established in Wales. Tenby had acquired its first bath house by 1781 and another was opened in the early years of the nineteenth century by wealthy London banker Sir William Paxton. This featured ladies' and gentlemen's swimming baths and an assembly room. Paxton also built a promenade to the harbour and theatre, and issued the town's first guidebook. Swansea was a popular bathing place in the early part of the nineteenth century. In 1804, the Welsh

newspaper *The Cambrian* reported, 'Swansea is very full – genteel company and families are almost daily arriving at this gay resort of fashion. The promenade on the Burrows on Sunday evening displayed an assemblage of beauty and elegance fascinating beyond description.' However, the resort aspect of Swansea was soon overtaken by its success as a port, although a fine stretch of sand remains for safe bathing. Aberystwyth was christened the 'Brighton of Wales' in 1797 and, ten years later, had four bathing machines for women and two for men. By the 1820s, an assembly room and theatre were in place. Llandudno, the 'Queen of the Welsh Resorts', was developed by the Mostyn Estate from the 1850s, initially under the guidance of Owen Williams, who also had a hand in the planning of Rhyl. The impetus to develop both resorts was the opening of the Chester-Holyhead Railway in 1848 and it was to be the spread of the railway system to the coast, and the facility for the mass moving of people, that was to kick-start the development of many resorts.

Prior to the coming of the railway, and thereafter in tandem with it, visitors often arrived at the resorts by sea; initially by hoys and then paddle steamers. The first piers (built in resorts without harbours), at Ryde (1814), Brighton (1823), Southend and Walton-on-the-Naze (1830) and Herne Bay (1832), were built as landing stages, although the Chain Pier at Brighton, in particular, soon became a fashionable promenade over the sea, for which customers were prepared to pay a handsome toll.

Nevertheless, pier development initially remained sparse and those early wooden piers were prone to attacks by marine worms. In 1846, Beaumaris was the first Welsh resort to acquire a small landing stage pier, built of stone and wood. However, it was the building of the two iron piers at Margate (1855) and Southport (1860) that would prove to be the template for pier design during their boom period for the next fifty years. This explosion of pier building was assisted by the passing of the Piers & Harbours Act in 1861, which eased Parliamentary assent for their construction, and promenade piers began sprouting up in resorts big and small.

Aberystwyth was the first resort in Wales to erect a purpose-built promenade and pleasure pier. By the 1860s, the development of the resort was gaining momentum, with its rows of uniform terraces around the crescent-shaped bay of Cardigan Bay, a widening of the promenade and the building of the Queens Hotel. The Hafod Hotel Company was instrumental in much of this development and they were involved in the building of the pier, which opened in 1865. Unfortunately, the pier was to show all too vividly the financial risks involved in building piers, when the end section was washed away less than a year after opening. The original promoting company crashed, and although the pier was repaired in 1872, it never paid its way until a large pavilion was erected upon it in 1896. By the 1890s, visitors wanted more from a pier than just a bracing promenade, and pavilions, theatres and floral halls were being added to existing piers or built on new ones. Rhyl Pier had the Grand Pavilion added to it in 1891, but this pier had had a troubled history. Opened two years after Aberystwyth, in 1867, the pier was impressively long in order to reach the deep water for steamers to call, but was beset by a series of ship collisions, fires and storm damage that placed a heavy financial burden on a succession of owners.

The elegant town of Llandudno, the largest resort in North Wales, was an obvious choice for a combined promenade and landing pier. Various proposals for a pier in the 1860s failed to get off the ground and it was not until 1877 that one was built. Unlike the piers at Aberystwyth and Rhyl, the pier proved to be a success and was extended in 1884 past its root end by the Grand Hotel to the North Promenade. An ornate pavilion was added at the same time, which became renowned for the quality of its musical productions. The success of the pier was also due to its intensive steamer services along the North Wales coast and to Liverpool, Blackpool and the Isle of Man.

The remaining piers in Wales were not built until the 1890s or early in the twentieth century as nascent resorts developed and steamer traffic flourished. The long-established resort of Tenby didn't get its pier until 1897, and even then it was derided as not being a 'proper' pier, resembling more an arched bridge! The pier was built principally to enable

steamer traffic to call at Tenby (which had a harbour) at all states of the tide, but as the resort was at the far western limits of the Bristol Channel operations, there were usually no more than twenty calls per year. The pier became a popular fishing venue, but as it was local-authority-owned, it was often criticised as being a burden on the rates.

By the 1880s, Penarth was developing as a seaside suburb of Cardiff and there were a number of proposals for a pier. This was to have a dual purpose as a promenade pier and landing stage for the lucrative Bristol Channel steamer services. After several failures, the pier was built in 1895 by a company consisting of Cardiff businessmen.

Mumbles Pier was more of a straightforward pleasure pier. The pier was opened in 1898 as part of the extension works of the famous Swansea & Mumbles Railway, which had started the world's first regular railway passenger service (horse-drawn) in 1807. Mumbles had developed as a popular day trip destination for Swansea people riding on the train and the pier was expected to attract many of them. Diving shows, pierrot performances, band concerts, refreshments and shops were provided to entice people to use the pier. Mumbles was in a sense a pier built in kit-form, as it was one of a number of piers erected by the Widnes Iron Foundry using pre-fabricated parts.

An unusual South Wales promenade pier was at Aberavon, the seaside suburb of Port Talbot, where, in 1902, the north breakwater of the entrance into Port Talbot Dock was converted into a promenade pier complete with wooden decking, handrails and a tollbooth (following similar harbour conversion examples in England at Lowestoft and Torquay).

In North Wales, Bangor and Menai Bridge piers were built principally as landing stages for the Liverpool to North Wales steamer services, although both provided limited amusements. Bangor, opened in 1896, was an attractive structure stretching 1,550 ft into the Menai Straits. The pier's creators, engineer John James Webster and contractor Alfred Thorne, also built the nearby pier at Menai Bridge, albeit on a much smaller and plainer scale. This pier had a pavilion sited on the shore by the entrance, whilst Bangor provided concert parties, diving displays, and shops and refreshments in its attractive kiosks.

Colwyn Bay was a later starter amongst the Welsh seaside resorts, only springing to life during the 1890s. A pier was opened at the adjoining resort of Rhos-on-Sea in 1895, principally for use as a steamer landing stage for the Colwyn area (its original owners were the Colwyn Bay Pier Company), but it was not until 1900 that Colwyn Bay acquired a pier itself. This was purely a pleasure pier (it never had a landing stage) and sported a magnificent concert pavilion.

The desire of every resort, however small, to have a pier led to a number of pier proposals that never got off the drawing board. At Tywyn, work was actually started on a pier in 1877 and the entrance kiosks and a concrete section were erected before the work was stopped owing to a lack of finance. Pwllheli, Penmaenmawr, Pensarn and Porthcawl were amongst the Welsh resorts where pier schemes were drawn up but never implemented. Llandudno could have had two piers, if the grandiose Victoria Pier had become a reality.

The Edwardian period saw the end of the great pier-building era. The majority of the larger resorts had acquired their piers, whilst others had realised the finance would never be raised to build them. Even in established and popular resorts, some piers were already becoming costly white elephants, expensive to run and maintain. The long pier at Rhyl had never paid its way and by 1910 was in a bad condition. The council proceeded to buy it at a knock-down price and then dithered while they decided what to do with it. Eventually, during the 1920s, the majority of the pier was demolished for scrap, leaving only a small section to be reopened to the public. This in turn was eventually closed and demolished.

The piers at Tenby and Rhos-on-Sea are also both no more, having been demolished in the 1950s when it was felt they were not worth restoring following wartime dilapidation. Aberavon's breakwater pier lasted little more than twenty years before repeated storm damage forced its closure to the public.

One of the fine Victorian
kiosks that grace the
superbly restored pier
at Bangor. (Marlinova
Collection)

Six pleasure piers remain in Wales, of which Llandudno, Bangor and Penarth are indeed the jewels in the crown. Of the others, Aberystwyth is now little more than a pavilion over the sea, but at least its future looks secure. Mumbles is a fine pier, retaining much of its attractive ironwork, but sadly large sections of the pier head remain closed off to the public, awaiting restoration. The outlook for Colwyn Bay is uncertain: the pier remains closed as battles rage between its private owner and the council over its future.

The piers of Wales were at the forefront of the country's coastal leisure development and continue to give the opportunity for the enjoyment of a walk over the waves – long may that be so.

PENARTH

A modest seaside resort and now thriving dormitory town of Cardiff, Penarth grew rapidly following the opening of Penarth Docks, an overspill of Cardiff Docks, on 10 June 1865. In 1884, the docks were extended and in the following year handled 2.75 million tons of coal. Houses were built for wealthy Cardiff businessmen and a Marine Parade was laid alongside the shingle beach, but Penarth also attracted some of the rougher elements of Cardiff society, which the local landowner, Lord Windsor, attempted to change in association with his agent, Robert Forrest, and architect, Henry Snell. Forrest was the first chairman of the Penarth Local Board, established in 1875, and was determined that Penarth should be an exclusive resort free from day-trippers, which had led it to be nicknamed 'Donkey Island'. He claimed that

Mr Morgan's tea gardens, the donkeys, donkey boys, stalls for ginger beer, buns etc and Mr Matthew's refreshment rooms have become a perfect nuisance by obstructing the legitimate use of the beach and preventing those people whom it ought to be our study to draw to Penarth from enjoying its privileges. We cannot stop the rabble from coming to Penarth, but we can throw obstacles in the way of their getting accommodation and that may have the desired effect in the end. My aim is to increase the comforts of the residents and legitimate visitors and entice respectable people to come here to reside.

With these sentiments in mind, Windsor, Forrest and Snell added the Windsor Gardens in 1880 (1d admittance), the esplanade (1883-84), Yacht Club (1884, extended 1905), bath house (1885) and Esplanade Hotel (1885). Exclusive new housing was provided, which was tightly regulated and usually constructed of light grey Liassic limestone.

A railway was opened between Cardiff and Penarth in 1878, but many visitors also arrived on ferries run by the Cardiff Steam Navigation Company. A moveable landing stage enabled them to land at Penarth, but there were calls for a proper pier and landing stage to be provided.

The first attempt to build a pier at Penarth was made by the Penarth Promenade & Pier Company, led by Horatio Richard Snellgrove, which was granted a Provisional Order in May 1881 to erect a 640-ft-long iron pier from a point on Penarth Esplanade near Balcony Villa at a projected cost of £12,903. However, no work was carried out and, in December 1885, a new company, the Penarth (Cardiff) Pier Company, was formed with a share capital of £30,000 in 5,000 shares of £5 each. In 1886, they applied for an extension of time to complete the works conferred to the 1881 order, but within two years had gone into liquidation. The rights to the pier were acquired for £100 by the Penarth Promenade & Landing Pier Company, formed by Messrs Edwards, Robertson & Company, Cardiff ship owners. The principal directors were James Edwards, Chairman of Penarth Local Board, and Frederick Edwards, ship owner of Cardiff. The company had a share capital of £35,000 in 7,000 shares of £5. Engineer John Paton, who had worked on Southend Pier, designed a promenade pier of cast iron columns and piles carrying wrought iron girders, timber deck, shelter houses, pavilion and a timber landing stage. Two thousand fully-paid-up shares were to be allotted to the contractor Philip Hordle Stevens in part payment of the

works, leaving £25,000 to be subscribed by the public. The owner of the foreshore, Lord Windsor, granted the lease of the pier site for ninety-nine years at a nominal rent of £25 per annum.

Work was started on the pier in October 1888 and, on 17 December 1890, Stevens claimed that the company had spent £3,500 and employed twenty-five men to fix 152 foundation piles and forty-four columns and bring a quantity of plant to the pier site. Paton however had informed the Board of Trade of alleged alterations to the pier contrary to what had been authorised. Paton was annoyed that another engineer, Noel Ridley, was being consulted about building an extension beyond what had been proposed. The building of the pier was also being opposed by the Taff Vale Company, lessees of the Penarth Harbour, Dock & Railway Company, who claimed it would interfere with vessels using the harbour.

In June 1890, the Penarth Promenade & Landing Pier Company was taken over by a syndicate of local businessmen and reconstituted with a capital of £10,000 in 2,000 £5 shares. The directors were led by Sir Thomas Morrel of Bute Docks, Cardiff, and the registered office was at 12 Mount Stuart Square, Cardiff. In April 1891, the *Western Mail* reported that the pier was to be called the 'Windsor Pier'. The company asked for a further extension of time for the pier to be built and, in 1892, the Penarth Promenade and Pier Order was granted. Local engineer Herbert Francis Edwards, of 24 Windsor Terrace, Penarth, designed a pier of cast iron piles and columns, wrought iron girders and timber deck to extend seawards no more than 650 ft from the high-water mark owing to the shipping channel into Cardiff Docks passing close by.

In August 1893, the pier company discussed whether to buy the pier which was up for sale at Douglas, Isle of Man, but an outcry from locals deriding the acquisition of a 'second-hand' pier put paid to that idea. However, there were some in favour of the idea, as reported in the *Western Mail* on 3 October 1893:

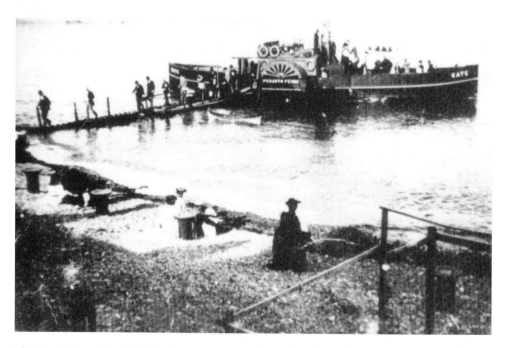

The Penarth ferry boat *Kate* landing passengers at Penarth in the early 1890s. The pile sockets of the abortive pier works begun in 1890 can be seen on the beach. (Marlinova Collection)

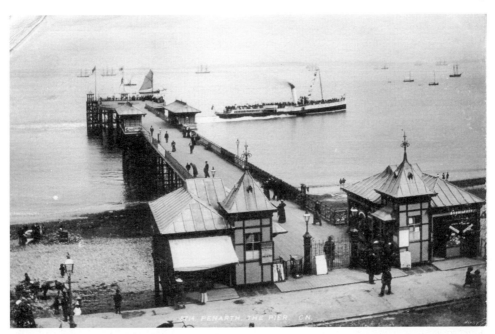

This postcard view of 1904 shows the pier as originally built in 1894-95 with shops at the entrance, two shelters halfway along the pier and a small building on the pier head. The paddle steamer leaving the pier is the P. & A. Campbell vessel *Lady Margaret*. (Marlinova Collection)

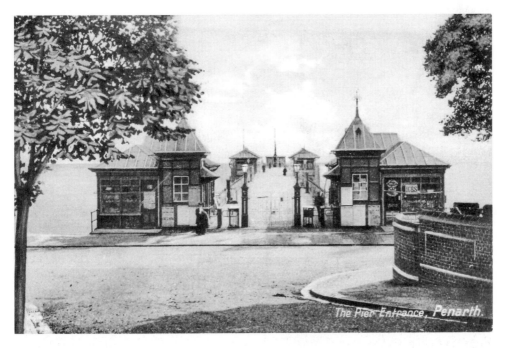

The pier entrance *c.* 1905 showing the shelter erected on the pier head for those using the paddle steamers. The sailing times of the steamers are advertised on the boards seen at the pier entrance. (Marlinova Collection)

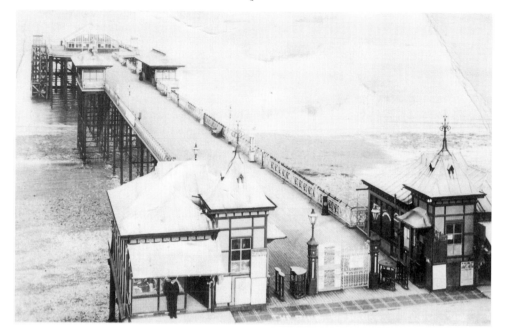

A postcard used on 1 June 1907 which shows the Bijou Pavilion erected on the pier head in that year. The building was leased to Oscar Mills, who held afternoon matinées and evening entertainments, with sacred and military concerts on Sundays. (Marlinova Collection)

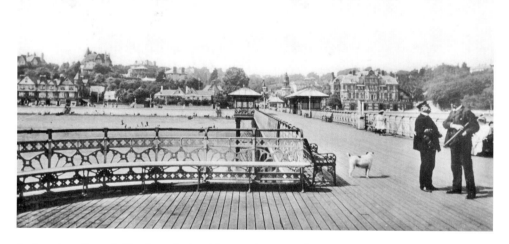

A view along Penarth Pier from the head in 1908 featuring the pier master and his dog. Note the fine wrought iron railings provided by the contractors James and Arthur Mayoh of Manchester. (Marlinova Collection)

PROPOSED PIER FOR PENARTH – TO THE EDITOR OF THE WESTERN DAILY MAIL, SIR – The Douglas Iron Pier, which has been offered to the directors of the Penarth Pier Company for about a quarter of what it will cost to put a new pier down, is no "eyesore" but a really very pretty structure. It is 40 ft wide at the end for a distance of about 90 ft, and then narrowing to about 18 ft to the shore. The most elaborate structure in the same position in the centre of Douglas Bay would be called by the islanders an "eyesore" and obstruction, but the same structure at Penarth would be both ornamental and useful and surely the businessmen of Cardiff and district do not want to spend say £20,000 when they could gain the same practical results for £4,000.

Work on building the pier finally commenced in January 1894, undertaken by the contractors Joseph and Arthur Mayoh of Manchester, who had submitted a tender of £8,500 to build the pier (£8,000 in cash and £500 in 100 shares). The official description of the pier stated that

The pier proposed to be erected at Penarth will be about 640 ft long, with a 'toe' end 100 ft in length, in the centre of which will be four landings and stairways for the convenience of passengers embarking and disembarking. The sea face of the pier will be protected with heavy wooden piles and fender pieces. It will be 30 ft wide, and the height from the ground at the extreme end will be 46 ft. This exceptional height is the most costly feature of the structure, and is rendered necessary by the very great rise and fall of tide in the Bristol Channel. It will be the highest landing pier in the United Kingdom, those on the south and east coasts rarely exceeding 26 ft. There will be 210 vertical cast iron columns, and the deck will be carried on three longitudinal wrought iron lattice girders the whole enclosed with a handsome iron railing. The columns will be in sections of fours, braced together with tie-rods. On the deck, at the centre of the toe end, it is proposed to build a pavilion, with an upper deck for bands, &c, under which will be the companion-ways for the landings, shops for the sale of fancy goods, refreshments, &c, while at the sides there will be seats and shelters for visitors. At the entrance to the pier will be the necessary toll-houses and offices, constructed upon a light and ornamental design.

On 12 October 1894, the *Western Mail* reported that the work on the pier was practically completed and Captain Evans, formerly in command of the *Bonnie Doon,* has appointed pier master.

The first section of the pier was open to the public on 4 February 1895. However, on 1 April 1895, the schooner *Aurora* collided with the northern end, causing minor damage to the piling. The pier was quickly repaired and was officially opened on 6 April 1895 with the Cogan Brass Band welcoming the pleasure steamers *Bonnie Doon* (part of Edwards, Robertson & Co.'s Bristol Channel Passenger Service Limited) which was sailing to Weston-Super-Mare, and P. & A. Campbell's *Waverley,* from which Herbert Edwards stepped on to the pier. The finished pier's dimensions were slightly different from those originally projected, being 658 ft long and 25 ft wide. It had two shops flanking the entrance, two shelters halfway down the pier and a shelter on the pier head (but no pavilion). The pier had a successful first season, making a profit of £234 11s 2d.

Admission to the pier was 2d and entertainments were initially provided by Messrs Darrell & Co. of London, who engaged variety artists and bands such as the Band of 7th Volunteer Division of the Royal Engineers, who often performed under canvas on the pier head. In 1897, Edison's Projectoscope was an attraction, and three years later Harry Benet and his Happy Coons performed twice daily on the pier. Steamer trips were available to Cardiff, Weston-Super-Mare, Clevedon, Lynmouth and Ilfracombe aboard the *Bonnie Doon* and *Lorna Doone,* operated by Messrs Edwards, Robertson & Co., and *Westward Ho!, Ravenswood, Cambria* and *Waverley,* part of the P. & A. Campbell fleet. However, in 1897, a dispute arose between the Penarth Pier Company and P. & A. Campbell regarding the tolls levied by the pier. Campbell's threatened not to call at the pier, but an agreement was quickly reached.

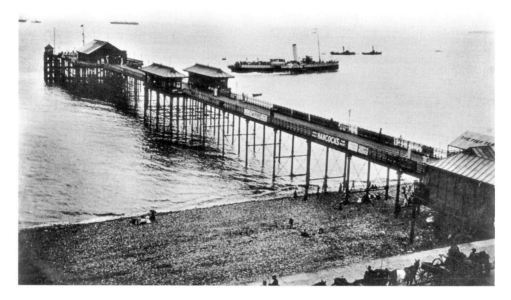

A paddle steamer of the P. & A. Campbell fleet departs the pier *c.* 1911. Additional revenue was gained by allowing advertising panels along the side of the pier. (Marlinova Collection)

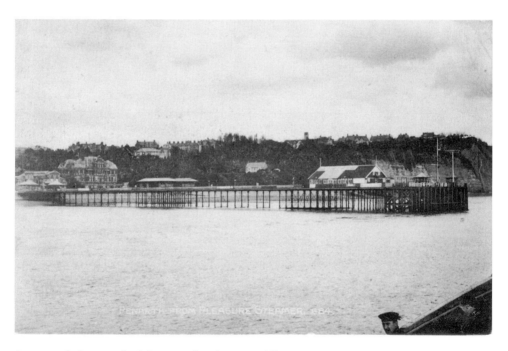

An unusual photograph of the pier taken from a paddle steamer in 1908, which gives a good view of the rather plain Bijou Pavilion. (Marlinova Collection)

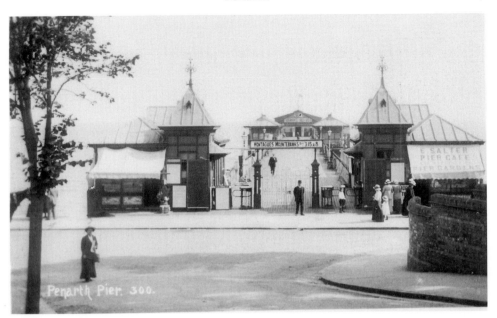

A photograph of the pier taken by local photographer Fred Viner *c.* 1920. Montagues Mountebanks is appearing in the Bijou Pavilion at 3.15 and 8 p.m. daily and E. Salter is running the Pier Café. (Marlinova Collection)

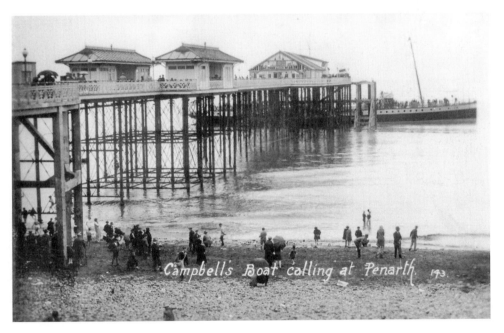

A P. & A. Campbell paddle steamer calling at Penarth Pier during a low tide in the 1920s. (Marlinova Collection)

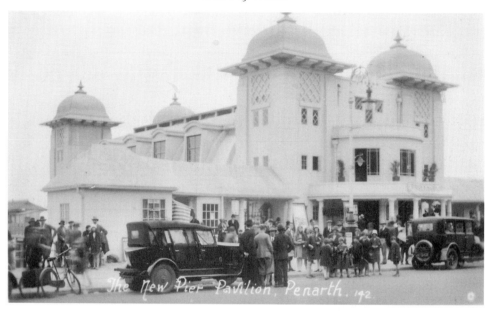

The pavilion erected at the entrance to the pier photographed in the year it was opened, 1929. The Art Deco-influenced concrete building was erected by Messrs E. J. Smith of Cardiff and could seat 600 people. (Marlinova Collection)

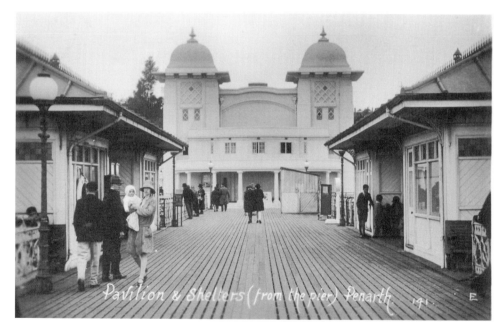

A view taken on Penarth Pier *c.* 1930 showing a close-up of the shelters in the centre of the pier and the new pavilion erected in 1929. (Marlinova Collection)

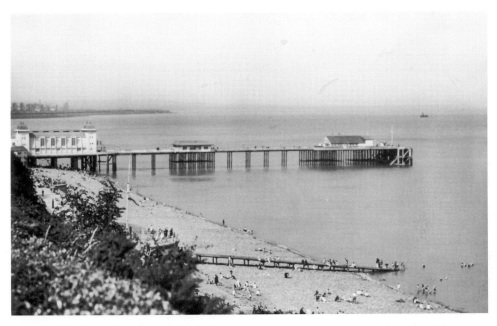

This postcard of 1929 shows both the new pavilion at the entrance to the pier and the old Bijou Pavilion on the pier head. (Marlinova Collection)

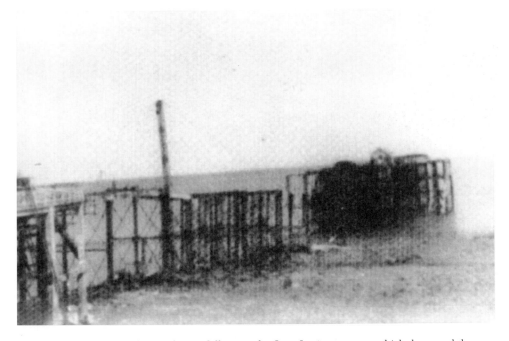

The shattered remains of Penarth Pier following the fire of 3 August 1931 which destroyed the Bijou Pavilion and much of the pier beyond the new pavilion. The structure was fully rebuilt by the following year, although the Bijou Pavilion was not replaced. (Marlinova Collection)

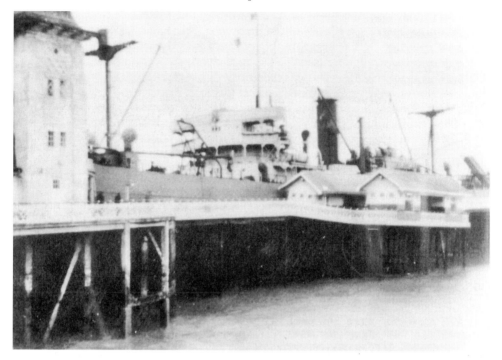

On 2 May 1947, the pier was extensively damaged when the steamer *Port Royal Park* was driven into it during a gale. Repairs to the structure took two years at a cost of £28,000. (Marlinova Collection)

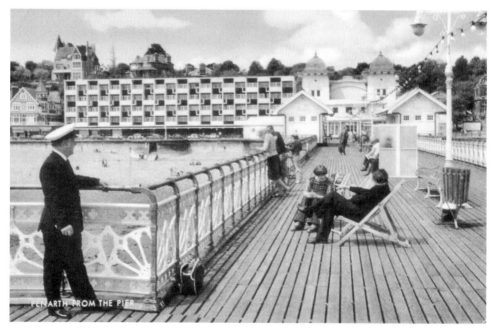

A postcard view of the pier in the late 1960s, showing the Pier Master on the left surveying his domain. The new block of flats on the Esplanade stands out, although the pier itself looks little changed from thirty years earlier. (Marlinova Collection)

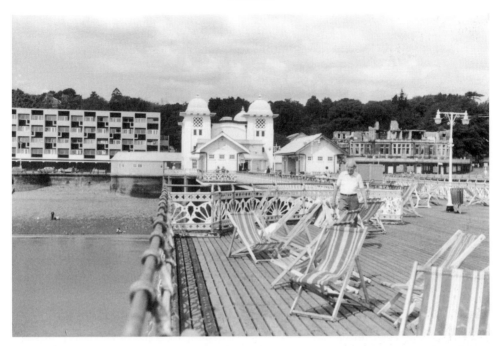

Looking towards the shore from the end of the pier in 1982. On the right can be seen the burnt out shell of the Esplanade Hotel. (Marlinova Collection)

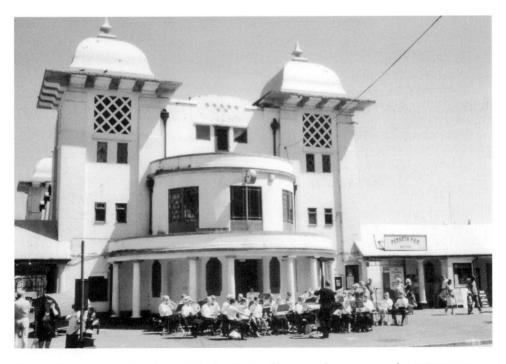

The St Albans Band performing outside the Pier Pavilion on a glorious sunny day in June 2001. (Anthony Wills)

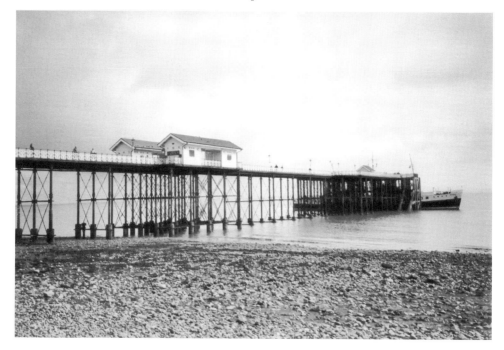

The MV *Balmoral* calls at the Penarth Pier in September 2005. (Marlinova Collection)

In 1907, the Bijou Pavilion replaced the shelter on the pier head and it was leased to Oscar Mills. He provided afternoon matinées at a cost of 3d-6d per person with tea given to the occupiers of the front seats. The evening entertainments cost between 3d and 1s per person, whilst on Sundays sacred and military concerts were held. Alfred Newton acquired the pavilion lease in 1911 (which he held until the building burnt down in 1931) and provided much the same fare as his predecessor – matinée concerts, variety acts, farces, musical sketches, light plays and the occasional operetta and ballet. The pier also provided Salter's Pier Café at the entrance, tearooms and shops.

In the years before the First World War and the first two years of it, the pier proved to be a profitable concern with profits of £200 in 1909, £174 in 1910, £309 in 1911, £325 in 1912, £79 in 1913, £239 in 1914 and £258 in 1915. The war had seen the pier requisitioned by the army and a searchlight placed at the end to provide illumination for craft entering Cardiff Docks. However, it remained open to the public, although the steamers (which had been requisitioned by the Royal Navy) did not call. The army personnel billeted on the pier occasionally put on shows in the Bijou Pavilion, yet the army presence led to damage to the landing stage in particular, and annual losses began to occur. A claim for damages was submitted to the War Department and £353 was paid out in compensation. However, this was not enough to enable the landing stage to be repaired and steamers were unable to call. This led to a loss of patronage both for the pier and resort, which was losing out in favour of Barry Island and Porthcawl with their funfairs. In 1922 and 1923, the Penarth Promenade & Landing Pier Company incurred heavy losses, which led it to be wound up on 20 April 1925. The pier passed to Penarth UDC in October 1924 for £5,000 and two years later they built a new ferro-concrete landing stage to enable steamers to call once more. An Art Deco, Indian-styled, concrete pavilion was the next addition, opening in May 1929. To house the pavilion, the shore end of the pier was widened by Messrs MacDonald of Abergavenney and the building itself was erected by Messrs E. J. Smith of Cardiff to a design by M. F. Edwards. The main hall of the building on the ground floor measured 95 x 42 ft and featured a large balcony, seating for 600 and a 44 x 21 ft stage. The total cost of the 1926-29 improvements to the pier was £26,000.

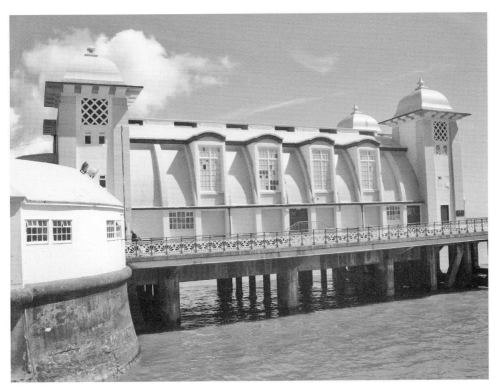

A view of Penarth Pier Pavilion taken in June 2009. The fine exterior of this Grade II listed building hides the fact that it awaits restoration and a new function in life. (Marlinova Collection)

The old pavilion on the pier head continued to remain in situ until it was destroyed by fire during the evening of Monday 3 August 1931. The fire was probably started by a discarded cigarette igniting rubbish under the dance floor and 200 people in the building had to rush to safety. Nevertheless, around thirty people were trapped on the landing stage and had to be rescued by boat. Unfortunately, two of the boats capsized and the poor occupants had to be rescued for a second time – quite an ordeal! The Moonbeams concert party, performing in the new pavilion, helped fight the fire whilst still wearing their costumes and greasepaint. A gangway was placed over the damaged portion of the pier to enable access to the landing stage and by the summer of 1932 the pier had been repaired at a cost of £3,157, although the old pavilion was not replaced.

The new pavilion became a cinema in 1932 and also acquired an outdoor café, run on continental lines, although the venture was short-lived. During the summer of 1933, the leaseholders, Messrs Cooper and Wright of Newport, had been turned out and, by the following year, the pavilion was being used as a theatre again and as a dance hall, known as the Marina Ballroom.

Following the Second World War, when the pier had remained open in a reduced capacity, the pier gained a new Pier Master in Stan Galley, who was to hold the post until 1970. Unfortunately, just a year into his tenure, Mr Galley saw the pier extensively damaged when the steamer *Port Royal Park* was driven into its north side during a gale on Friday, 2 May 1947. Over seventy of the cast iron supports were fractured or pushed out of alignment and virtually the whole of the pier neck was damaged, necessitating extensive repairs. Many of the cast iron columns had to be underpinned and several new reinforced concrete supports were added. The pier was eventually reopened on Whit Monday 4 June 1949, having cost £28,000 to repair.

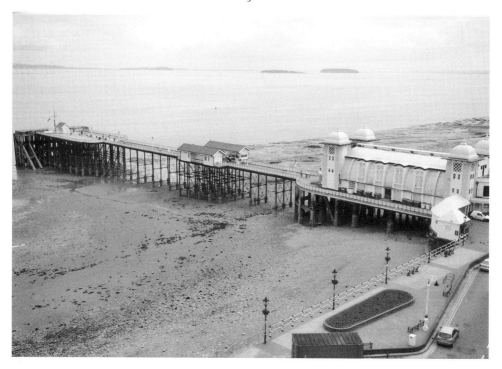

The elegant outline of Penarth Pier and Pavilion at low tide photographed from the hill above in March 2010. (Marlinova Collection)

Although the 1950s saw the pier remain a popular attraction, visitor numbers began to decline during the 1960s. The pier suffered further damage on 20 August 1966 when the paddle steamer *Bristol Queen* hit the pier during thick fog, damaging the pier head. Two years later, P. & A. Campbell replaced their paddle steamers with motor vessels, but their vessels ceased calling at the pier in 1981. Nevertheless, the landing stage remains in use, and is often visited by PS *Waverley* and MV *Balmoral*.

The pier came under the control of Vale of Glamorgan Council in 1974 and, on 1 April 1985, they abolished the entrance tolls. The pavilion was being used as the Commodore snooker club and bar. In 1994-98, the pier was extensively refurbished at a cost of £1.7 million with the help of National Lottery funding and, in 2007, received a further £50,000 of lottery money towards the cost of a feasibility study into possible uses for the rather run-down Grade II listed pavilion. These include a 95-seat art cinema at the landward end of the structure. The two central buildings on the pier house refreshment outlets and toilets.

BARRY ISLAND/YNYS-Y-BARRI

In 1874, John Davies Trehane, who owned land in the area, wished to erect a small pier on the west side of Whitmore Bay to enable pleasure steamers and private craft to call at the island. He engaged Cardiff engineer Peter Price, who wrote to the Board of Trade on 2 June 1874 asking for permission to erect a pier and landing stage of concrete with timber framing 10 ft wide and 15 ft high. Four days later, Price wrote again to the Board of Trade:

I beg to inform you that the pier is to be open to the public, but Mr Trehane's present intention is to allow the tenant of the hotel on his island to charge a 1d toll to excursionists and pleasure parties which it is expected will flock in large numbers from Cardiff and neighbouring ports. Mr Trehane's intention is to develop the island for building purposes and in that event will probably discontinue (as it will be his interest to do) the charge for the toll, the object being to draw visitors to the island.

However, by the following year, the design of the proposed pier had been changed. Engineer Chas Jacobs had drawn up a plan for an iron pier of 112 ft in length with a width of 10 ft and a pier head of 40 ft x 12 ft. Because of the high tidal range, the pier was a tall structure with a three-tier pier head. The foreshore was granted to Trehane in November 1875 and the pier was opened the following year.

Alas, Trehane's plans for developing the island never took off and the pier appears to have been little used. The structure became unsafe and in 1902 it was demolished.

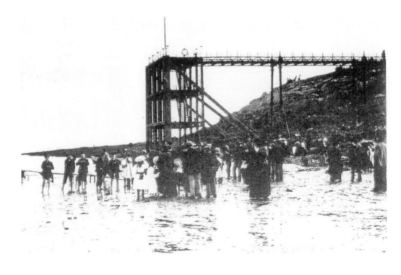

This small 112-ft-long iron pier was built on Barry Island in 1876 for the local landowner John Davies Trehane. This view, taken in *c.* 1898, shows the tall structure at low tide. (Marlinova Collection)

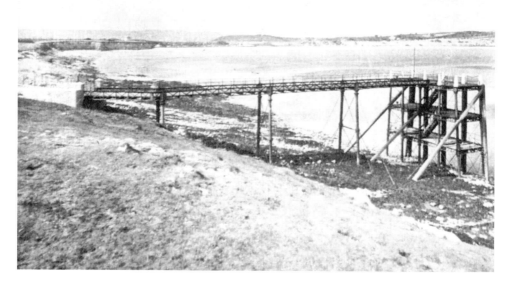

A deserted Barry Island Trehane Pier *c.* 1900, a few years before the structure was demolished.
(Marlinova Collection)

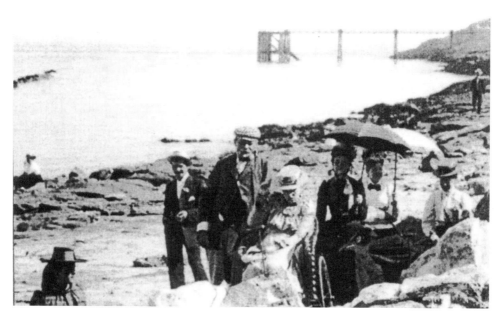

A Victorian family poses on the beach at Barry Island in the 1890s with the Trehane Pier seen in
the background. (Marlinova Collection)

ABERAVON/ABERAFAN

Aberavon is the seaside suburb of Port Talbot whose sandy beach became popular with visitors and locals in the late Victorian era; centred in the area around the wooden north breakwater erected in 1898 by the Port Talbot Railway & Dock Company to protect the entrance into the New Dock. The area was initially developed by W. Williams, who tidied up the beach around the dock entrance and erected wooden shelters and refreshment huts. He also built the Jersey Beach Hotel, which he sold on to a syndicate from Newport. Aberavon Town Council, in association with the new hotel owners, approached the local landowner, Lord Jersey, to secure permission to further develop the area, which was granted. The contractor, Thomas Scott of Rugelan, near Motherwell, was engaged to construct a 640-ft-long esplanade fronting the beach and to convert the 1,500-ft-long breakwater (which had been leased from the Port Talbot Dock & Railway Company) into a pleasure pier with the addition of an entrance kiosk, turnstiles, seating and wooden decking. The total cost of all the work was £4,000.

The official opening of the new esplanade and pier by Lord Jersey took place on 22 May 1902. Despite the pouring rain, a large crowd watched the procession leave the town hall for the sea front at 3 p.m., headed by the Band of 2nd U. B. Welsh Regiment, police, fire brigade, Friendly Services and a carriage containing the Mayor and Mayoress and Lord Jersey. Equally large numbers of people lined the new esplanade to witness Lord Jersey perform the opening ceremony before people were allowed on the pier at a penny a time.

The pier proved to be popular and had to be strengthened. In 1905, eight piles at the shore end were replaced by some of a greater length to form a sloping approach down to the pier.

However, the structure was prone to storm damage from south-westerly gales and by 1914 the wooden decking was sporting large cracks. The pier had lost its initial popularity and Aberavon as a whole was losing out as a resort to Porthcawl and Barry Island. Matters were not helped by oil being washed up onto the beach from vessels using Port Talbot Docks, or indeed by the close proximity of industry. The pier was closed off to the public by the early 1920s, although that did not stop many from climbing onto it. Repairs were carried out to the structure, but it was never returned to use as a paying promenade pier.

During the Second World War, the pier became derelict and its condition continued to deteriorate after the war as the timber bulks and concrete sections broke away. Responsibility for repairs to the structure was argued over between the council and the pier's owner, the British Transport Commission.

In the meantime, anglers climbed over the barbed wire at the entrance to fish from the pier. The BTC carried out some re-decking of the pier in December 1957 to make it safe, but stopped short of reconstructing it for the use of the public. Notwithstanding, gales in April 1961 caused a breach in the structure, and it became progressively hazardous. This finally prompted the BTC to commence a £250,000 scheme in September 1962 to reconstruct the pier with concrete blocks and place 2,147 concrete Tetrapods around it to absorb the energy of the waves.

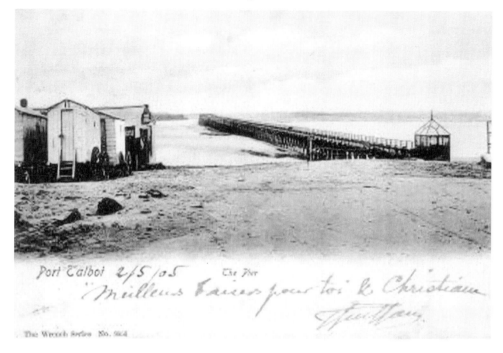

Port Talbot 2/5/05 *The Pier*

The Wrench Series No. 964

A postcard of Aberavon Pier posted on 2 May 1905, three years after the pier was formed by the addition of wooden decking, railings and a toll house to the north breakwater at the entrance to Port Talbot Docks. (Marlinova Collection)

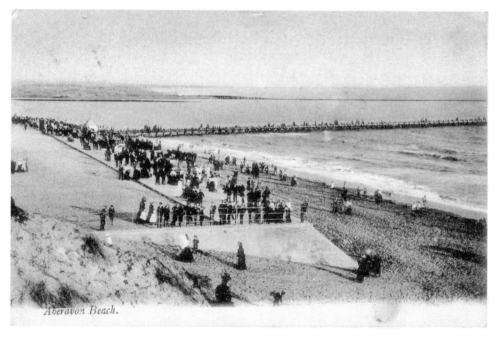

Aberavon Beach.

This postcard, also from 1905, shows the sea front at Aberavon on a busy day with the pier also well patronised. The esplanade was developed around the same time the pier was developed. (Marlinova Collection)

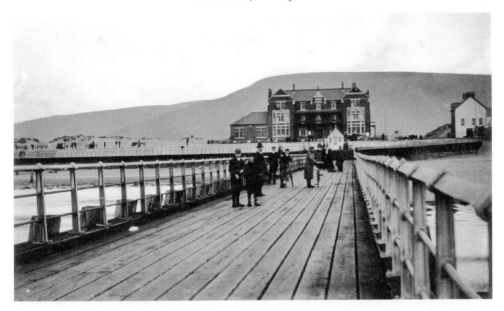

A view of Aberavon Pier looking towards the shore and the Jersey Beach Hotel *c.* 1911. The hotel was erected as part of the development of the area in the late-Victorian/early-Edwardian era, but like the pier, is no more. (Marlinova Collection)

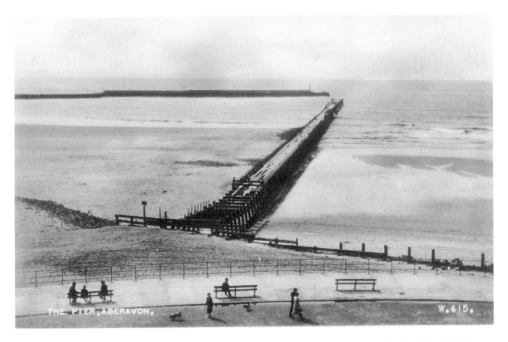

This mid-1930s postcard shows Aberavon Pier closed and in a sorry state. It had suffered badly from repeated storm damage and the decision was taken not to restore it as a pleasure pier. (Marlinova Collection)

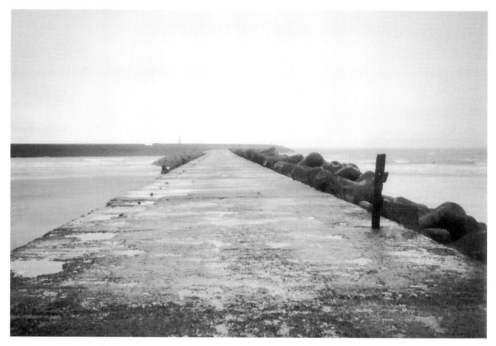

The breakwater that once housed Aberavon Pier is still accessible, as this photograph from September 2005 shows. The wooden decking and railings are long gone, but the structure still provides a bracing marine promenade. (Marlinova Collection)

The work was completed in October 1964 and rails were provided along both sides of the structure for those who wished to walk along it, although dock chiefs stressed that it was purely and simply a breakwater to protect the approaches to the port.

By 2005, the railings had gone and the shore end of the breakwater was buried under a rising level of beach sand. However, it is still used by locals as a promenade, although strictly at their own risk.

MUMBLES

Situated at the far western end of Swansea Bay, Mumbles was a favoured day-trip resort for the people of nearby Swansea and the two were connected by the famous Swansea & Mumbles Railway, which, in 1807, commenced the world's first regular passenger service, using horse power.

In 1864, railway contractor John Dickson applied to Parliament to extend the line from Oystermouth to Mumbles Head and erect a stone pier to enable the railway to run onto it. Work was carried out on the railway and the track bed was in place by March 1866, but the scheme was abandoned following Dickson's bankruptcy in 1867. That was not the end of Dickson's involvement however, for, in 1878, he acquired the line, still with the intention of building a deep-water pier for steamers to call at at all states of the tide.

Dickson's scheme for a pier was never carried out, but the idea was revived by Sir John Jones Jenkins, Chairman of the Rhondda & Swansea Bay Railway, who took a lease on the Swansea & Mumbles Railway in 1885. His plan included the extension of the railway from Oystermouth to a pier and harbour at Mumbles Head. On 24 May 1889, the *Western Mail* reported that engineer G. N. Abernethy had inspected the site of the pier and designed a structure of cast and wrought iron where passengers could be landed at all states of the tide.

The Mumbles Pier & Railway Company was formed and was incorporated by an Act of Parliament on 26 August 1889 'for making a railway from the Oystermouth line or tram road to Mumbles Head, with a pier in connection therewith on the shore of Swansea Bay'. The length of the extension line was 2 ¼ miles and the period for completion was five years. The capital of the company was £81,000 in £10 shares and it had borrowing powers of £27,000. Work on extending the railway commenced in 1892 and the line was opened to Southend in 1893. The final extension to Mumbles Head was eventually opened on 10 May 1898.

The proposal for a harbour was to be thwarted by the Swansea Harbour Trustees, but, on 14 April 1897, the sea bed for a pier was conveyed by the Board of Trade to the Mumbles Railway & Pier Company. The contractors, Messrs Mayoh and Haley, commenced work on building the 835-ft-long pier at a cost of £10,000 to a design by W. Sutcliffe Marsh using pre-cast parts supplied by the Widnes Iron Foundry. They consisted of cast iron screw piles with steel-railed bracing and tie rods. Steel lattice girders, braced transversely, supported pitch pine deck pieces. In April 1898, the contractor's offices on the pier were destroyed by fire, although the pier itself escaped harm. The pier was officially opened by Lady Jenkins, wife of Sir John Jones Jenkins, on the same day the railway was extended to Mumbles (10 May 1898), and a steamer trip from the pier was run by Messrs P. & A. Campbell. In the following year, on 1 July 1899, both the railway and pier were leased to the Swansea Improvements & Transport Company for a term of 999 years.

The pier proved difficult however for the steamers to use at low water. On 3 September 1898, the *Bristol Mercury and Daily Post* reported that the steamer *Menapia*, having sailed from Tenby, went aground 300 yards off the pier and its passengers had to be rowed ashore in small boats. On 11 August 1900, the *Brighton* was grounded 80 yards from the pier and its passengers also had to be rowed to the shore. Fortunately, the steamer was freed from the rocks the same day and was able to sail on her way.

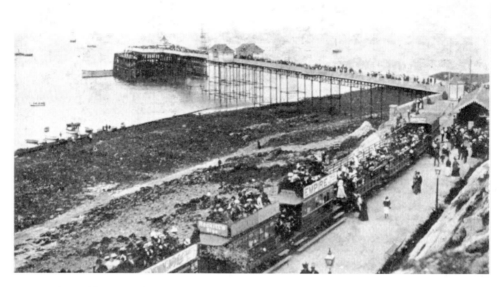

A view of Mumbles Pier taken soon after it was opened on 10 May 1898. The Swansea & Mumbles Railway was extended to the pier on the same date and here it can be seen with a full load. (Marlinova Collection)

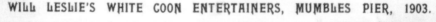

WILL LESLIE'S WHITE COON ENTERTAINERS, MUMBLES PIER, 1903.

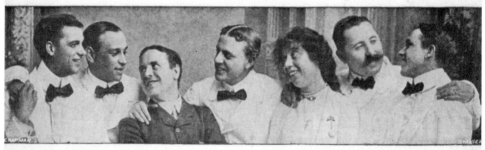

Mr. Eric Charleswood. Mr. Will Leslie. Miss Amy Kendal. Mr. Ern. Jones
 Mr. Moss Joseph. Mr. Leo Royburn. Mr. E. St. Clar Barfield.

An unusual postcard showing Will Leslie's White Coon Entertainers on Mumbles Pier in 1903. They performed in the shore pavilion and in the pier head bandstand when fine. Will Leslie is third from the left with the dark jacket. (Marlinova Collection)

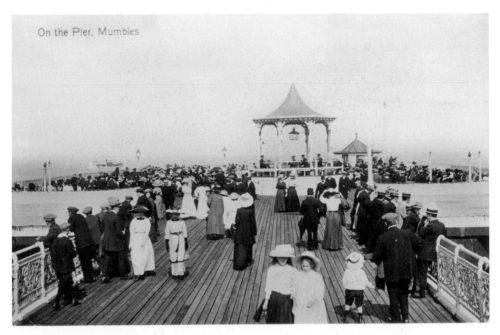

On the Pier, Mumbles

On Mumbles Pier looking at the pier head bandstand *c.* 1910. The pier's wrought iron railings, cast by the Widnes Iron Foundry, were particularly attractive. Their work can also be seen on Colwyn Bay Pier. (Marlinova Collection)

Looking down on Mumbles Pier from the hill above in 1907. The entrance kiosk to the pier can be seen, and by the carriage is what looks like a camera obscura, which gave a panoramic view of the scenery around. (Marlinova Collection)

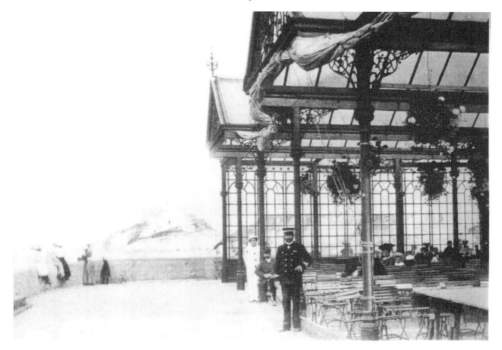

The open glass veranda of the pavilion of Mumbles Pier which was located on the shore by the pier entrance. This view was taken around 1905. After a few years, the building was totally enclosed. (Marlinova Collection)

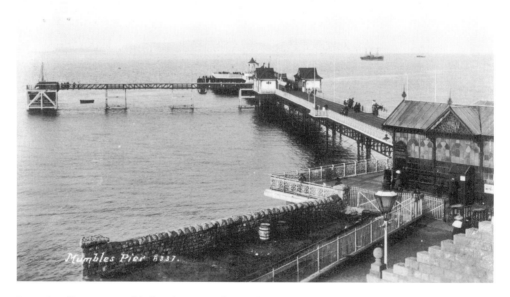

In 1916, a slipway was added to the pier to house the Mumbles Lifeboat, and this postcard shows the pier shortly after the addition. On the right can be seen the pier pavilion after the veranda had been enclosed. (Marlinova Collection)

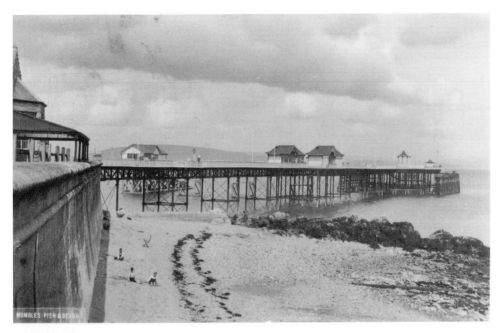

An unusual postcard view of Mumbles Pier taken from the west, posted in June 1929. The beach remains a nice secluded spot to this day. (Marlinova Collection)

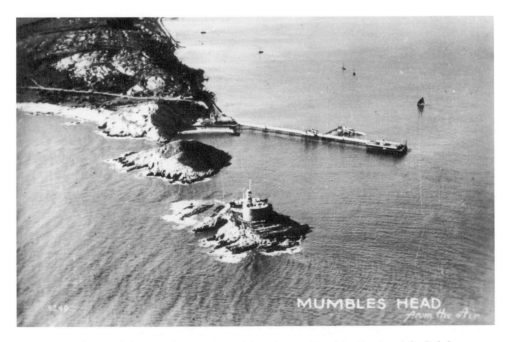

A 1920s aerial view of the pier showing its position close to Mumbles Head and the lighthouse. (Marlinova Collection)

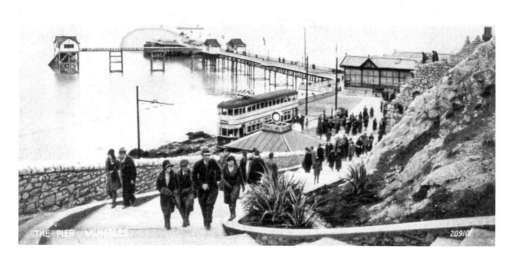

Mumbles Pier in the 1930s, showing the lifeboat house added in 1922 and the new electric trams, which took over the steam services on the Swansea & Mumbles Railway in 1929. (Marlinova Collection)

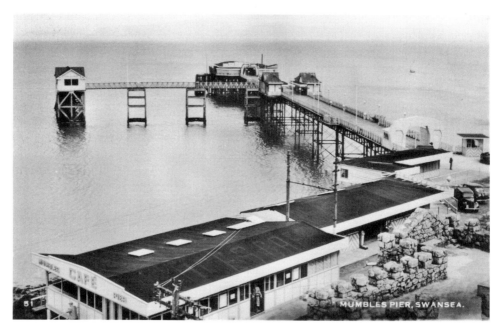

This postcard, sent in 1954, shows the pier following postwar rebuilding with the amusement arcade by the railway terminus and the short-lived performance area on the pier head. (Marlinova Collection)

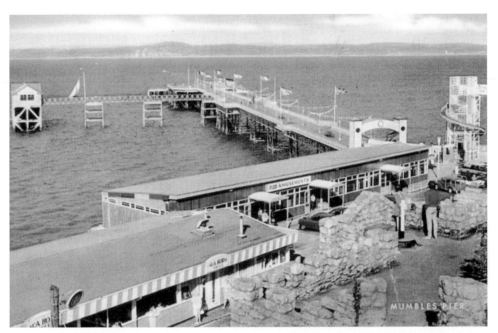

A late 1960s postcard view of Mumbles Pier featuring the amusement arcade built on the site of the Swansea & Mumbles Railway terminus. (Marlinova Collection)

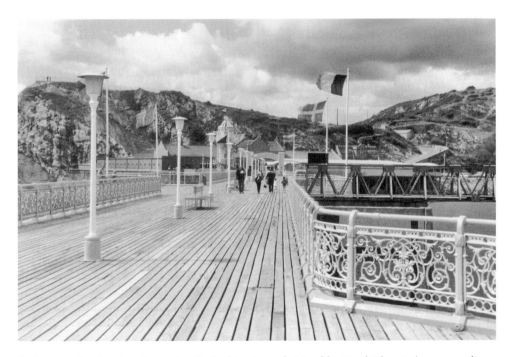

A photograph taken in 1982 on the pier looking towards Mumbles Head. The pier's ornate railings were supplied by its builder, the Widnes Iron Foundry and similar examples were provided on other piers erected by them. (Marlinova Collection)

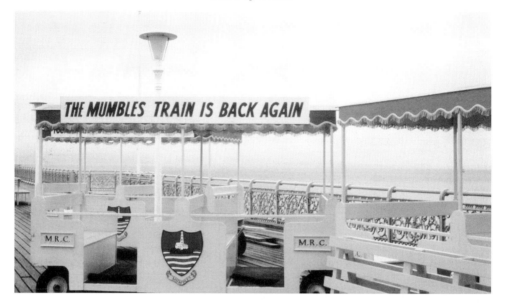

During the late seventies and early eighties, the pier had a road train run up and down the deck, which cheekily proclaimed 'The Mumbles Train is Back Again'. These carriages were pulled by a red loco-shaped car called *Oystermouth Castle*. This photograph was taken in 1978. (Marlinova Collection)

Attractions offered included a refreshment room, shop, tea kiosk and an ornamental pier pavilion at the entrance to the pier. This originally had an open glass veranda on the seaward side, which was later covered in. Adjoining the pavilion was a hotel. The pier head sported a bandstand where military and local bands, such as the Aberamman Silver Band, performed. Carnivals were also a feature of the pier: in July 1900, one held for invalided soldiers from the South African War raised £80 and another for the RNLI £220. The carnivals featured aquatic events, male-voice and choral singing and military band music. A further attraction for visitors was performing divers, and, in 1904, Billy Thomason, the one-legged diver, and W. Doherty, 'the accomplished ornamental swimmer', gave displays.

During the summer of 1916, a lifeboat slipway was added to the pier, although a boathouse was not erected until 1922. Before then, the lifeboat *Charlie Medland* had to be covered with a tarpaulin. In 1924, a new motor vessel *Edward, Prince of Wales* was placed on station. Sadly, the vessel was to capsize on 23 April 1947 with the loss of eight of her crew whilst going to the rescue of the SS *Samtampa*.

On 3 March 1938, the Amusement Equipment Company Limited (AMECO) gained a licence to operate the pier from the owners, the South Wales Transport Company, who had acquired the pier in 1927. However, with the onset of the Second World War, the pier was closed and decking removed to prevent it being used in the event of an enemy landing. An inspection of the pier at the war's end revealed that the steelwork had corroded owing to lack of maintenance. The pier was patched up and reopened, but was closed as unsafe in 1953. Work began on restoration and, on 9 June 1956, it was officially reopened by Councillor Harry Libby, Mayor of Swansea. The work had cost £75,000 and the pier featured a new landing stage, from which a pleasure steamer service was inaugurated. The MV *Queen of the Isles* ran trips around the Welsh coast to Menai Bridge, which took twelve hours to complete and involved an overnight coach journey home – quite a stamina test! An amusement arcade had been added by the railway terminus and a performing arena on the pier head, although the latter proved to be short-lived.

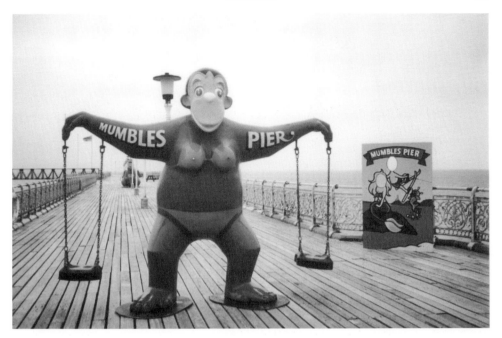

A photograph taken in February 2003 of the gorilla swing ride, nicknamed 'Nansi'. In 1999, it was stolen, but was returned two weeks later having been painted with the red breasts and knickers seen here! A visit to the pier in 2009 saw Nansi sadly dumped amongst rotten decking and corroded metalwork at the end of the pier. (Marlinova Collection)

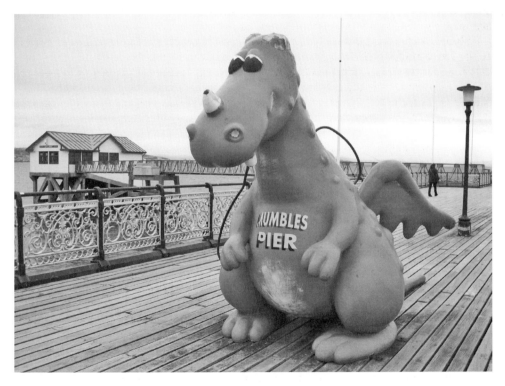

Unlike Nansi the gorilla, the Welsh dragon remained in place on the pier during a visit in June 2009. In the background can be seen the lifeboat arm and boathouse. (Marlinova Collection)

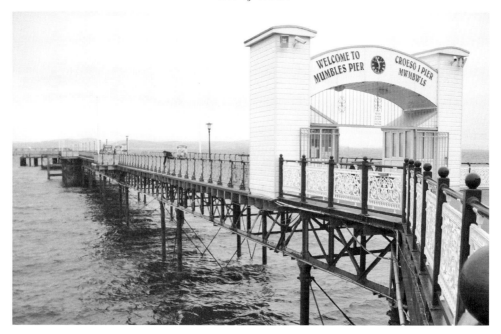

Mumbles Pier in June 2009. The shore end of the pier was in a fair condition, but a large part of the sea end was closed off awaiting restoration. The landing stage remains open for fishermen. (Marlinova Collection)

Sadly, in 1960, the Swansea & Mumbles Railway, which during its 153-year history had been horse-drawn, steam powered and then an electric tramway, was closed.

The pier survived, however, and, in 1966, AMECO rebuilt the amusement arcade at the shore end. On 22 December 1971, they finally acquired the freehold of the pier and hotel for £65,100. Unfortunately, visitor numbers declined and, on 1 October 1987, AMECO closed the pier after claiming they had no funds to maintain the structure. They stated that over the past ten years between £25-30,000 per annum had been spent on the replacement of steelwork and, in 1985, the company had informed the local authority that unless some financial assistance was given, the maintenance would have to stop. Nevertheless, the pier was reopened on 1 April 1988 following extensive structural repairs at a cost of £40,000 to the forecourt of the hotel complex at the pier entrance. In 1999, a new pavilion, housing amusements and a restaurant, replaced the old amusement arcade and café on the seaward side of the promenade area. That same year saw the mysterious disappearance from the pier of a 10-ft-tall steel and fibreglass gorilla, nicknamed 'Nansi', used as a swing ride. However, two weeks later, it returned to much surprise, having been painted brown and red and sporting a pair of breasts! Two years later, Noddy and a red and yellow taxi were stolen from the pier and, although the taxi was discovered, Noddy had been ripped out of it and the ride had to be scrapped. At Easter 2006, a skating rink, featuring synthetic ice, was opened opposite the entrance to the pier.

The pier itself remains free of buildings and is a delightful promenade exhibiting fine wrought iron railings dating from when it was built. AMECO unveiled ambitious plans in 2008 to fund the rebuilding of the pier by selling off land for the construction of a 150-bed hotel and spa complex, with a conference and exhibition centre. In 2010, it was announced that a feasibility study is to examine whether a scaled-down version of the railway could be rebuilt between Oystermouth Square and the pier.

TENBY/DINBYCH-Y-PYSGOD

The attractive town of Tenby (Dinbych-y-pysgod in Welsh), with its spectacular cliff-top setting, became a fashionable resort from the second half of the eighteenth century and, by the 1830s, boasted a bath house, assembly rooms, theatre, circulating library and other attractions. The town's harbour dates back to 1328 and, in 1842, the old stone quay was replaced by a larger structure to cater for the needs of visiting steamers which were bringing tourists to the town. However, the harbour was not available at all states of the tide and in 1868 there was a scheme to build a pleasure and landing pier for the town that would be readily accessible. This idea proved abortive, as did another in 1880. In 1892, there were two further schemes to build a pier for the resort: one for a landing pier in the harbour promoted by Tenby Corporation and the other for a pier stretching out from the more sheltered north-easterly corner of Castle Hill, promoted by the Tenby Pier & Promenade Company (which included members of the council). Some work had been carried out on the approaches to the pier before the work stopped and the company foundered (see the 'Piers That Never Were' chapter for further details of other failed Tenby pier schemes).

Having abandoned their harbour pier plans, the corporation directly took on the Castle Hill pier scheme and a Provisional Order to construct the pier was granted in 1895. In February 1895, there was a proposal to erect a temporary landing stage using the hulks of four vessels connected by light lattice steel gangways, but this was soon dropped in favour of a pier designed by engineer Richard St George Moore, who had been involved in the earlier unsuccessful schemes. His original design proposed groups of pitch pine piles 100 ft apart and driven 15 ft into the ground, although iron piles were eventually used. Upon the piling were to be placed steel bowstring girders and rolled joist cross girders. The decking was to consist of 3 x 4.5 in planking laid lengthways along the pier, screwed to the steel joists from the underside. The handrails were formed of seven-strand, galvanised wires strained along the girders, with cast iron lamp standards between the girders and at the end of the pier. The pier was to be initially 230 ft long and would stand 17 ft above the high-water mean spring tides. A temporary landing stage was to be built in pitch pine with three landing decks and interconnecting staircases, placed to the south of the pier and connected to it by another staircase. This arrangement allowed for any future extension of the pier.

The tenders to build the pier were received in April 1895 and included experienced pier contractors Alfred Thorne (Moore's preferred choice, £1,670), Heenan & Froude (£1,974) and Head, Wrightson (£1,950). Nevertheless, the lowest tender, £1,460, by John Lysaght of Bristol, was chosen. The work was set to commence on 27 May 1895, with a completion time of fourteen weeks, but Moore argued that Lysaght's estimate was too low and thought the pier and landing stage could cost up to £4,300.

By October 1895, what little work was taking place had been stopped as the council had no money to pay the contractors. They nevertheless imposed penalties for the non-completion of the work, leading to the sub-contractors, Messrs Dixon Brothers, withdrawing from the site. Moore's antipathy towards the contractors continued, arguing

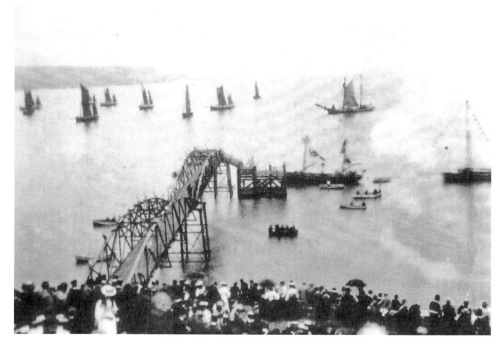

The opening day of the first 230-ft section of Tenby's Royal Victoria Pier on 22 June 1897, Queen Victoria's Diamond Jubilee Day. (Marlinova Collection)

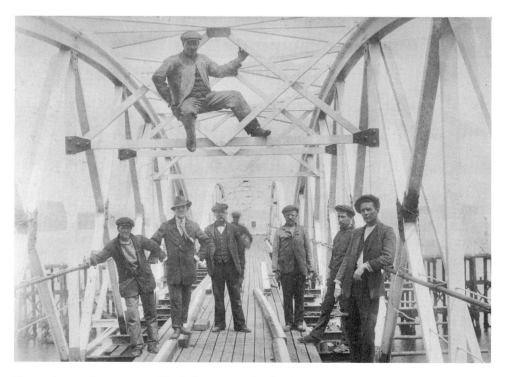

The workmen of contractors Alfred Thorne pose for the photographer as they near completion of the extension to Tenby Royal Victoria Pier in 1899. (Tenby Museum and Art Gallery)

it was their neglect that was holding up the work. Furthermore, a storm proceeded to wreck the construction gear.

The stalemate between the council and the contractors continued into 1896 with the council not prepared to pay anything to Lysaght until some work had been done, and the contractors in turn were not prepared to recommence building the pier until they had been paid some money. The council claimed that Lysaght had broken the terms of their contract by not completing the pier on time, but offered them the option to finish the pier at their own financial risk and then collect their payment by farming the tolls and dues when the pier was opened. Lysaght rejected this and then offered to complete the pier on a deferred payment system with an interest of 5 per cent. The council countered by ordering the company to remove their plant and materials within two weeks or they would be sold off; the council subsequently failed to carry out the threat.

To compound Lysaght's woes, in June 1896, he was taken to court and fined for failing to pay local ship merchant Robert Wolfe for the use of the hulk *Robert* in the works. However, he retained use of the vessel, which was damaged during a severe storm on 7 October 1896 that led to the collapse of 150 ft of the quay, upon which Lysaght had stored girders used in the pier's construction.

Some sort of agreement was finally reached between Lysaght and the council regarding a payment to the contractor and the work recommenced. By February 1897, the last group of piles had been driven in and the girder spans were ready to be put in position. On 18 February 1897, the *Tenby Observer* reported:

The idea is to extend the present structure another 100 feet seawards (though this is still thought to be insufficient), the engineer Mr St George Moore, will examine the structure prior to placing the girders. The abutment, which is composed of concrete, is now thoroughly set, and it was felt that the abutment looked stable and if the piles were of the same stability they would not give way (like Morecambe and other piers).

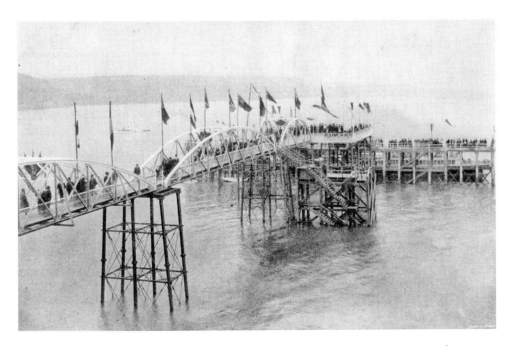

The fully completed pier at Tenby was opened by the Duchess of York on 9 May 1899. The pier measured 330 ft, enabling the landing stage to be available at all states of the tide. (Marlinova Collection)

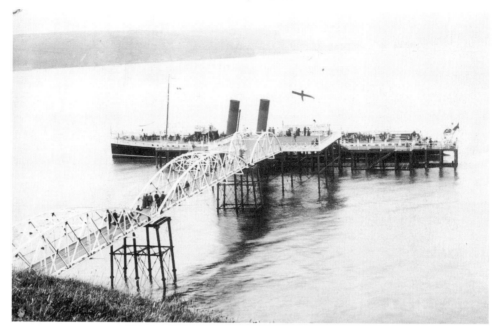

The Barry Railway steamer *Gwalia* calls at Tenby in 1909. The vessel was sold the following year to the Furness Railway and was renamed *Lady Moyra*, but she returned to the Bristol Channel after the First World War as part of Tucker's 'Yellow Funnel Fleet', then with P. & A. Campbell. (Marlinova Collection)

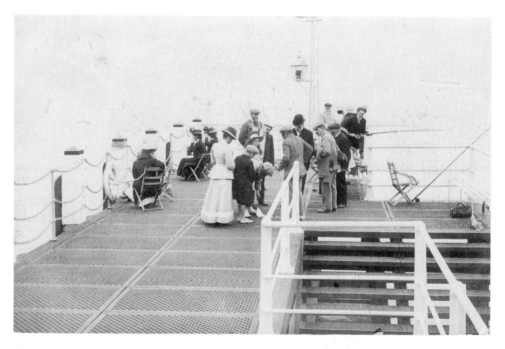

Fishing from the landing stage at Tenby Pier in 1908 with one man's catch provoking some interest. The steps to the lower stage can be seen in the foreground. (Marlinova Collection)

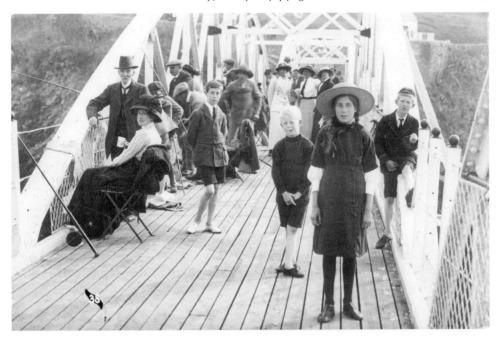

A delightful study of a fishing competition on Tenby Pier in 1909 with the children happy to pose for local photographer H. Mortimer Allen. The photograph gives us a good idea of the narrowness of the pier deck and its arched sections. (Marlinova Collection)

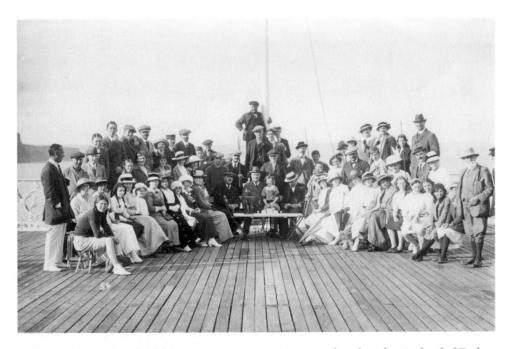

A photograph showing the fishing competition prize winners gathered on the pier head of Tenby Royal Victoria Pier in 1909. Fishing was one of the main income sources for the local council, which owned the pier. (Marlinova Collection)

The placing of the girders was duly reported by the *Tenby Observer* on 1 April 1897:

The first iron girder was placed in position under the supervision of Mr Wardle, who represents Messrs Lysaghts the contractors. The placing of the girders caused quite a commotion in the town as the spectators included Mr T. Aneurgh Rees (Town Clerk) and Mr J. Preece James (Borough Surveyor) and when one girder was done by seven o'clock, Mr Wardle announced to the spectators that the girders weighed 13 tons each, and as there is [sic] four of them, the combined weight is 52 tons. In length they are 104ft each. Thirty men were engaged in the operation, which passed with safety and success. The second girder will be placed on Tuesday following the same routine and all the work will be carried on until all the girders are in place.

The first 230-ft section of the pier, consisting of a two-arched deck section with a small landing stage on the southern side, was opened on 22 June 1897, which was Queen Victoria's Diamond Jubilee Day. The *Tenby Observer* reported:

THE OFFICIAL OPENING OF THE LANDING STAGE – At around 10 a.m., the Mayor and the Corporation proceeded to the Old Pier, where a stone commemorating the repair of the structure was laid by Mr Stokes. The party then boarded the yacht 'Kate' and in tow of Mr Cunningham's steam yacht 'Firefly' all proceeded to the new landing stage. The 'Kate' was accompanied by the yachts 'Arrow', 'Sirous', 'Mabel' and 'Condor'. The whole of Castle Hill was covered with spectators. The structure, which had been christened the 'Victoria Pier and Landing Stage', was decorated with a profusion of flags. The Tenby Male Voice Choir, under the leadership of Mr Richard Williams, was present on the pier for the opening ceremony.

The Mayor was the first to disembark on the landing stage, where he was met by Mr Wardle (Messrs Lysaghts superintendent) and workmen, the other members of the corporation followed, they all ascended in front of the brass plate, which had been fixed to the right hand side of the pier, and which contained an inscription to the effect that the

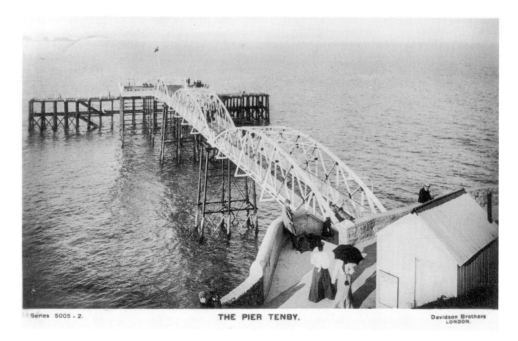

Series 5005 - 2. THE PIER TENBY. Davidson Brothers LONDON.

A close-up view of the pier and its entrance hut from Castle Hill *c.* 1912. The board on the side of the building is advertising the table of tolls to use the pier. (Marlinova Collection)

structure was opened by the Mayor and Corporation on Diamond Jubilee Day, together with the names of the Mayor, Town Clerk, Engineer and High Sheriff, the Reverend Godfrey Wolfe. The Mayor then unveiled the plate and declared the pier open. The crowd gave a large cheer and the Male Voice Choir sang 'All Hail the Power of Jesus' Name'. The cheering have subsided, the Mayor then presented Mr. Wardle with a writing desk, given by all the employees who worked on the pier.

The new pier has the following particulars: Length of first span 100 feet in the clear, second span 100 ft; width of first group of columns 18 ft x 6 ft and 10 ft; the gangway of the pier between the girders is 10 ft wide. The main girders are 104 ft long and 13 ft deep, tied together with cross girders at the bottom and cross bracing underneath. The top of the main cross girders are strongly braced with vertical and horizontal angle iron bracings. The girders are on the bolstering lattice principle, all riveted together. The underside of the main girders is 44 ft 6 in above low water mark. There is a 30-foot rise and fall of the tide where the pier is erected. The foundations of the inner group of columns are sunk in the solid rock; the method of sinking was by cylinders under compressed air.

The landing stage erected near the end is constructed of pitch pine piles driven 16 feet into a good solid base and strongly braced, and will be a perfect landing stage for boats and yachts.

The eventual cost of the first stage of the pier was £2,389. Two weeks after the opening, *Britannia* became the first steamer to call and during August and September of that year the pier handled some 18,000 passengers.

The proposal to extend the pier a further 100 feet was formally adopted at a meeting of the Landing Stage Committee of the council on 13 July 1897. Tenders were invited for the work and the following were received: Messrs Lysaghts, Bristol, £13,300; Messrs Brattel, Worcester, £9,950; Messrs A. Fassey & Sons, Liverpool, £8,850 and Mr A. Thorne, Westminster, £8,076. Thorne's estimate, which included the addition of ornamental lamps and railings along the length of the pier, was accepted, although with the addition

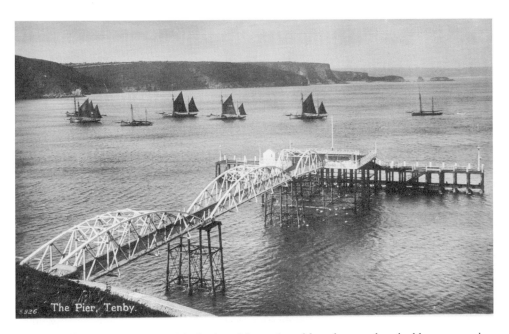

Tenby Royal Victoria Pier in 1936, little altered from 1899 although a wooden shed has appeared on the landing stage. By now the pier was little used and was a considerable burden to the council. (Marlinova Collection)

of the engineer's fees, work to the pier approach and other sundries, the total cost of the extension was expected to be £9,205. To pay for the work, a loan of £15,000 was obtained in February 1898 from the Yorkshire Penny Bank at 3.25 per cent interest.

Work on the extension was underway throughout 1898 and, on 21 July that year, the *Tenby Observer* reported:

Messrs A. Thorne (London) have been helped by good weather and have driven the piles in and decked over a large portion of the structure, and by means of a temporary bridge from the end of the present landing stage they are able to avoid any blocking of the way.

The opening of the fully completed pier, with its larger landing stage available at all states of the tide, was carried out by the Duchess of York on 9 May 1899. Having been met at the railway station, Her Royal Highness was driven in a procession of eleven carriages through the town in front of large cheering crowds before unveiling a commemorative brass plaque on the pier. The ceremony, however, did not all go to plan. The Duke of York was also meant to have been at the opening (he is recorded on the commemorative brass plaque) but was indisposed. Furthermore, due to the high price charged by the council for seats on the pier head, there were less than fifty people present to witness the Duchess officially open the pier. Those who were there could barely hear her softly spoken voice. She then departed Tenby with a silver spanner presented by the contractor Alfred Thorne and proceeded to the unveiling of the new royal yacht *Victoria and Albert* at Pembroke Dock. A controversial aftermath of the occasion involved the removal of the 1897 commemorative brass plaque from the pier to give Her Royal Highness the impression she was the first to have opened the pier! The total cost of the finished pier was a rather crippling £11,500, which was to be never fully paid off by the council.

Afternoon channel cruises ran from the pier's landing stage, as did steamer trips to Ilfracombe, Swansea, Cardiff and Bristol, predominantly operated by P. & A. Campbell. However, because of the resort's far western location, visiting steamers were fairly infrequent. During the summer months, band concerts were held on the pier head, and the pier was very popular for fishing with a number of angling competitions held there. Admission to the pier was 2d, but additional tolls for luggage were also charged (at a rate three times more than charged at the railway station) and this led to some ill-feeling about excessive charges.

There were frequent grumbles from ratepayers in Tenby regarding their 2s pier rate and on 16 April 1926 the *Tenby Observer* reported: 'For nearly thirty years now, the Tenby ratepayers have been paying off the debt on the Royal Victoria Pier, and there still remains some thousands of pounds to be cleared before the structure is free.'

During the Second World War, the pier was damaged by two landing craft and was in a poor state by the war's end. In October 1945, the council engaged consulting engineer D. C. Coode to inspect the pier and he thought the pier could be repaired at a cost of £5,000. This led the council, in February 1946, to invite tenders for the pier's repair and to ask the Welsh Board of Health for their sanction of a loan, despite still owing £700 on the cost of the pier's construction. The pier had an implacable enemy, however, in Alderman H. F. Berry, who claimed the pier had had its day, never paid its way and wasn't even a proper pier! He thought P. & A. Campbell should take over the pier, for even in their best days, the steamer company never ran more than twenty trips to the pier in a season! The boot was put in further with claim that motor cars had killed boat traffic and that the pier had been a burden on the rates.

The pier lay derelict as the council dithered over whether to repair or demolish. In August 1950, the council engaged Coode to inspect the pier in the company with members of the council and representatives from P. & A. Campbell. They estimated it would cost £7,942 to restore the pier and contractors L. H. Heaps were engaged to carry out some initial repair work during the winter of 1950. However, upon the removal of the wooden

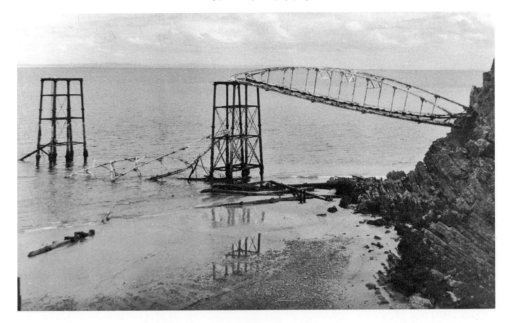

The sad sight of Tenby Royal Victoria Pier being demolished in 1952. Badly corroded steelwork following years of neglect had finally sealed the pier's fate after attempts had been made to restore it. (Tenby Museum and Art Gallery)

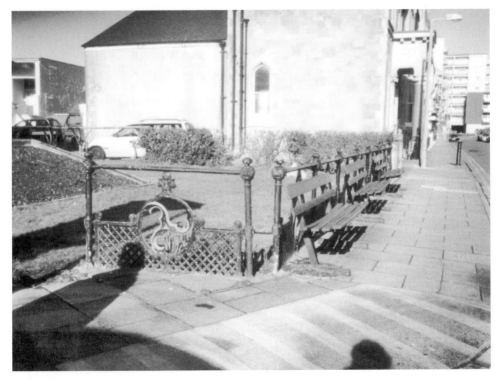

Surviving pier head panels photographed in Tenby in February 2003. A number of these were rescued after the pier's demolition in the early 1950s and are now at Tenby Museum. The panels are exact copies of those which can still be seen at Swanage Pier, another pier constructed by Alfred Thorne. (Marlinova Collection)

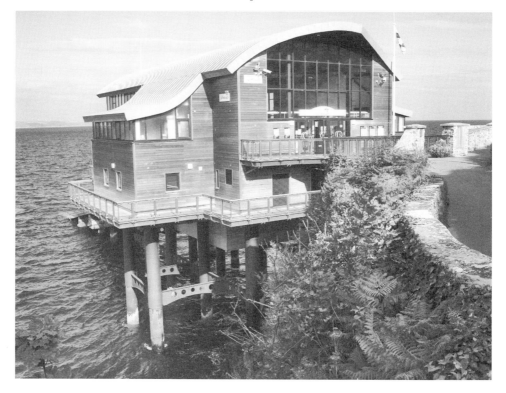

The lifeboat station erected on the site of the Royal Victoria Pier in 2005 is seen in this 2009 photograph. (Chris Wyatt)

decking, further sections of corroded steelwork were discovered which had been missed in the earlier inspection. This led to a further inspection of the pier in January 1951 when it was concluded that £15,000 would now be needed to repair corroded steelwork in the main approach spans. This was the final straw for Councillor Berry, who led the council to abandon the repair work in March 1951. The pier was put up for scrap in June of that year and its demolition was confirmed by a three-vote majority in October. Heaps submitted a contract of £1,685 to demolish the pier, which was to be completed by 30 April 1952, but difficulty in removing the piling from the rock meant the work was not finished until 1954.

Some members of the council remained keen, however, for Tenby to have a pier and in November 1953 a new landing stage was proposed. Berry remained as 'anti-pier' as ever and said, 'You have had the Victoria Pier for sixty-five years. It never paid and this one wouldn't, it would lay there going to wreck and ruin like the Victoria Pier, upon which we spent £6,000.' His argument won the day and it was recommended by seven votes to five not to proceed with the scheme.

The ornamental railing panels from the pier head (which were identical to those still found on Swanage Pier) survived the pier's demolition and can be seen on the North Cliff, outside the Tourist Information Office and in Tenby Museum.

In 2005, Tenby's new lifeboat house was built on the site of the pier at a cost of £5.5 million to house the new computerised, Tamar-class lifeboat.

ABERYSTWYTH

Aberystwyth is the largest resort in west Wales and is noted for its university and the remains of its Norman castle. The town was promoted as a watering place from the first quarter of the nineteenth century and a line of attractive and uniform residences and boarding houses were erected around the crescent-shaped inlet of Cardigan Bay. In the early 1860s, the Hafod Hotel Company stimulated further development of the resort by widening the promenade along Marine Terrace and building the Queens Hotel. They were also involved in the formation of the Aberystwyth Promenade & Pier Company, which was incorporated on 12 March 1863 to 'provide a promenade and landing pier in Cardigan Bay at Aberystwyth'. The capital of the company was announced as £8,000, divided into 1,600 shares of £5 each, and the first shares were issued on 1 January 1864. The design of Eugenius Birch was chosen and the contractor was John Dowson. Mrs Robert Edwards, wife of one of the directors, drove in the first pile on Friday 22 July 1864 on the day the Cambrian Railway arrived in the town. The pier was opened on Good Friday 1865, when it received 7,000 visitors, although it was not fully completed until October 1865, having cost a total of £13,600.

The structure was a typical pier design of its day. The length was 800 ft and there was a deck width of 20 ft leading to a 120-ft-wide pier head. The main structure consisted of pairs of 10-in-diameter cast iron columns and piles, mounted on concrete bases tied to the bed rock. The columns splayed from a width of 13 ft 3 in at the column caps to 25 ft at the base. The decking of the pier was supported on 12 x 12 in timber baulks, running along the full length of the structure on each side with 12 x 4 in cross members between the heads of each pair of columns and running diagonally across the bays.

Unfortunately, disaster struck in January 1866 when 100 ft of the seaward end of the pier was washed away. The blame for this lay with the engineer Eugenius Birch, claimed local photographer A. J. Lewis, in 1938, when the pier was damaged again:

The 7,000 who paid admission to the pier on its opening day gave a promise of future success, a promise yet unfulfilled, owing in the largest measure to the short sightedness of the engineer. Originally the head of the pier was widened by about 30 ft, and a light refreshment room erected. An opening was made in the centre of this portion of the pier, from which was run down a fixed flight of heavy timber steps.

On the first Sunday of January 1866 at six in the morning; when the sea was rolling with restless strength; a terrible crash was heard, and the end of the pier for about 100 feet was seen to sway to and fro for a minute, and then sever itself from the trunk. The iron supports snapped like so many columns of little glass and the timber was torn to rags. As however, the ironwork still attached the demolished head to the decapitated body, serious fears were entertained for the rest of the pier, which curved like a serpent to the beating of the seas upon a suspended wreck. At this juncture, the courage and promptitude of Mr Cullman, the manager, and some others who assisted him are worthy of high praise. They sawed the pier asunder of the rivets and bolts, by which the wreck still clung to the pier, and thus, no doubt, saved the remainder of the structure.

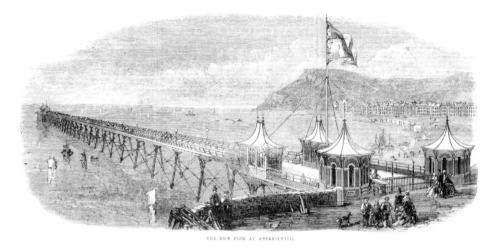

THE NEW PIER AT ABERYSTWITH.

Aberystwyth Pier depicted by the *Illustrated London News* shortly after it was opened on Good Friday 1865. The little building at the end of the pier would be washed away within eight months. (Marlinova Collection)

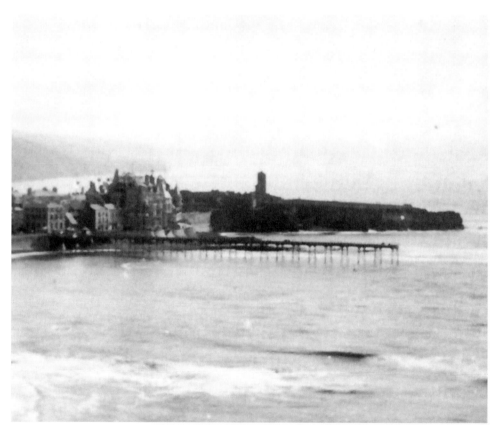

A photograph of the truncated Aberystwyth Pier following the storm in January 1866 which removed 100 ft of the seaward end. The pier was repaired in 1872. (Marlinova Collection)

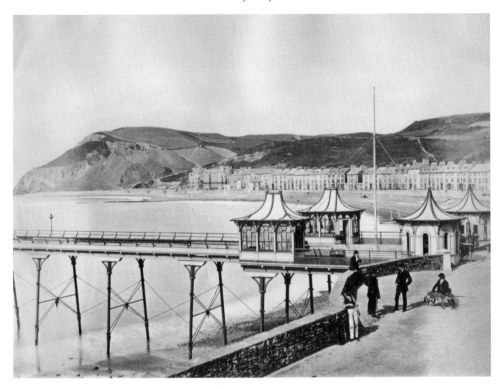

The shore end of Aberystwyth Pier *c.* 1870 showing the attractive toll houses and kiosks provided by its designer, Eugenius Birch, who was responsible for fourteen pleasure piers in England and Wales. (Marlinova Collection)

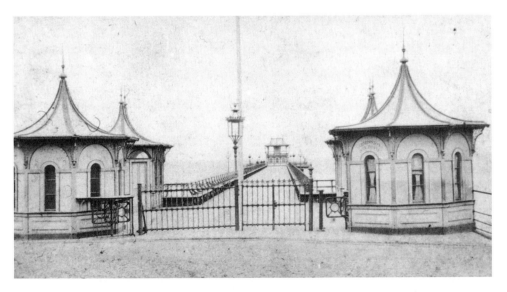

Looking along Aberystwyth Pier in the 1880s. The refreshment room at the end of the pier had been added when the pier was restored in 1872 following storm damage six years earlier. (Marlinova Collection)

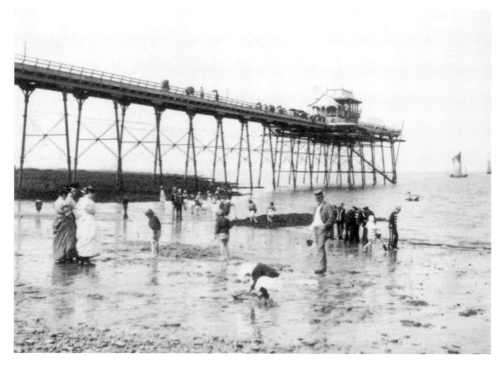

A delightful beach scene at Aberystwyth in the 1890s showing the elegance of the pier at low tide. A bandstand has been added to the pier head adjoining the refreshment room and it can be seen the pier has no landing stage, just steps. The pier was built purely as a pleasure pier and boats rarely called there. (Marlinova Collection)

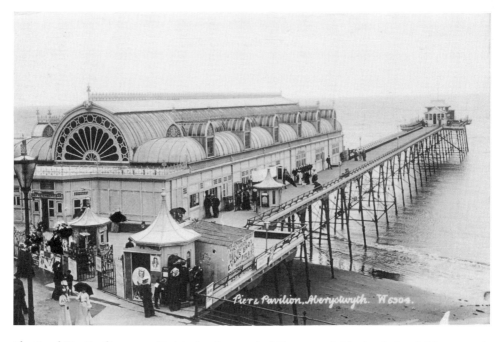

The Royal Pier Pavilion was added to the shore end of Aberystwyth Pier in 1896 and this postcard shows the pier and pavilion *c.* 1906. The pavilion could seat 2,000 and cost £8,000 to build. (Marlinova Collection)

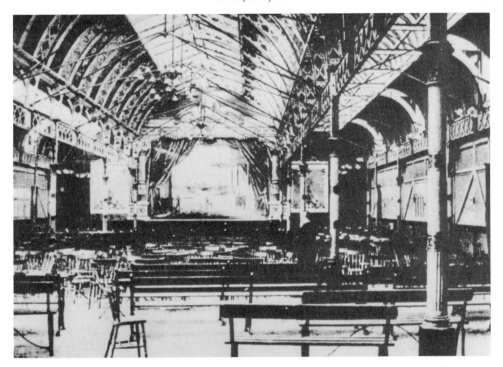

An Edwardian view of the interior of the Royal Pier Pavillion, Aberystwyth, erected in 1896, which could seat up to 2,000 people. (Marlinova Collection)

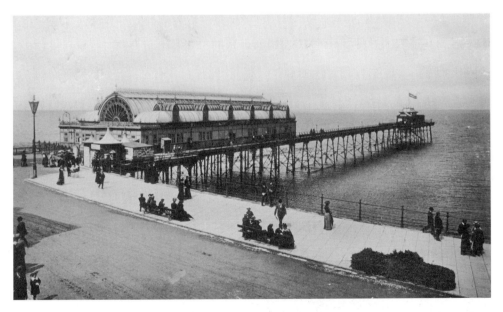

A postcard of Aberystwyth Pier sent to a lady in nearby New Quay on 7 August 1908. The sender commented that the town was full during her stay. (Marlinova Collection)

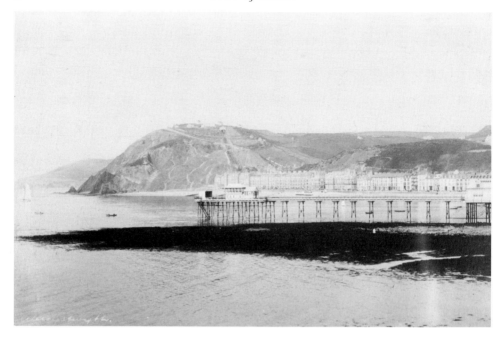

The sea end of Aberystwyth Pier photographed in *c.* 1908, which shows the refreshment room, bandstand and small stage on the pier head. The cliff railway, owned by the pier's owners, the Aberystwyth Improvement Company, can be seen on Constitution Hill. (Marlinova Collection)

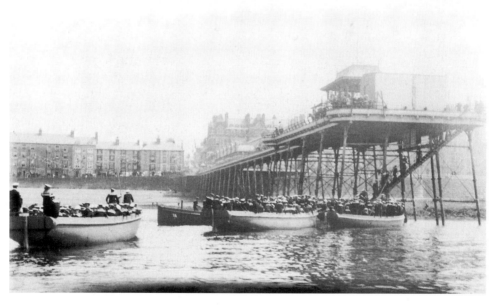

Sailors being landed at Aberystwyth Pier *c.* 1912. The pier had no landing stage, so the sailors had to climb from the boats onto the one set of landing stairs. (Marlinova Collection)

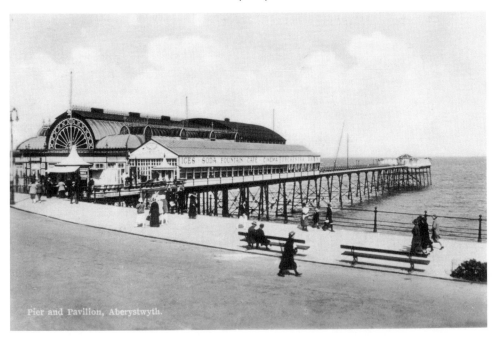

This postcard of Aberystwyth Pier issued in the 1920s shows the café building erected alongside the pavilion, which is advertising some of the latest attractions on the pier, including ices, a soda fountain, café, cinema and orchestra. (Marlinova Collection)

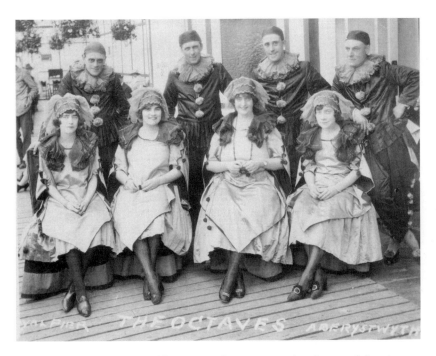

The Octaves concert party, led by Tom Rushton, was another feature of the pier during the 1920s and performed twice daily at 3 and 8 p.m. (Marlinova Collection)

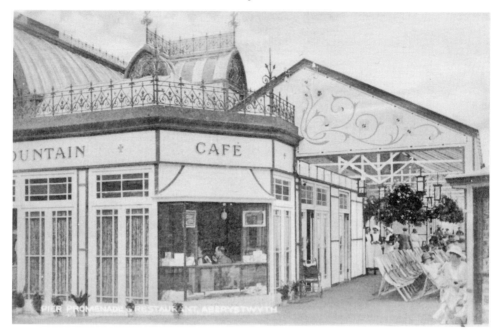

A photograph taken on the pier in the 1920s showing the café building added on to the side of
the pavilion, which is advertising the latest import from America – the soda fountain. (Marlinova
Collection)

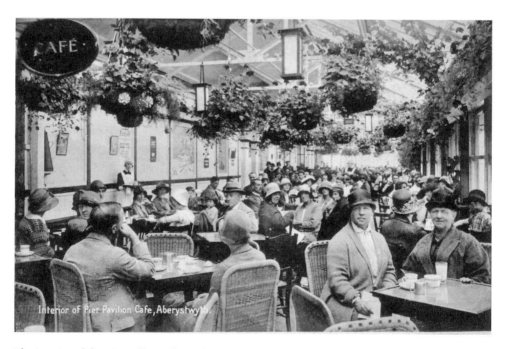

The interior of the pier café on a busy day *c.* 1930 showing its glass roof and profusion of flora.
(Marlinova Collection)

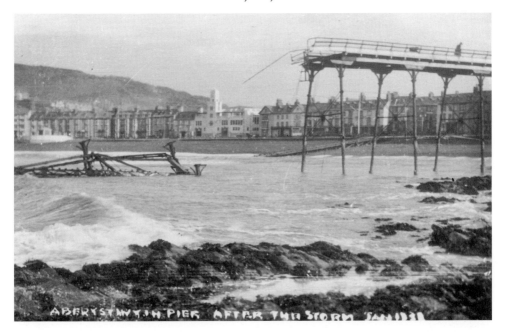

The pier head was washed away for a second time in January 1938 and the aftermath of the disaster has been captured on this postcard by local photographer A. J. Lewis. (Marlinova Collection)

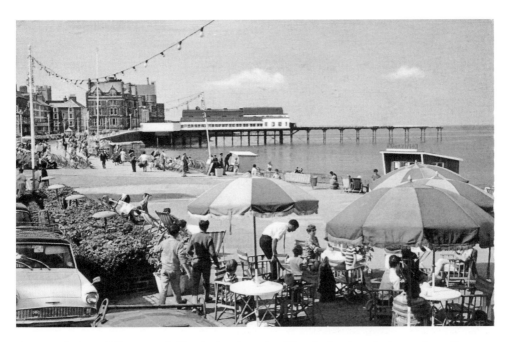

A postcard view of Aberystwyth Pier during the 1960s. The pier head washed away in 1938 was not replaced and the neck of the pier beyond the pavilion was closed off to the public. The end four spans seen in the photograph would soon be demolished. (Marlinova Collection)

The structure remained unrepaired until the Aberystwyth Pier Company was re-formed under the directorship of Jonathan Pell of the Belle Vue Hotel and incorporated on 7 May 1872 with a capital of £4,000 in 800 shares of £5. The damaged section of the pier was restored to a wider length by Mr A. Brown and a small pavilion housing a refreshment room, gallery and bandstand was placed on the pier head. The pier was reopened on Saturday 21 September 1872, by the Mayor, Thomas Jones, and the celebrations included a regatta, bands from Ffestiniog and Corris and fireworks during the evening.

Band concerts, a string orchestra and novelty acts were the mainstay of the entertainment provided on the pier. For example, Sidney and Alphonse 'Juvenile Trick Cyclists' had a three-week engagement on the pier in the summer of 1879 while in 1884 the Eccentric Ollives were one of the attractions.

Unfortunately, the company was unable to make the pier pay and in 1884 they were petitioned to be wound up, although this was not finalised until 7 October 1904. The pier was acquired by Mr Palmer of the Queens Hotel, but he also found it to be a heavy financial burden and the only year he was to clear working expenses was in 1891. The pier's main attraction as a promenade over the sea was no longer tempting enough to attract sufficient custom. By the 1890s, holidaymakers desired a bit more excitement for their hard-earned cash and piers had to adapt by adding pavilions and other amusements.

Unfortunately, Palmer did not possess the finance to even maintain the pier, let alone add improvements, and in the winter of 1892-3 it was closed as unsafe. There were calls for the council to acquire the pier, but in September 1893 it was acquired by Messrs Bourne and Grant, who aimed to restore it and add a pavilion. The duo had other aims too, including the acquisition of Constitution Hill to provide a cliff railway and amusements, and the building of the Hotel Cambria. To finance the improvements, the Aberystwyth Improvement Company and Aberystwyth Marine Pier Company were formed; the latter with a capital of £5,000 divided into 1,000 shares of £5. The pier was repaired and reopened in time for the 1894 season, but sadly Grant died in January 1895 of typhoid before the

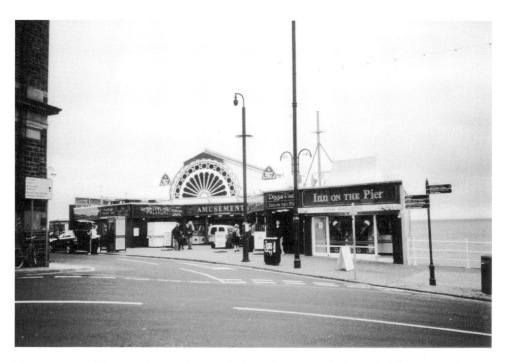

The entrance to Aberystwyth Pier photographed in July 2003, with the roof of the pavilion having been restored to its Victorian splendour. (Marlinova Collection)

main improvements to the pier were begun. This involved widening the shore end of the pier by 200 ft to house a new pavilion seating 2,000. Designed by George Croydon Marks, the pavilion was erected by Bourne Engineering and Electrical Company upon new piling and girders manufactured and erected by Messrs Lysaght of Bristol, with the work in total costing £8,000. The building featured three aisles surmounted by glass-domed roofs, with the elevations being ribbed and decorated in Gothic style, and a 30 x 26 ft stage and electric light throughout. The official opening was performed by HRH Prince of Wales and Princess Alexandra on Friday, 26 June 1896. The royal couple had luncheon in the building, which was given the title of the Royal Pier Pavilion.

The new pavilion was open throughout the year and featured dramatic and musical performances and the Royal Pier Orchestra. Advertisements were placed in *The Era*, the weekly newspaper for actors, theatre and variety performers, etc., inviting bookings for the pavilion, although 'first class companies need only apply'. Amongst those who appeared there in the 1897-98 seasons were Harley and De Mare (Negro comedians and acrobatic dancers), Willy Cony (comedian), The Oscars (comedy oddities), R. Mansell Fane (baritone) and F. Edgar Manaton with his velograph showing moving pictures. The old pier head building continued to be let out as a fully licensed refreshment room.

In 1907, the Board of Trade was informed regarding concerns about the condition of the ironwork under the pier and defective woodwork and side railings. A surveyor's report, however, concluded that the pier was not in a dangerous condition.

The council took on the lease of the pier in 1910 and held it for two years, during which time considerable repairs were carried out. In 1912, the pavilion was converted into a cinema. The debt-ridden Aberystwyth Marine Pier Company was eventually dissolved on 14 December 1917 and in 1922 the pier was acquired by Messrs Samuel Butler & Co., of Stanningley, Leeds. A café was added on the outside of the building and the Octaves concert party performed twice daily on the pier at 3 p.m. and 8 p.m.

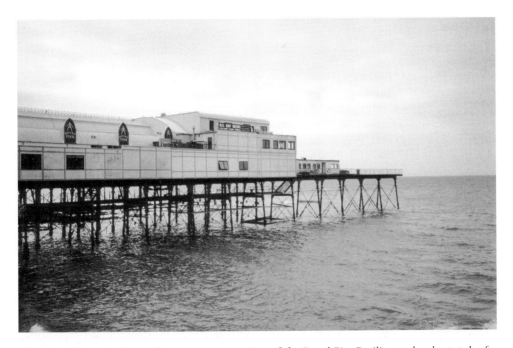

Aberystwyth Pier, in September 2005, now consists of the Royal Pier Pavilion and a short stub of neck. Amongst the attractions in the pavilion are a restaurant, bars, nightclub and snooker club. (Marlinova Collection)

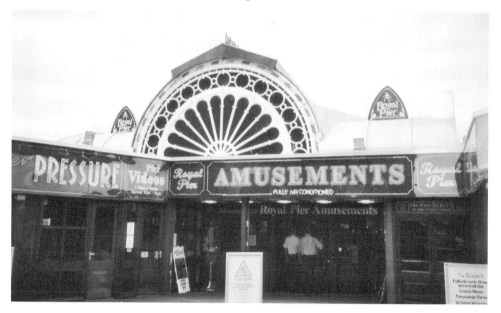

The nicely restored frontage of the Aberystwyth Royal Pier Pavilion, photographed in September 2005. (Marlinova Collection)

During a storm in January 1938, the pier head was washed away for a second time and this time it was not replaced. The surviving section of the pier neck was allowed to deteriorate and in 1957 Aberystwyth Council met with the current pier owners, Messrs Ruffler & Walker, regarding the unsightly, damaged seaward end of the pier. The owners manufactured amusement machines and their interest in the pier lay strictly with the money-earning pavilion, which housed their games, along with a cinema, two cafés and a licensed premises. Ruffler and Walker offered to lease the deck beyond the pavilion to the council at a peppercorn rent or alternatively sell the whole pier to them for £45,000. The council refused the two offers however and relations between them and the pier owners became strained. The pavilion suffered damage by fire and was closed as a cinema in 1961, becoming a bar and amusement arcade.

The pier changed hands on 30 April 1964, when it was acquired by Robert Howse, proprietor of Aberystwyth Entertainment Caterers. Mr Howse was formerly Entertainments and Publicity Manager for Aberystwyth Council but had resigned over differences of opinion regarding the development of the resort. He set about strengthening the pier underneath the pavilion by engaging Messrs Wallace A. Evans & Partners, engineers from Penarth, and contractors Robert F. Watson & Co. of Oldham. The work involved removing timbers and substituting rolled steel beams to protect against corrosion. Howse was also keen to repair the broken end of the pier, but claimed he was unable to afford the £20,000 needed and felt that, as the pier acted as a breakwater and was useful for coast protection purposes, he should receive financial help. However, this was not forthcoming and the section of the derelict pier was removed.

In 1979, the pier was acquired by Dom Leisure and, in 1988, they opened a new restaurant at a cost of £250,000. The pier pavilion currently houses the 'Inn on the Pier', 'Pier Pavilion Brasserie', 'Pier Video', 'Pizza Royal', 'Pier Pressure' nightclub, social and snooker club and amusement arcade. A small section of the pier deck beyond the pavilion survives, and, in 2010, it was reopened to the public. A staircase was built down to it from the brasserie and picnic tables were provided.

ABERDOVEY/ABERDYFI

The pier is a prominent feature of the attractive village of Aberdovey (Aberdyfi in Welsh), which faces south at the mouth of the River Dyfi. The village became a port in the late eighteenth century and the Cambrian Railway that ran through the area acquired twenty-one acres of the foreshore to build a wharf and jetty to handle the considerable amount of local slate traffic.

A local contractor, Abraham Williams, was engaged in 1882 to carry out the work, which consisted of a wharf and sea wall 500 ft in length and 100-150 ft wide and a wooden jetty 370 ft in length. The pier supported a double-track railway (connected to the main line), turntable and at the end were three landing stages on different levels. The cargo landed at the jetty included timber, slate, railway sleepers, coal, potatoes and livestock.

However, the increasing popularity of railways soon brought about a decline in the number of vessels using the wharf and pier, and, in the years after the First World War, the wharf was used principally to store coal. The area deteriorated and the jetty became dilapidated. In 1959, Tywyn District Council expressed a wish to acquire the wharf and jetty from the British Transport Commission (British Railways), but the protracted

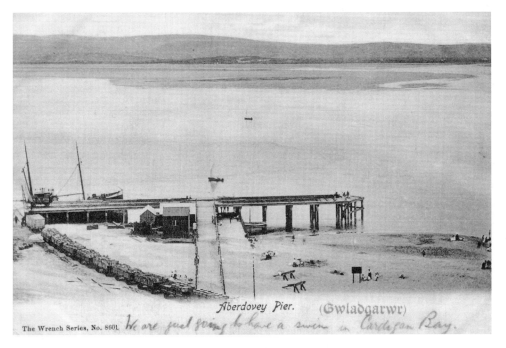

Aberdovey Pier, seen here on a 1904 postcard, was built as a 370-ft wooden structure in 1882 and was used for both goods and passenger traffic. (Marlinova Collection)

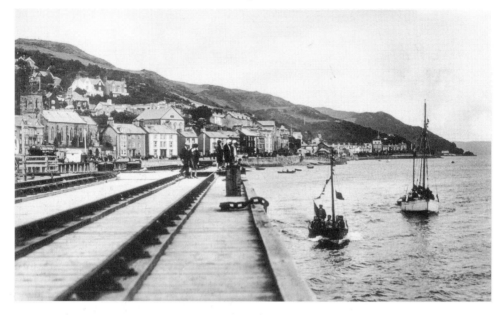

A 1920s postcard showing the railway connected to the main line that ran onto Aberdovey Pier. By this time the line, which was used to transport cargo, was little used. (Marlinova Collection)

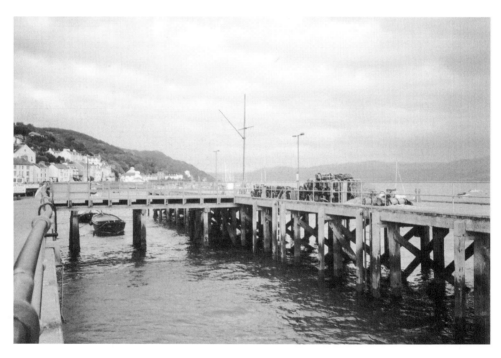

Aberdovey Pier, seen here in September 2005, is now largely used by small boats operating scenic and wildlife trips. (Marlinova Collection)

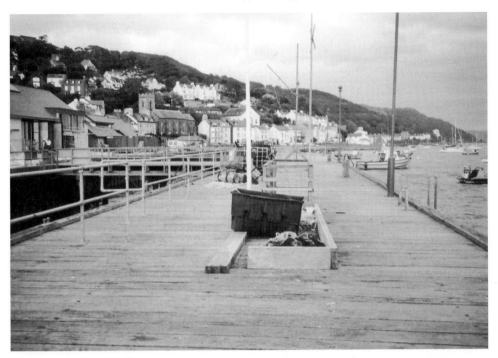

A photograph taken on Aberdovey Pier looking towards the town in September 2005. (Marlinova Collection)

negotiations were not completed until November 1965, following the intervention of the Secretary of State of Wales, Mr James Griffiths. The council was asked to pay £5,000 to the Crown Commissioners for the land, although £2,300 of that was provided by British Railways. The remainder was donated to the council by the Aberdyfi Advertising & Improvements Committee. The council proceeded with a large redevelopment of the old wharf area with the provision of a new sewage pumping station and a new 700-ft-long, steel-piled wall around the perimeter of the old timber-framed wharf. A new sea wall, promenade, gardens and car park were laid out and the main road was widened. The total cost of the work was around £110,000.

The pier ownership was also transferred to the council, along with the sum of £6,000 from British Railways to pay for the cost of removing the unsafe structure. An inspection of the jetty on 22 May 1968 revealed that the timber supports and piling had been badly eaten away by the teredo worm, which burrows inside timber and eats it from the inside. The pier was declared beyond saving and the decision was taken to replace it with a smaller structure of 240 ft in length and 23 ft wide at a cost of £28,242. The new jetty was built of the resilient hardwood greenheart with piles 12 in square and 30-40 ft in length. The cost of construction was borne partially by the Outward Bound Sea School, who contributed 4 per cent of the cost, as they were to use the new jetty for training purposes. The balance of the construction costs, £12,030, was donated by the Aberdovey Advertising & Improvements Committee. The new wharf and pier were officially opened by Lord Maelor on 28 September 1972.

The pier today provides a pleasant place to stroll and is used by small craft for fishing, wildlife and scenic trips. The Dovey Yacht Club provides water activities from the jetty.

TYWYN

The inclusion of Tywyn (the former English spelling was Towyn) as having a pier is tentative (and indeed this is the first publication on piers to recognise it as such), but we feel justified, as the entrance kiosks and a small section of the proposed structure were built. During its approximately twenty years of life, locals always referred to it as the 'pier'.

The first mention of a pier scheme at Tywyn was reported in the *North Wales Chronicle* on 15 August 1868: 'It is proposed to construct a pier at Towyn at a cost of nearly £1,000. Half the shares have already been taken.' This must have been for a very modest structure and it was to be a further eight years before a serious proposal for a pier was made.

The Towyn Pier Company Ltd was incorporated with a capital of £12,000 in £5 shares on 28 November 1876 in order to build a 1,200-ft iron pier standing 9 ft 5 in above the high-water mark commencing opposite the end of the High Street. The company consisted of local men, the following of whom held shares: William Parry (Chairman), R. G. Price (wine merchant), O. Daniel (auctioneer), Richard Hammond (cabinetmaker), John Hughes Jones (merchant), Edwin Jones (schoolmaster, Towyn Academy) and Robert Jones Roberts (druggist). The company secretary was Pryse Henry Hughes, an accountant who had an office in the High Street, which was the company's registered office.

On 21 December 1876, the Board of Trade was informed of the £11,000 projected cost of the pier split into the following estimates:

Stone work – 800 cubic yards at 16s per cubic yard	£64
Embankment – 1,500 cubic yards at 3s per cubic yard	£225
Iron Piling	£8,000
Flooring of Pier and Landing Places and fencing for the same	£250
Toll and Piermaster's house and other buildings	£600
Cranes, Tramways and Fittings	£285
Contingencies – 10 per cent	£1,000

Land acquisition was not included in the total and the estimates are at best conjecture. They were drawn up by Charles Elliott, Land Agent to A. J. S. Corbet and the Ynysmaengwyn Estate, who optimistically described himself as a 'Civil Engineer' and was to be the leading light in the pier project.

Six days later, on 27 December 1876, a line of stakes was driven into the sands to outline the pier's course, followed by a procession through the town led by the Aberdyfi Band. The Town Crier announced the event and the bells of St Cadfan's church were rung out in celebration. A grand firework display rounded off the day. The Provisional Order was granted for the project on 2 March 1877 and the Towyn Pier Bill received the Royal Assent on 12 July 1877.

In April 1877, the *Cambrian News* announced that, initially, 300 ft of the pier and two entrance buildings were to be constructed. The pier was to be built partially of concrete (using five parts shingle to one part concrete) and partially of iron piles and was to have a

The seal of the Towyn Pier Company, incorporated on 28 November 1876 to build a 1,200-ft iron pier at Tywyn. (Marlinova Collection)

Work was started on Tywyn Pier in 1877 and the entrance buildings and 300 ft of concrete approach and abutment were built that year. However, the construction of the iron section was never commenced. This photograph shows the entrance building in use as a refreshment room in 1884. (Marlinova Collection)

frontage of 65 ft. The two buildings were to have a depth of 35 ft each and be fronted by a pair of handsome iron gates and a glass veranda. The north building was to house ladies and gentlemen's waiting rooms, Pier Master's sitting room, bedroom, kitchen, the pier company's offices and two cellars, whilst the south building contained two refreshment rooms, an attendant's bedroom, kitchen, cellars and lavatories.

The memorial foundation stone was laid on Saturday 14 July 1877, although work had already been started on the pier as *Cambrian News* reported that 'bunting adorned the partially constructed buildings'. The laying of the stone was performed by W. W. E. Wynne of Penarth and following the ceremony foot races were held and the Aberdovey Brass Band and Towyn String Band gave performances. The day's festivities were concluded with a display of fireworks.

The contractors, Messrs Henry Jones and Humphries, commenced with the work, despite the purchase of the foreshore from the crown for £5 and a rent of 1s per year not being completed until 3 September 1877. The area acquired was 'all that piece of land being part of the foreshore at Towyn below high water mark situate opposite to High Street, Towyn ... and extending seawards for a distance of three hundred feet at the east end thereof and for the remainder a breadth of twenty feet or thereabouts': therefore only the initial 300 ft. The plan of the pier was shown as having an enlarged shore end of concrete extending for 300 ft and the remaining 900 ft being of conventional iron construction ending with a small pier head and landing stage.

Work on the first stage of the pier had been completed by November 1877, when on the 16th of that month, the *Cambrian News* reported, 'A pier adorns the beach and defies the angry sea.' By the pier of course, they meant only the 300 ft concrete section (perhaps partially utilising iron piles) and the toll houses. The pier's 300-ft length included the approach to the toll houses, which were about 100 ft from the shore, and it appears the section beyond the toll houses was laid with wooden decking.

During its first winter, however, the pier was soon struggling to 'defy the angry sea' and suffered some damage. One of the toll houses was opened as a refreshment room and the decked area beyond was available on good weather days. However, in November 1878, heavy seas scoured away the sand from the foundations and, in February 1879, further damage was caused, leading to the sea end becoming unsafe. The crown foreshore rights for the iron section of 900 ft were granted until 1 May 1879 with the conveyance: 'All that piece of land ... as will be occupied by the pillars and supports of the extension nine hundred feet or thereabouts in length which the grantees propose to make to the pier already constructed by them at Towyn.' The plan with the conveyance showed that the pier head would have measured 120 ft x 90 ft.

However, no work was started on the iron section, as owing to lack of finance, the Towyn Pier Company crashed. The winding up of the company was reported by the *Daily News* on 8 November 1879:

HIGH COURT CHANCERY DIVISON: IN RE TOWYN PIER COMPANY. This company was formed to construct a pier at Towyn and when the pier was about half erected the structure was washed away by the sea, and the company became embarrassed. It is now ordered to be wound up on the petition of the creditor. Mr Caldecott for the petitioner.

Only thirty shares in the company were ever taken up (twenty by the Marquess of Londonderry) and, in February 1880, William Paice was appointed the official liquidator. The petition to wind the company up had been brought by Charles Elliott, who had paid £830 to the contractors for the work done. As security for the money he had spent, Elliott had retained the two conveyances of land from the Crown and was given the order to sell it and the pier works at public auction. This took place on 2 June 1880 and the pier was purchased for £450 by John Corbett, who had acquired the Ynysymaengwyn Estate just outside Tywyn. Corbett was known as the 'Salt King', after having made his fortune in salt

mining, and he owned the largest salt workings in Europe at Stoke Prior, Worcestershire. He was MP for Droitwich, where he built a huge French-style château called Château Impney for his wife, who had been brought up in France.

Corbett was a great philanthropist and in Tywyn he assisted in the laying out of the water and sewage system and the provision of the Assembly Rooms, Brynarfor school, Market Hall and a new Corbett Arms Hotel. Corbett leased out one of the pier toll houses as the 'Pier Refreshment Room' and was said to have drawn up plans for the completion of the pier. However, this never happened and the pier café closed around the time of the construction of the promenade in 1890, which was also funded by Corbett. In connection with the promenade works, the *Cambrian News* on 8 December 1889 reported,

Some years ago an attempt was made to construct a pier at Towyn. A couple of pagodas were erected at the entrance. A sort of Tete or head was then constructed of concrete on the beach, filled with sand and decked. In less than one winter however, it was evident that something more substantial than concrete or at least something which offered less resistance to the sea would have to be put up before a permanent Pier could be secured. The experience of the past will doubtless result in erection in the near future of a Pier which will not only be permanent but attractive in appearance as well as fact.

Alas, not so, Tywyn never acquired an iron pier. By the early 1890s, the concrete of the pier had been broken up by the sea and the toll houses were dilapidated, as reported by the *Cambrian News* on 27 January 1893: 'The concrete houses which remain to point out by their battered condition the melancholy fate of the late pier need to be removed. Their fate is no doubt sealed as they are an eyesore and a stumbling block.' They may have been removed shortly afterwards, although the *Cambrian News* still refers to a pier in 1898. The

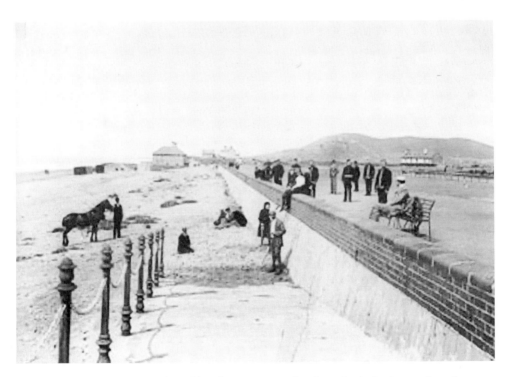

A photograph of the promenade and beach at Tywyn in the 1890s. In the background can be seen one of the pier toll houses and remains of the concrete section that was built, shortly before they were demolished. (Marlinova Collection)

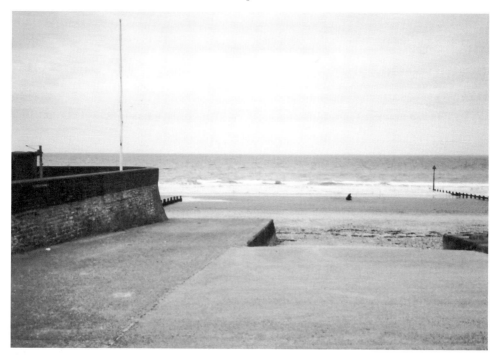

The site of the long-lost and obscure pier at Tywyn photographed in September 2005. (Marlinova Collection)

promenade was further improved during the winter of 1899-1900 and any remains of the pier would have been removed then, as the 1900 Ordnance Survey map of Tywyn shows no sign of it.

Corbett died on 22 April 1901 and his generosity to Tywyn is commemorated with plaques on the promenade, Market Hall and Brynarfor School. The Towyn Pier Company actually outlived the pier, not being officially dissolved until 11 August 1905. Reminders of this ill-fated pier venture survive to this day in 'Pier Road' and 'Pier Villas'.

The following poem, written by J. E. Roberts in 1890, poignantly captures the resort and pier aspirations of Tywyn:

Fine terraces shall tower
Along the beach one day;
A well constructed pier
Shall meet Neptune's fray;
Canoes and craft for hire
Shall fleetly cross our sea;
And boats that swarm with tourists
Shall traverse to our quay

No more shall Aberystwyth
Nor Barmouth proud excel;
'Tis on the charms of Towyn
The visitors shall dwell!
A safe and glorious shore.
As Queen of the Watering Places
Stands Towyn evermore!

TREFOR

Trefor is a small seaside village on the Llŷn Peninsula and its three beaches are a popular summer destination. In 1912, a wooden pier was built at the end of the stone breakwater to export granite from the quarries above the village. When the quarrying ceased, the pier was used for fishing and as a base for divers exploring the varied marine life under the structure. However, the pier was closed on safety grounds and needs £500,000 worth of repairs. A Facebook campaign was launched in March 2010 in a bid to save it.

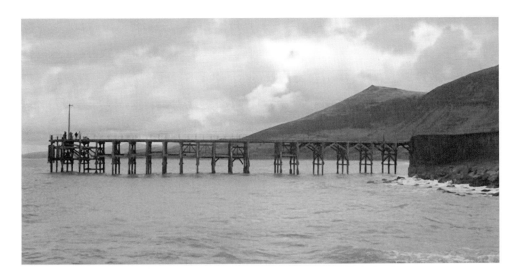

CAERNARFON

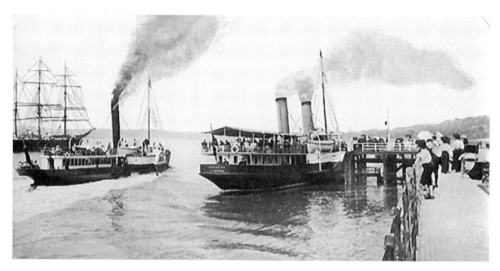

The small pier seen above, shown here *c.* 1910, was used for ferry services to Anglesey and also by steamers who plied between Liverpool and the North Wales coast. The PS *Snowdon* can be seen at the pier, whilst the *Rhos Trevor* (later *St Trillo*) is seen passing by. In June 1996, the Landerne Pier (seen below) was opened as part of the Victoria Dock development. The pier is 121 ft long and 131 ft at its widest point, and has five levels to enable boarding and landing at all states of the tide.

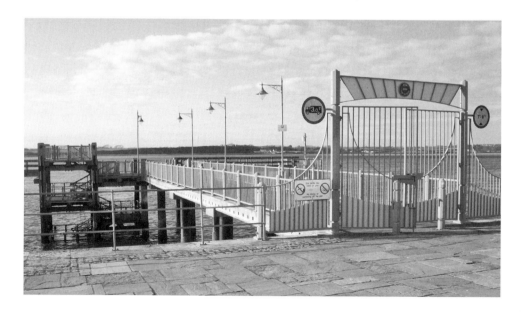

MENAI BRIDGE/ PORTHAETHWY

Menai Bridge (Porthaethwy in Welsh) is a small town on the Isle of Anglesey at the narrowest point of the Menai Straits and lies by the Menai Suspension Bridge, built in 1826 by Thomas Telford. Steamer services to Menai Bridge from Liverpool and places along the North Wales coast commenced in the 1820s and used a stone pier called the St George's Pier. In 1832, the vessels *Prince Llewelyn* and *Air*, operated by Messrs Watson and Pim, sailed from Menai Bridge to Liverpool, Beaumaris, Bangor, Caernarfon, Dublin and Douglas. In 1836, the *Prince Llewelyn* was still in service along with *Vale of Clwyd*. At this time, the services from Menai Bridge were operated by the St George Company of Liverpool and George Evans of the Sportsman Hotel, Caernarfon. In 1838, the St George Company advertised the *St David* as operating a goods service between Caernarfon, Menai Bridge and Liverpool and, by 1850, the *Ayrshire Lassie* was calling at Menai Bridge.

A further pier, the Princes Pier, was constructed after official sanction to lease the foreshore was granted on 30 August 1876, although this resembled more a quay than a pier.

A wooden landing stage was added to the St George's Pier and sanction was given in 1884 to extend the pier. However, a pontoon was offered as an alternative, which for a time consisted of an old tug. The pier was owned by a local landowner, Colonel Bulkeley Price, and leased to steamer companies whose vessels called there. These included the City of Dublin Steam Packet Company and the Liverpool, Llandudno & Welsh Coast Steam Packet Company, which was taken over in 1890 by the Liverpool & North Wales Steamship Company. Among the vessels which called at the pier were *Alexandra*, *St Tudno*, *St Seirol* and *Snowdon*.

However, the inadequacy of the stone pier as a landing stage led to frequent calls for Menai Bridge Urban District Council to acquire it and rebuild it as a 'proper' pier. In 1897, when the pier was described as 'broken down', a majority of fourteen ratepayers voted for the council to erect a new pier. However, the negotiations between the council and Price were protracted and, on 5 April 1900, Price's lease of the pier and foreshore was renewed by the Commissioners of Woods and Forests for sixty years at an annual rent of £65 plus one full seventh part of the gross receipts in excess of £470 yearly.

On 21 January 1902, Menai Bridge Urban District Council finally acquired the St George's Pier and the surrounding area from Price in order to build a new pier and promenade. The replacement pier was to be erected around the base of the old stone pier, whose rubble was used to fill the promenade under construction. The tried and tested pier-building team of engineer John James Webster and contractors Alfred Thorne, who had built the nearby Bangor Pier, were engaged to build the St George's Pier. They used steel supports and wrought iron decoration, along with a wooden deck, for the new pier and extended it slightly more seaward than the old structure, where a floating landing stage was connected to the main pier by a pontoon.

The grand opening of the pier was performed by David Lloyd George MP on 10 September 1904. The town was decorated with bunting for the occasion and most businesses closed between 3-4 p.m. during the pier's opening ceremony. Lloyd George arrived by train at Menai Bridge station, accompanied by his wife, and they were taken

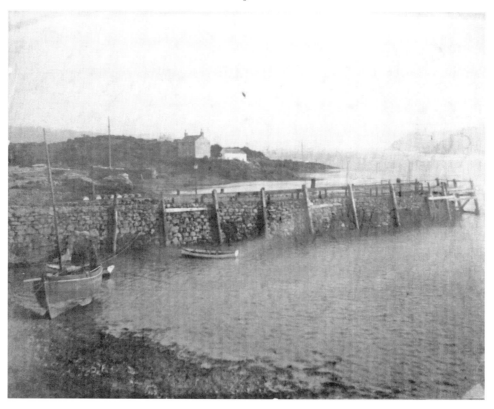

The original stone St George's Pier at Menai Bridge, erected in the 1820s for steamer landings and demolished when the iron and steel pier was built in 1904. (Anglesey Archives Service)

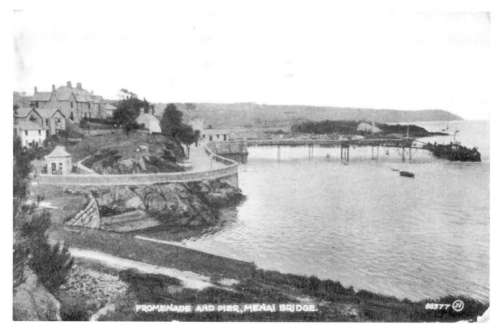

A postcard of the iron and steel St George's Pier at Menai Bridge opened in 1904. The pier toll house, gardens, promenade and pavilion are also shown. (Marlinova Collection)

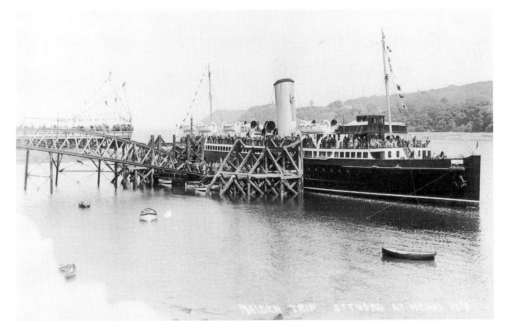

A postcard by H. N. Cooper of Liverpool showing the steamer *St Tudno* calling at the St George's Pier, Menai Bridge, on its opening day, 10 September 1904. The promenade deck of the pier can be seen gaily decorated for the occasion. (Marlinova Collection)

to the Anglesey Arms Hotel for lunch before performing the opening ceremony on the circular head of the new pier. The official opening was recorded by Herbert Anthony in his *History of Menai Bridge*:

St George's Pier was officially opened at 3.30 p.m. on September 10th 1904 by David Lloyd George. The weather was fine, the pier was decorated with bunting, and Menai Bridge brass band led by a procession of councillors, guests of honour and the Fire Brigade along the promenade which had been completed by Mr Isaac Evans in 1903. The boys of the old training ship, the Clio, *which was anchored off Cadnant, were admitted free but other spectators had to pay sixpence.*

The total cost of building the pier, promenade and other improvements was £14,000, plus £2,500 in legal fees.

The pier's amusements included occasional band concerts, fishing and sweetmeat machines. Adjoining it on the shore was the Pier Pavilion, which was used for concerts by the Menai Bridge Brass Band (who also played on the pier), political meetings, sports meetings and a cinema. A garden was laid out on the small hill above the pier.

The pier's main function, however, was as a steamer landing stage. It was used as a terminus for the passenger services run by the Liverpool & North Wales Steamship Company, whose vessels calling at the pier included the popular *La Marguerite* and *St Tudno*, *St Seirol* and *St Trillo*. The *St Elian* operated to the pier from Caernarfon. Another company to use the pier was the Snowdon Passenger Steamship Company. The bell from their vessel PS *Snowdon*, which operated trips from the pier to Caernarfon and Bardsey Island, was later displayed on the pier head. This had been acquired upon the death of the Snowdon Company's manager, W. H. Dodd, who had promised it to Menai Bridge. Other steamer companies to use the pier were the Isle of Man Steam Packet Company, White Funnel Fleet Company, the Bangor Corporation ferry and the Bangor, Beaumaris & Menai Bridge Ferry.

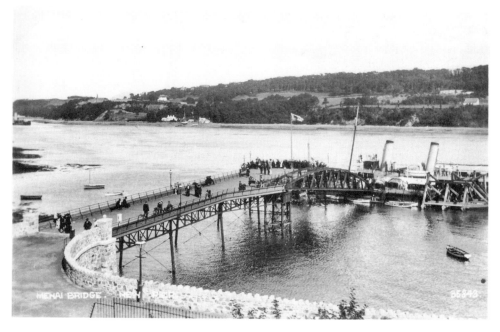

A view of the St George's Pier at Menai Bridge taken from the pier gardens *c.* 1910. The gardens and promenade were included in the toll paid to use the pier. A crowd can be seen at the end of the promenade deck watching the steamer. (Marlinova Collection)

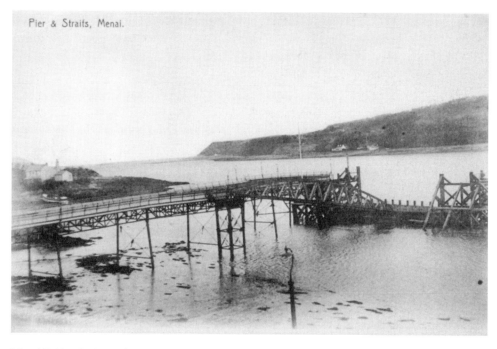

Menai Bridge St George's Pier seen on a quiet day in the 1920s. The pier structure had similarities to the one erected by the same team at Bangor, but was much shorter and had no decorative kiosks. (Marlinova Collection)

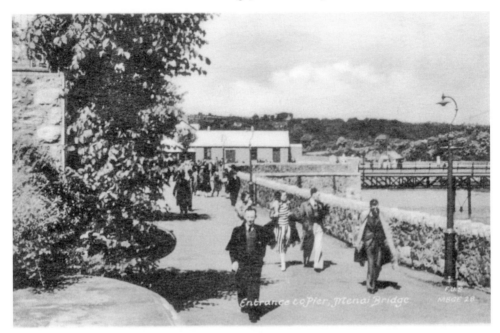

This Frith postcard of the pier from the 1950s shows the promenade from the pier entrance to the Pier Pavilion, used for concerts and other entertainments. The pier gardens were situated to the left of the photograph. (Marlinova Collection)

The former toll house and entrance gates of the St George's Pier, Menai Bridge, photographed in March 2010. (Marlinova Collection)

On 16 March 1979, the new concrete St George's Pier as opened, featuring a 120-ft concrete gangway leading to a floating landing stage. The vessel is the *Prince Madog*, a marine research vessel owned by Bangor University. (Marlinova Collection)

The *Greyhound* and *Queen of the North* ran to the pier from Blackpool and the pier was used by yachts. The Hughes family served as Pier Masters for Menai Bridge from 1878. John Hughes took over from his father in 1908 and he, in turn, was succeeded by his son, in 1962.

Plans were put in place in 1908 to widen the pier from 19 ft to 25 ft and extend the pier westwards for 100 ft and thence south for a further 130 ft. However, the work was never carried out, although the pier was extensively repaired in 1934-35 at a cost of £23,000.

Menai Bridge advertised itself as the 'Slipway to the Straits' and the 'Beauty Spot on the Anglesey Coast easily accessible by bus from all parts of the island and mainland'. The St George's Pier was advertised as a pleasant way to spend an afternoon, with the following attractions:

STEAMER CRUISES – daily to and from Llandudno aboard the *St Trillo*
EXCURSIONS – on the *St Trillo* around the delightful coastline of Anglesey
ISLE OF MAN trips from Llandudno may be booked at the local agency
MOTOR LAUNCH CRUISES – every day to Bangor and Beaumaris
AMUSEMENT ARCADE – for teenagers and others who are 'young at heart'. It includes a bimbo (juke) box, photovation photographic studio, various other amusements, ices, soft drinks and souvenirs
SAILING adds even more colour at the height of the summer and the Straits Regatta is the mecca for yachtsmen from all over the country
FISHING is popular too, with plenty of codling, mackerel, whiting, dabs, plaice, Pollock, salmon and bass
SEATING – ample accommodation to sit back and enjoy the wonderful scenery

A photograph taken on Menai Bridge Pier in March 2010 showing the Mostyn Arms on the left and the two-storey building erected on the site of the pier pavilion. (Marlinova Collection)

Between 1967 and 1969, the pier was totally rebuilt and altered in appearance when the whole of the promenade deck and substructure lattice girders were removed and replaced by a reinforced concrete walkway bearing on the original piles, which were encased in concrete. The pier was reopened on 18 August 1969 by D. Carey-Evans, grandson of Lloyd George. However, by this time, the regular steamer traffic had ceased and the pier was used mainly by vessels of the Marine Science Laboratory of the University College of North Wales until the structure was closed in 1977 after being declared unsafe. In the following year, the pier was dismantled and a small replacement was provided for the university's research vessels, although other small craft may also use it. This was built by the local authority Ynys Mon (Isle of Anglesey) and was officially opened by the Mayor of the Isle of Anglesey, Councillor W. J. Williams, on 16 March 1979. The new jetty consisted of a narrow 120-ft gangway, which turns to the right two-thirds the way along, leading to a berthing head.

In 2000, the old pier and promenade gatehouse were restored by the Menai Bridge & District Civic Society and reopened in June of that year as part of the Millennium celebrations. The pier is currently used by *Prince Madog*, belonging to Bangor University, which is a marine research vessel of the Faculty of Ocean Sciences.

BEAUMARIS

The history of the town of Beaumaris dates back to its thirteenth-century castle and its garrison of the soldiers of King Edward I. At this time, French was still the language of the English court, hence the name: Beaumaris is from the French, 'beau mareys', beautiful marsh. The castle formed a part of the English defences against the Welsh and was garrisoned from 1295, but shortages of money meant it was never actually completed. The town began to develop beside the castle walls at this time and, in 1296, the town received its charter. It was intended as an English settlement; Welsh families were evicted from their lands there and moved to south-west Anglesey.

The new town prospered and grew. In Saxon times, there had been an important port there on the shores of the Menai Straits and Beaumaris' importance to coastal shipping continued to grow over the centuries. It became the port of registration for all vessels in north-west Wales, from Conwy to Pwllheli, and had a small shipbuilding industry at Gallows Point, west of the town. Trade between North Wales, Liverpool and London prospered in the seventeenth and eighteenth centuries, and, with the arrival of steam-powered ships, trade increased rapidly. However, Beaumaris had no deep-water landing place for vessels. Passengers and cargoes had to be loaded into small boats or dragged ashore. The town was on the main London-Holyhead road, involving a four-mile crossing of the dangerous Lavan Sands and a ferry. To make matters worse, the crossing was only viable for four hours a day when low tides exposed the sand. In 1805, local landowner, Lord Bulkeley constructed a new road, costing £3,000, through his land in order to provide a more direct line of communication to Bangor, thus shifting traffic westwards. As early as 1776, the idea of a bridge linking Anglesey with the mainland was put forward, but the island remained isolated until the opening of Telford's suspension bridge on 30 January 1826. Overland travel to the island was, however, still slow and dangerous; most travellers continued to arrive at Beaumaris by sea.

The *Albion* was the first steam-powered vessel on the Liverpool – North Wales route. She brought thirty-five passengers on a maiden trip to Beaumaris in June 1822. Within two years, there were four wooden paddle steamers, also rigged to carry sail, working the service. The thirteen-year-old future Queen Victoria came to the newly fashionable watering place of Beaumaris in 1832. She and her mother stayed at the Bulkeley Arms Hotel, which had been completed the year before. Fares from Liverpool were high at ten shillings first class and five shillings second. Horses travelled for one guinea and carriages were charged ten shillings and sixpence per wheel. The boats left Liverpool, stopped at Hoylake, Orme's Head, Beaumaris and terminated at Bangor Ferry five hours later. None of these places had a satisfactory landing place. So it was that, by 1840, demand was growing for a pier at Beaumaris. A 'Landing Pier Company' was set up and construction began, but when the money quickly ran out, the local council stepped in. The initial costs of construction were defrayed, with the consent of the Lords Commissioners of Her Majesty's Treasury, out of the sale in 1842, by the Beaumaris Town Council of a parcel of land, *Caeau Mair* to Sir Williams-Bulkeley, enabling the council to move ahead and develop the pier. The 1 November 1843 was a perfect day; after a procession from the nearby Bulkeley Arms Hotel,

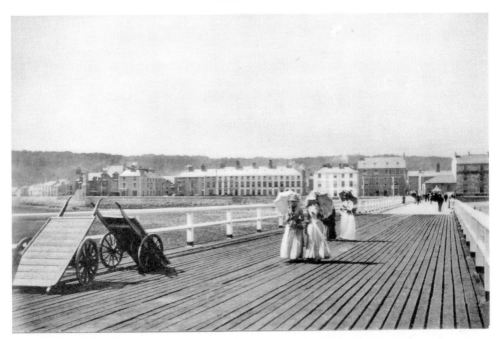

A stroll on Beaumaris Pier in the 1890s, when the pier was considerably improved. The pier had both stone and wooden sections and was opened in 1846. (Marlinova Collection)

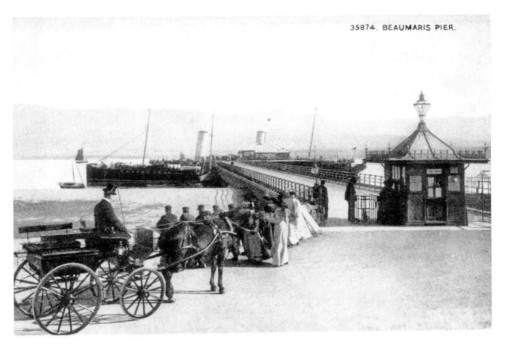

A vessel of the Liverpool & North Wales Steamship Company calls at Beaumaris Pier *c.* 1904. The pier was a regular port of call at this time for the steamer service along the North Wales coast and was also used by ferries going to Menai Bridge, Bangor and Caernarfon. (Marlinova Collection)

The Beaumaris Town Band pictured inside the pavilion which had been erected at the end of the pier in 1895. (Marlinova Collection)

Lady Bulkeley laid the foundation stone in an imposing ceremony attended by invited guests and crowds of townsfolk. The day was declared a holiday, the church bells rang, the passing Liverpool steamer *Erin Go Bragh* fired a salute, the *Dolphin* and the pilot boat flew all their flags and a flotilla of forty to fifty coasters set sail. Upwards of 3,000 people lined the streets to cheer as the Bulkeley party left the celebrations.

Details of the plan for the pier, reputedly by Frederick Foster, were given in the extensive article covering the ceremony, in the local newspaper. The structure was to be carried out a distance of 563 feet from the end of the old town wall, in a direct line with Church Street. It was to be constructed partly of solid masonry in-filled with rubble and partly of timber, about 26 ft high at its extreme ends, having a roadway 23 ft wide for its whole length. It was calculated that the larger class of steamers would be able to land passengers and cargo on the *Slip* (which was to extend at a right angle from the extreme end) almost at any time of the tide, there being 15 ft of water even at the lowest spring tide. Work on the pier went well, but severe storms the following year damaged the supporting pillars and most of the wooden structure was washed away. A loan of £3,000 was sanctioned by the Lords of the Treasury so repair work soon began.

By December 1845, the local newspaper announced that the new pier contract was due for completion by 1 May 1846 in time to coincide with the commencement of the Liverpool steam packet summer season services. A new steamboat, the *Prince of Wales*, was under construction for the City of Dublin Steam Packet Company, and when completed, would call at Beaumaris. It was estimated that she would make the passage: Liverpool – Beaumaris in three hours. A further loan of £3,500 was raised in 1847 on the mortgage of the corporate estates in order that the pier might be completed. News reports for the pier's partial opening in 1846, or its completion in 1847, as stated in documents at the National Archives, have not been found.

Beaumaris was expecting a royal visitor in August 1847. Queen Victoria, her husband and family had left Cowes aboard the *Victoria and Albert* yacht with a retinue of many aboard another five vessels, for a sail around the kingdom. Their plans were not widely known, but the national newspapers attempted to keep track of the flotilla's progress. Excitement grew on Anglesey as it became known that their majesties wished to see the progress being made on the railway bridge across the Menai Straits. The royal party, having

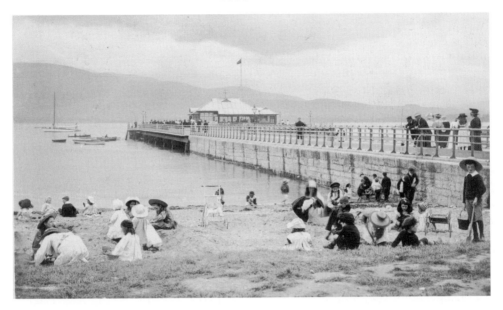

A fine real photographic postcard of Beaumaris Pier issued in 1909. The pier's stone and wooden sections, and pavilion, can clearly be seen. The sender of the postcard had just experienced a very rough sailing from the pier to Llandudno and noted many people had been sick on the journey: the golden age of the paddle steamer was not always romantic! (Marlinova Collection)

transferred to a smaller vessel, *Fairy*, sailed into the Straits from the west and anchored near the bridge to enable Prince Albert to cross and re-cross the structure. Thereafter, the royal party proceeded to Penrhyn Castle and went ashore. Afterwards, the other vessels, having rounded Anglesey, met up with the *Fairy* and cast anchor in Beaumaris Bay for the night. Excitement was running high in Beaumaris. Speeches in English and Welsh had been prepared, and Sir Richard Bulkeley and his wife, accompanied by a large party, were in attendance at the pier to greet the Queen, Prince Albert and the Prince of Wales. Plans must have changed, however, and as the local newspaper reported, 'none of the Royal party landed at that place'. At four o'clock the following morning, the flotilla sailed out of the bay en route for the Isle of Man. What a wonderful start it would have been for the pier to have had the 'Royal' attribution in the first year of its existence.

In the 1850s, the Liverpool Arms was a posting house of some importance. Its coaching services ran to Bangor, Holyhead and Amlwch. Once the steamboat services were up and running, the coaching services were timetabled to coincide with the arrival and departure of the pleasure steamers. The Chester – Holyhead railway was built during the latter part of the 1840s and the link to the island, Stephenson's famous Britannia Bridge across the Menai Strait, was opened on 5 March 1850. Beaumaris never had a railway link, but used Menai Bridge station, five miles away. The railway must have presented stiff competition to the steamboats, especially for freight; the latter dropped their ticket prices in order to compete and retained their popularity until well into the twentieth century. The pier at Beaumaris averaged an annual income of £238 in its first nineteen years; it had quietly served its purpose as a landing pier. This was brought to an abrupt end on Good Friday, 14 April 1865, when the pier was badly damaged by the *Great Emperor*, a 252-ton iron paddle steamer, which collided with the pier. A dispute between the ship's owners, Messrs W. T. Joliffe of Liverpool, delayed repairs and storms wrought further damage. Time passed, but as the fifth summer without the pier approached, one councillor, John Slater, called a meeting to urge fellow council members to act. He brought a petition signed by 'nearly all of the respectable householders' of the town; reinstatement of the pier was an urgent need. He claimed that during the years since the

pier's destruction, visitor numbers had been drastically reduced and the townspeople were beginning to suffer.

Slater's proposal was to resurface the 'road' with 'asphalte' from the gate to the start of the wooden structure and to face it with limestone chippings to avoid the frequent damage caused by waves crashing over it. The timber section would be replaced to an identical plan. A more adequate toll house would be a boon to the toll collector, especially if it could be fitted with a fire and provision made for the incumbent to eat his meals there. It had also proved difficult to stop people trying to avoid paying the entrance tolls so a turnstile was also included in the plan. He estimated the cost of green heart oak, for the structure and 'Baltic' for the decking to be around £800, and with other materials, such as 150 iron bolts, and labour costs, the whole could be achieved for £2,000. The town would then have a pier to last fifty years. He put forward his plans to finance the venture, suggesting an application to the Lords of the Treasury to borrow £2,000 at 5 per cent for twenty years, using the rates of the borough and proposed income from the pier as security. He then turned to the possible income from the pier. In the past, the council had, in some years, let on annual lease the pier tolls. This would have to stop in order for the repayment of the loan. A new scale of tolls was required in order that the council could recoup the maximum benefit from the pier. He summarised the past scale for an 'average year': 16,154 passengers at 2d = £134 14s 0d; 206 season tickets £53 5s 2d; packages of merchandise, etc., £23 17s 7d. Under his new scale, income might be 15,000 passengers by steamer at 4d = £250; 6,000 persons boating, etc., at 2d = £50; various seasonal tickets = £121 11s 0d; charge on steamboats £50; packages of merchandise £10. Once repayments and expenses were covered, the town would have a handsome surplus. The meeting, chaired by the mayor, Sir Richard Bulkeley, agreed to put forward a memorial to the Lords of Treasury to borrow the money required.

Sanction was obtained from the Treasury in 1870 to borrow a sum of £2,100, but instead, seven local tradesmen came forward and became security to the bank for £1,500. In addition, John Slater, who was by then the mayor, collected the remainder from local gentry and trades people. The contractors had agreed to a sum of £2,560 to rebuild the pier. A new scale of tolls was agreed, thus 2d for landing from or embarking upon steamers. For a family of four for daily admission, for three months 11s 6d, for six months 15s 6d, and for 12 months £1 3s 0d. For servants, for a year, 3s 6d.

The pier was completed and reopened 1871/72; a turnstile was included and a new toll house with fireplace was built. In August 1872, a correspondent wrote to the letters page of the local newspaper reporting that 'some evil-disposed persons have ... commenced the process of demolition'. The toll gates were smashed. It was thought at the time that this was done in protest at the level of tolls or to the early daily closing time of the pier. Neither of these were much different to other piers in the area. The writer ended by urging the mayor to bring the culprits to book; nothing short of a period of imprisonment would suffice. It is not known whether justice was done.

Eight years later, the costs of the repairs to the pier were defrayed. As predicted, there was a surplus of money and this used to build a ladies' waiting room on the pier. People were still grumbling about the tolls, and 'A Visitor' wrote to the local newspaper complaining that if he wished to take a sail to Llandudno, he would pay his 2d toll at Beaumaris, pay for his ticket on the boat, and on his return, pay 2d again to land at Beaumaris. The same visitor also complained that the gaps in the planking of the pier were too wide and that boat trips could become even more expensive if travellers were unlucky enough to drop money or jewellery between the gaps into the sea! Another correspondent, signing himself 'The Fourth Commandment', complained that the pier was being used on Sundays, despite the Town Council's resolution prohibiting use of the pier on Sundays. A catch of oysters had been unloaded the previous Sunday morning onto the pier from the *King Ja-Ja*. There was no necessity to remove them from the boat as they had subsequently lain in the sunshine on the pier deck and were only carted away the next day.

A competition was held in the early 1890s for designs for the pier to be reconstructed

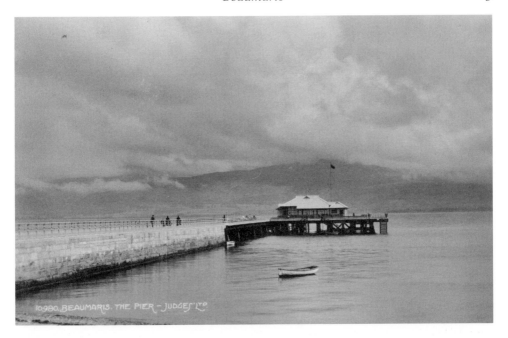

Beaumaris Pier pictured on a very still day in the 1920s with the hills of Snowdonia looming up through the clouds. The pier head was then wider than it is now and remains of the lost section can still be seen. (Marlinova Collection)

to give a wider promenade and space for a pavilion. The well-known Manchester firm of Mayoh and Haley, engineers and constructors, were the winners who produced beautiful plans for a lengthened structure and a T-shaped pier head with a fixed landing stage. The supports were to be in iron, replacing the old wooden section, which was in poor condition, and provision was made for a baggage track below the level of the pier deck. The plans show cast iron decorative railings with panels and classical capitals to the column supports. In July 1894, Beaumaris Corporation asked the Treasury to sanction a loan of £13,000 (£7,250 to pay off existing bonds and £5,500 to rebuild the pier). Eventually, the scheme was cut back; Mayoh and Haley refurbished the old wooden section, the pier was widened at the shore end, a 2-ft 6-in narrow-gauge tramway for luggage was built, and steps were constructed at the western end of the pier head for landing purposes. The improved pier was leased to a Board of Guarantors and opened in 1895. The following year, Mayoh and Haley placed advertisements in local newspapers inviting tenders for the erection of a timber pavilion at the seaward end of the new pier. This was intended to be used for concerts and a café and lavatories were provided.

The Board of Governors of Beaumaris, which was responsible for the new pier, advertised for 'the service of a trustworthy person to act as Collector at the Pier Gate for the coming season. Applications 'stating wages expected, etc.' were invited. This was in addition to the post of Pier Master. The opening of the pavilion, at the seaward end of the pier, towards the end of the 1896 season, was celebrated with a concert 'attended by ladies and gentlemen'. The following year, the Board made arrangements for the Bangor Pier Band of thirteen musicians, under the leadership of their conductor, Dr Rowland Rogers, to perform on the pier on Monday and Friday afternoons. The concerts were well attended; the numbers at Beaumaris being treble those attending the same concerts on Bangor Pier, much to the dismay of the Bangor Council. Almost all householders at Beaumaris bought a season ticket for the pier, but at Bangor, they did not.

One of the main sources of income for a pier such as this, after tolls, was from charges

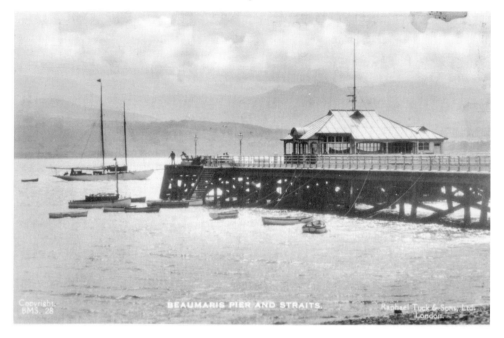

Beaumaris Pier Pavilion in the 1930s, which was used as a shelter for those waiting for the steamers and as a refreshment room and concert hall. (Marlinova Collection)

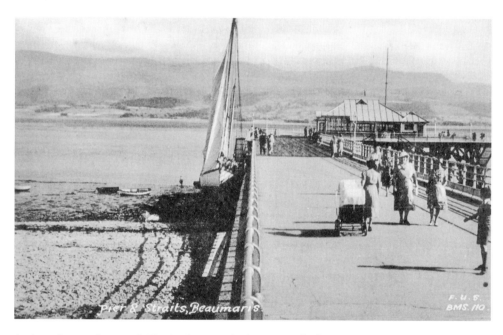

A view taken on Beaumaris Pier in the 1950s looking towards the Menai Straits. The wooden decking of the pier head is clearly defined and the track of the luggage tramway can be seen on the right. (Marlinova Collection)

to boat companies for their use of the pier. On the early services, conditions for passengers were generally poor. The vessels were basically cargo boats or tugs which carried passengers; services from the 1820s had some improved facilities, but this was really a 'packet-boat' service which did not keep up with the more luxurious facilities offered by the trains. A big change came in the summer of 1881, when the City of Dublin Company's *Bonnie Doon* began operating excursion services. However, some of the company's boats were very old and none were fast. There was an opportunity for a new company. The Liverpool & North Wales Steamship Company (L&NWSSCo) was formed in 1891 and became the principal operator for the next seventy years or so. Of its nine founding directors, one represented the Fairfield Works (shipbuilders), Glasgow, and another was a director of the Isle of Man Steam Packet Company. Another was the former chairman of the failed Liverpool, Llandudno & North Wales Steamboat Company and three were Liverpool businessmen. Making up the nine were Sir Richard Williams-Bulkeley of Beaumaris, William Bostock of Colwyn Bay, High Sheriff of Caernarvonshire, who later became managing director of the Colwyn Bay Pier Company which built Rhos Pier, and lastly Col Henry Platt of Bangor. The paddle steamers of the company called at Menai Bridge, Beaumaris and Llandudno piers from the start. In order to increase revenue, the Board of Governors wrote to the operators of the Isle of Man and Blackpool boats in 1899 to arrange for their boats to call at Beaumaris on their trips into the Menai Straits.

The paddle steamers were at their busiest during the first thirteen years of the twentieth century. In 1906, over 50,000 people paid the penny toll to promenade on Beaumaris pier and a slightly larger number the following year. During 1907, this amounted to £225 6s 2d; added to this, £316 12s 6d was received from shipping companies for use of the pier. A sum similar to that received from tolls was paid to the pier by Bangor Corporation. It is assumed that this was for the use of the pier by their frequent ferry boats. There were other small amounts received, and from this income, the Board of Governors was able to fund its expenses, including the purchase of a new suit for the pier master and all repairs. This happy period was brought to an abrupt end by the outbreak of the First World War. The larger vessels were put to war work and visitor numbers dwindled. During this time, the baggage rail tracks fell into disrepair and were not renovated after the end of the war.

The paddle steamers eventually returned and holidaymakers began to visit the pier again. Some of the older boats had given thirty to forty years service and began to be replaced by larger, faster boats. The *St Tudno* (ll), a twin-screw turbine steamer, entered the North Wales service during the season of 1926. However, she was too difficult to manoeuvre alongside both Beaumaris and Bangor piers and so the steam ferry boat *Cynfal* was used as a tender to transfer passengers to and from the *St Tudno* at both locations. This did not prove popular and so both piers were dropped from the company's timetables thus reducing the income of both piers. After the outbreak of the Second World War, a vicious cycle brought about by the neglect of routine maintenance work and declining visitor numbers for at least ten years, led to plummeting receipts. Peacetime saw income fall further, from £1,000 for the year ending March 1947 to just ten shillings by 1953.

The council had called in engineers, Lewis & Duvivier, to advise on the refurbishment of the pier. Their report of March 1950, suggested five possible solutions:

To refurbish the existing structure at a cost of £4,750
To complete as above with two new flights of steps at a cost of £5,000
To replace all with a pre-cast structure, costing £11,000
As above with 'extras', costing £12,000
To replace the existing pier with a similar structure, costing £14,500.

A local firm, Brooke Marine, was also called in, maybe to give a second opinion. Their report, a month later, summarised the condition of the pier in two words: 'dilapidated' and 'dangerous'. The iron work was oxidised, with holes in places where sections had fallen

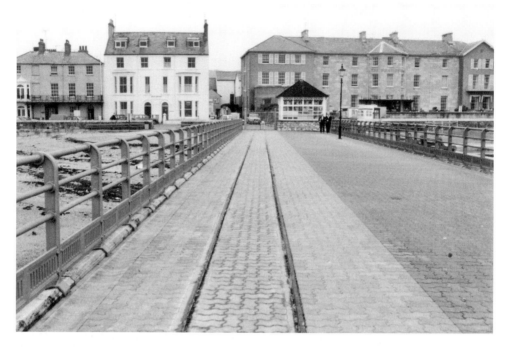

The luggage tramway of Beaumaris Pier was removed during the 1963-64 rebuild, but as seen in this 1990 photograph, a section of it was retained. (Marlinova Collection)

away. The timber bearers, some ravaged by marine organisms, and sections of decking were seriously decayed. Both flights of steps from the pier head were dangerous and immediate closure to avoid litigation was recommended. They suggested that if £860 was spent on renewing one flight of steps, partial use could be made of the pier that season.

The Beaumaris Pier Inquiry was held on 23 May 1950, by inspector C. S. Trapp Esq., AMICE. Local parties with interests in the pier were invited to state their case in support of the pier's repair. Replies came from three local yachting clubs and from Beaumaris Estates Ltd, who were all concerned that the pier might be lost. The council had written to the Welsh Board of Health for their permission to raise the finance and to Lady Megan Lloyd George for her help in securing funds. A small amount of money was spent immediately, but by May 1953, the pier account was in deficit and so the decision had to be made: repair or demolish. A reduced version of the Lewis & Duvivier plan 1 went ahead, costing £4,325. This was only a refurbishment; the most heavily corroded sections were replaced, and the rotten timbers renewed.

When the pier reopened for the 1954 season, the pavilion and kiosk were let to a local resident for a rental of £100 per annum. She was contracted to collect the pier tolls, on a commission basis. A new schedule of tolls was issued, though in essence it was little different to that of 1872. The toll for an adult to promenade on the pier was still 2d. In the years following the reopening, some routine maintenance was carried out, funded by the council, but this was little more than the painting of the structure and the pavilion. In early 1959, the estimate for the year's maintenance stood at almost £2,110, yet income was declining. Opening times had had to be reduced following many complaints of noise from the pavilion during the evenings. So, when the pavilion's tenancy was renewed for the 1961 season, closing times were brought forward to 11 p.m. nightly and to 10 p.m. the following year. There was to be a complete ban on any music on Sundays.

Lewis & Duvivier engineers and Messrs Pochin contractors, for the 1953 refurbishment, were called in again during 1960-61 for their estimates for another round of repairs. These

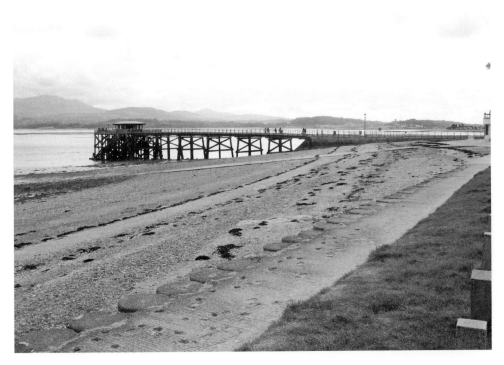

Beaumaris Pier seen from the shore at low tide in March 2010. The days of steamers calling at the pier are long gone, but it remains a popular attraction for fishing and as a promenade. The beach has been considerably built up against the stone section of the pier in recent times. (Marlinova Collection)

came in totalling approximately £15,000. Loan sanctions were again sought. In a great philanthropic gesture, former mayor of Beaumaris Miss Mary Conway Burton gave the council £10,000 towards the costs, and the then mayor, G. J. Dixon, launched the Mayor's Pier Repairs Appeal Fund on 1 July 1963 to raise the remaining £5,000. A time limit was set for the fundraising – to be achieved by the end of the year. There was a flurry of activity in the town with all manner of events and monetary gifts large and small sent in by residents and by people further afield who had a love of the town and its pier. Such were their efforts that the money was raised in time.

Demolition work at the pier was carried out by the Royal Engineers during 19-26 August 1963. Boating activities were curtailed during this period, with a 400-ft protection zone all around the structure. The old metal and timberwork was to be replaced to a similar length but with a pier head of reduced proportions, with landing steps to both sides and with a shelter at the far end.

Work went well and a grand opening reported on Welsh television, was held on 15 May 1964. The council was presented with the silver trowel used by Lady Williams-Bulkeley when laying the foundation stone in 1843. This was specially adapted to enable its use by Miss Mary Burton to cut the ribbon for the opening at an evening ceremony. A parade from the castle, composed of representatives of local organisations made its way to the pier, where local residents were seated. At 7 p.m., the mayor and councillors proceeded from the council chamber to the pier, where speeches were made, prayers offered and the ribbon cut.

Miss Mary Burton, who was then an alderman of the council, had been mayor for some years during the 1950s. Her family had been Beaumaris residents for most of the century. She was an enthusiastic sailor and had sent evidence to the pier inquiry in 1953. She was a lifelong supporter

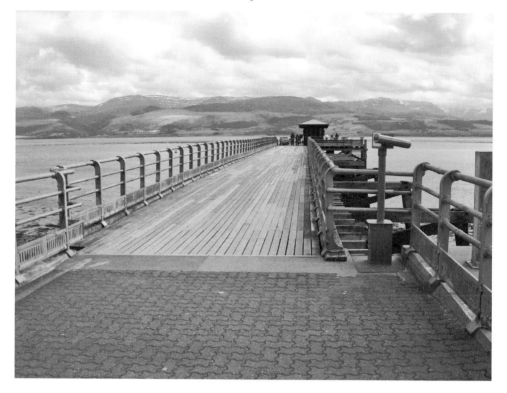

A look along the wooden section of Beaumaris Pier in March 2010. The pier head has been reduced in size and the pavilion replaced by a shelter. (Marlinova Collection)

of the RNLI and it is said that whatever time of day the lifeboat returned after a rescue, she would be standing at the pier head with flasks of soup and cocoa for the returning crew.

Local government reorganisation towards the end of the twentieth century brought changes in ownership; in 1974, the pier passed into the hands of the Anglesey Borough Council and in 1995-96, to the Isle of Anglesey County Council. A maintenance programme has been carried out since the 1960s rebuild, with major refurbishments during the 1980s.

Today the part-stone, part-iron pier comprises a small kiosk at the entrance leading to the promenade deck. At the seaward end is a small shelter with seating on each side. Some of the rails of the narrow-gauge baggage track, revealed during re-paving of the stone section of the pier, remain. The narrowed promenade timber section now sits on wide bearers, which show its earlier dimensions. The pier is a popular spot for crabbing and for short boat trips around nearby Puffin Island. On the shore beside the pier is the RNLI lifeboat station, opened 2000, with its Blue Peter B-class Atlantic 75 lifeboat. Its volunteer crew provides the busiest lifeboat service in Wales. There are currently plans to invest £2 million on the pier in an effort to safeguard its future and to boost tourism in the area. The scheme is backed by funding from the European Union's Convergence Programme – European Regional Development Fund (ERDF), the Welsh Assembly Government's Môn a Menai Programme and Targeted Match Fund and the Isle of Anglesey County Council. If all permissions are obtained, work could begin in autumn 2010. It is planned to reinstate the deck's width to its original dimensions, in effect doubling the width of the deck from four metres to eight, to build a landing pontoon large enough for two 40-ft boats and to refurbish the kiosk and shelter. The decking would be replaced and improvements to the structure would be made. The proposals are part of Anglesey's Coastal Environment Project, which aims to develop on-shore and off-shore facilities to benefit the island's economy.

BANGOR

The city of Bangor stands opposite the Isle of Anglesey. In medieval times, the Bishop of Bangor was granted the right to operate the Garth Ferry to the Gazelle Inn, Llandegfan, on the island. At high tide, a stone jetty was available; at other times, a treacherous grating causeway of some 500 yards was in use, on which the passengers had to walk or wade to the shore. To reach the steamers that plied to Bangor from Liverpool and resorts on the North Wales coast, passengers had to be rowed to and from the shore in small boats. Cargoes were also difficult to load and unload and a solution was urgently required. Discussions began in 1885 between the Bangor City Council and Mr Morgan, whose family had been lessees of the Garth Ferry for almost a century, for the purchase of the ferry lease and all rights. The ferry owners were still the Ecclesiastical Commissioners, so the council had also approached them regarding the outright purchase of the property, but a reply was slow in coming.

Finally, in August 1891, the council acquired the disused slate yard at Garth and carried out improvements to the landing jetty. Locals quickly termed this the 'Ja Ja Jetty' in honour of the steamer *Prince Ja Ja* which had commenced a twice-weekly service to Liverpool. The popularity of the service, along with the desire to enhance Bangor as a seaside resort (the town did not even have a proper beach or promenade to speak of) led the council to investigate the possibility of erecting a promenade and landing pier, and drop the idea of a freight terminal. In 1892, the council approached Messrs Mayoh Brothers of Manchester to advise on the effects on navigation if a pier were erected at the proposed site and to draw up plans for a pier at an angle to the shoreline to avoid the Garth Ferry. The firm estimated their structure would cost £13,000 plus £1,000 for the Act of Parliament and the contractor's fee.

However, by early 1893, the council was estimating that the cost of the pier and acquisition of the Garth Ferry would be around £25,000, apportioned as follows:

Pier and approach	£16,000
Purchase of Garth Ferry and appurtenances	£5,500
Extending Garth wharf and jetty	£500
Improving of the landing stage at Llandegfan	£300
Purchase of freehold of Gazelle Inn, improving and enlarging same; purchase of the new ferry boats, steam launches, etc.	£2,700

	£25,000

To cover the cost, the council petitioned the Local Government Board for a loan of £25,000. Negotiations were in hand with the Ecclesiastical Commissioners for the purchase of the ferry, and also with John Morgan for the transfer of the lease for the ferry operation, and Mrs Salis Schawbe, of Glyngarth, for the purchase of the jetty and Gazelle Inn on Anglesey.

The spiralling cost of the venture brought a hostile reaction in the town, which led to a Local Government Board enquiry on 15 March 1893. The opposition to the plans pointed out that the council was already in debt and the interest charges on the loan at 3 ½ per cent per annum would lead to an additional yearly payment of £875. Furthermore, an additional annual outlay of £1,325 would be needed to cover the cost of salaries, maintenance and insurance. In short, the pier would be an intolerable burden on the rates and would need to attract at least 150,000 visitors annually (at a toll rate of 2*d* per person) to break even. It was argued that Bangor, with its muddy shoreline, had little to attract visitors, who were more likely to be attracted to Menai Bridge with its bridges and to the castles at Beaumaris and Caernarfon.

Despite the objections, the Local Government Board sanctioned the loan and a special meeting of councillors and ratepayers was called on 12 October 1893 to discuss the proposed pier. Both the Ecclesiastical Commissioners and the lessee had approved of the plan and the council was now free to apply for a provisional order. The council had voted in favour of a pier by nineteen votes to two, and now it was the turn of the townspeople, who voted 1,342 for the pier and 545 against. Expected annual expenditure was calculated and a forecast of likely income was prepared. Expenditure near to the £1,000 mark was likely, but income from passengers and boat companies, even at the previous year's level, would cover these. During the season, the Liverpool & North Wales Steamship Company had only landed 7,000 passengers at Bangor, whilst at Menai Bridge, 10,000 had landed; the difference was surely because passengers did not relish the idea of wading ashore at Bangor if they did not have to. The resolution that the council should construct a pier was put to the meeting; the 'audience rose *en masse* in its favour'. The mayor then declared the resolution carried, amid ringing cheers.

A meeting of the council was held soon after. It was now proposed that the council should seek the advice of Mr John James Webster of Westminster. He offered his services to prepare the Parliamentary plan for the acquisition of the Garth Ferry and the construction of a pier, and to assist the committee in every way in applying for Parliamentary powers. There was some discussion concerning the previous relationship with Mayoh Brothers, but the council was assured that the firm had only been employed and paid to provide preliminary works; Mr Webster was experienced in working on Parliamentary orders and that was invaluable to the council.

The council proceeded as planned, and at the end of August 1894, the Bangor Corporation (Pier, etc.) Bill 1894 received the Royal Assent. On 1 September 1894, J. J. Webster was notified of his engagement as engineer for the project. In return, he promised to survey the site and draw up plans which would take about a month. Council ownership of the ferry and land at either side of the Menai Strait was not completed until mid-September 1894. The event and the passing of the Bangor Pier Bill were commemorated by celebrations held a week later, when a large procession progressed from the town clock to the ferry and Mr Morgan presented the council with a silver key with which to open the ferry gates. The Crown wanted to charge Bangor Corporation £150 for the sea bed below the pier, although a fee of £56 was eventually agreed.

John James Webster was a noted bridge engineer who had been Chief Draughtsman and Assistant Manager of Messrs E. T. Bellhouse & Company, Manchester, and Head of the Bridge Department of Messrs Thomas Brassey & Company before starting his own consultancy practice in Liverpool in 1881. Amongst Webster's noted bridge works were the Littlehampton Swing Bridge and the overhaul of the Conway Suspension Bridge. He later moved his practice to Westminster and designed the Promenade Pier at Dover, which opened in 1893 and was of a similar design to that prepared by Webster for Bangor. The council invited tenders for the construction of the pier. Seventeen companies tendered and, unusually, the figures were published. They ranged from Head Wrightson & Co. of Stockton-on-Tees at £26,779 18*s* 0*d* to

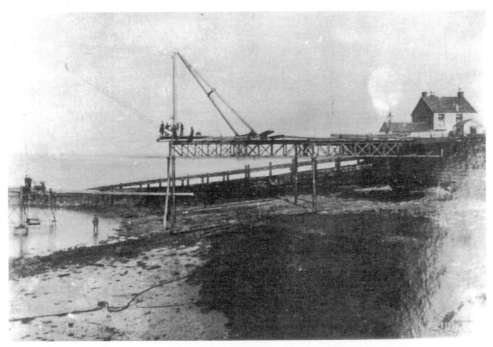

The construction of Bangor Pier by the contractor Alfred Thorne began in the autumn of 1894 and the commencement of the work can be seen in this photograph. (Marlinova Collection)

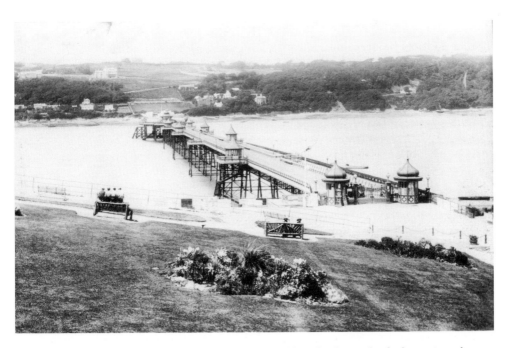

A postcard of Bangor Pier issued *c.* 1905 showing its full length of 1,500 ft which terminated halfway across the Menai Straits. The pier was opened in 1896 and closely resembled Dover Promenade Pier, built by the same engineer and contractors three years earlier. (Marlinova Collection)

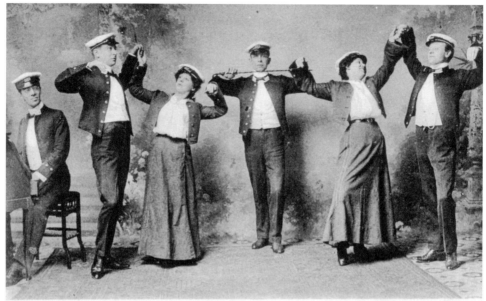

MR. WILL SUMMERSON'S MUSICAL MIDDIES, BANGOR PIER. *Wickens Series. No. 48.*

Will Summerson's Musical Middies performed on Bangor Pier for a number of years until 1910 when Summerson opened the Cosy Corner Pavilion. (Marlinova Collection)

Alfred Thorne of Westminster at £14,475. The latter had been recommended to the council by J. J. Webster, as he and Thorne had previously worked together on similar contracts. The council awarded the contract to Alfred Thorne, who listed for the benefit of the councillors the piers on which he had worked. These were extensions and additions to Brighton West Pier; new landing stage, Eastbourne Pier; Promenade Piers and landing stages at Dover, Shanklin and Llandudno (the latter with John Dixon); iron piers in Spain, Brazil and Mexico and at the current time he was constructing a promenade pier at Torquay and was about to complete the Colwyn Bay Pier (at Llandrillo-yn-Rhos).

Bangor Pier was to be 1,500 ft long and 24 ft wide, leading to a pier head 59 ft long and 99 ft wide. Cast iron columns rested on cast iron screw piles, supporting lattice girders of steel which held the wooden decking. Two ornamental kiosks at the entrance to the pier flanked a pair of handsome wrought iron gates which incorporated the arms of the city. On the pier, attractive domed shelters were placed along the deck at 250 ft intervals in recesses 55 ft across. Seating was provided at intervals and decorative gas lamps were fed from the top handrail of the ornamental cast iron railings, which was also a gas pipe. On the pier head was a covered bandstand with windscreens. The pier's landing stage measured 80 ft x 18 ft and was a floating structure kept in position by greenheart timber dolphins and approached by a fixed incline and a 120 ft long, 7 ½ ft wide girder bridge. This length of bridge was insufficient to reach deep water and so costly dredging was undertaken to allow the largest boats to tie up to the structure. Additional flights of steps led down from the pier for use by small craft.

Alfred Thorne commenced work on the pier in the autumn of 1894 and it was completed eighteen months later at a cost of £17,000 (although the purchase price of the Garth Ferry and the Gazelle Inn on Anglesey, along with other costs such as dredging and additional kiosks, brought the final bill up to £34,911). A 3-ft gauge tramway used in the construction of the pier was retained for moving baggage.

The pier was officially opened by Lord Penrhyn on 14 May 1896 in front of a crowd of 5,263 people, some brought on special trains. Bangor was gaily decorated for the occasion as the official procession assembled at the town clock, comprising the brass band of the local volunteers, various friendly societies, the fire brigade and football club pier officials, Lord Penrhyn and his daughter, the mayor, aldermen and councillors of the borough, the mayors of Beaumaris, Conwy and Caernarfon, and the chairman of Llandudno District Council. The procession was cheered through the town before reaching the pier for the opening ceremony, after which the dignitaries were treated to a sumptuous banquet at the George Hotel. The day's festivities were rounded off with an evening confetti fête, firework display and a torchlight procession of boats sailing past the pier.

The pier was principally built for use as a landing stage. The *Torbay* plied the ferry crossing to Beaumaris every half-hour at a cost of 6d and, in 1904, the council acquired the larger *Lady Magdalen* for the route. In 1906, this vessel also provided a summer service to Caernarfon. An annual average of 50,000 passengers used the Beaumaris ferries until 1914, whilst 4,500 used the Caernarfon service.

In addition, the *Nantllys* and *Mona* went to the Gazelle Inn for a penny each way. The slippery surface of the stone landing stage there proved a danger to passengers and, in 1897, £300 was spent on erecting a wooden jetty. At the same time, the inn was renovated and licensed to sell beer, wine and spirits. On average, the ferry carried 140,000 passengers a year up until 1914, along with 5,000 bicycles and 2,000 parcels.

The vessels *Snowdon* and *St Elvies*, of the Liverpool & North Wales Steamship Company, called at the pier twice weekly on their way to and from Menai Bridge, although, as the pier was still 250 ft away from the deep water channel, dredging had to take place to ensure they could still call. The acquisition by the L&NWSSCo of the palatial steamer *La Marguerite*, capable of carrying 2,000 passengers in 1904, allowed a daily service to call at the pier. The same year saw *Snowdon* replaced by the *St Tudno*, and the *St Elvies* operated a twice-weekly 'Grand Sea Trip' from the pier around the Isle of Anglesey. The first and last sailings of the season, in May and September respectively, were greeted by simultaneous cannon blasts from both the vessels and the pier. An average of 34,000 steamer passengers used the pier each summer up to 1914 and sailings were available to Douglas, Liverpool, Blackpool, Llandudno and Caernarfon.

The pier's other purpose was as an amusement and entertainment centre for both visitors and locals. In addition to providing a bracing promenade, the pier hosted pierrot shows, brass bands, divers, indoor salt-water baths, a bathing station, swimming contests across the strait and variety programmes performed by Will Summerson's Musical Middies. Originally known as the Bangor Operatic Pierrots, the Musical Middies provided a repertoire of comic songs and sketches, dances, piano and violin solos and duets, banjo and mandolin numbers, and ballads and lullabies. Occasionally, ventriloquists, jugglers, trick cyclists and conjurers were hired to supplement the entertainment. The day's programme on the pier for 20 June 1896 included a children's fête with prizes for the best-dressed perambulator and an evening confetti fête. The band of the Royal Anglesey Engineers played throughout the day. Admission to the pier was 2d, rising to 4d-6d for special events and fête days. The annual regatta saw hundreds of visitors assemble on the pier to view the boat races, swimming contests, duck hunts and climbing a greasy pole to grab the joint of meat dangling from the top. In August 1903, the pier showed its first electrograph moving picture show and in the following year a screening of Jules Verne's *The Wonders of the Deep* drew large crowds. During the period from May 1896 to March 1914, nearly 442,000 people paid to use the pier and a further 296,000 brought contract tickets. In roughly the same period, nearly 400,000 frequented the pier entertainments, with 1906 being the peak year. Thereafter, support of the entertainments declined as customers sought more comfortable venues rather than the often draughty and wet pier head with little more than a canvas screen for protection. In wet weather, the performance of the Merry Middies was usually transferred to the Penrhyn Hall. In 1910, Will Summerson abandoned his pier shows

The pier head and landing stage of Bangor Pier photographed from a steamer *c.* 1900. Note the advertisements adorning the pier, including some for local hotels. (Marlinova Collection)

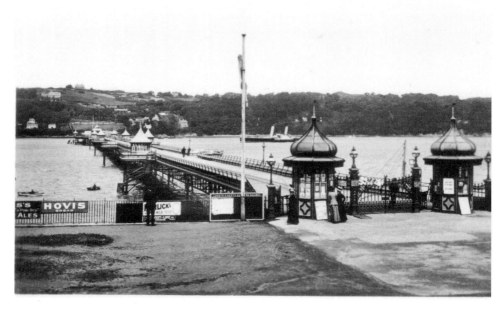

A postcard in the W. H. Smith Kingsway series showing Bangor Pier in *c.* 1912. The pier's ornate minaret toll houses can be seen to good effect, whilst out in the straits a steamer can be seen approaching the pier. (Marlinova Collection)

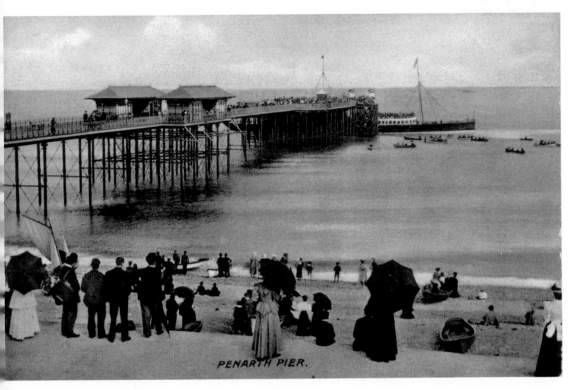

1 A steamer calls at Penarth Pier *c.* 1903, accompanied by a small flotilla of boats. This postcard shows the pier in its original form as opened in 1895. (Marlinova Collection)

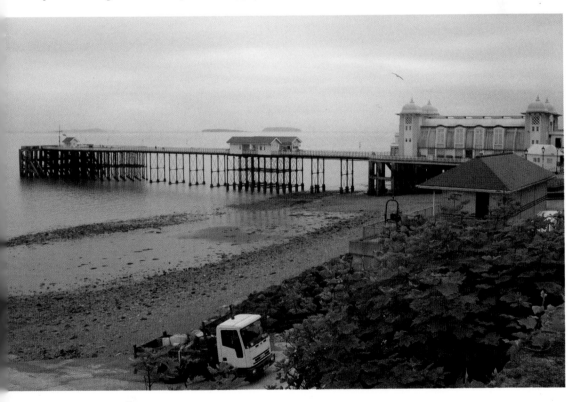

2 Looking down on Penarth Pier at low tide in 1982, showing the neat and compact structure at its best. (Marlinova Collection)

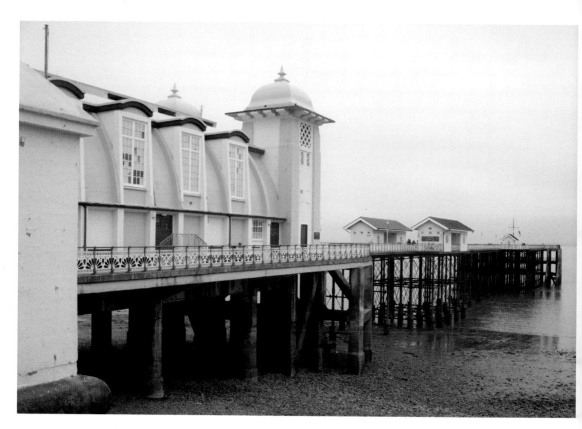

3 Penarth Pier and Pavilion photographed from the shore in June 2009. (Marlinova Collection)

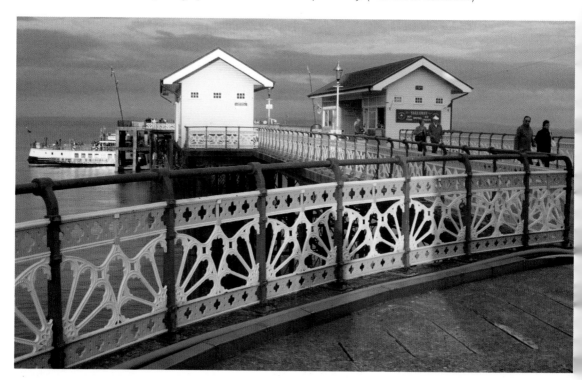

4 In the glow of a June evening, the PS *Waverley* calls at Penarth Pier. The pier's ornate railings can be seen to good effect (Marlinova Collection)

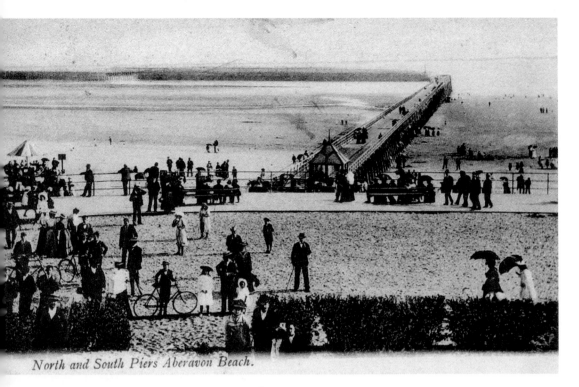

North and South Piers Aberavon Beach.

5 Aberavon Pier was opened in 1902, having been converted into a pleasure pier from a harbour breakwater. This postcard view from *c.* 1904 shows the pier from the Jersey Beach Hotel. (Marlinova Collection)

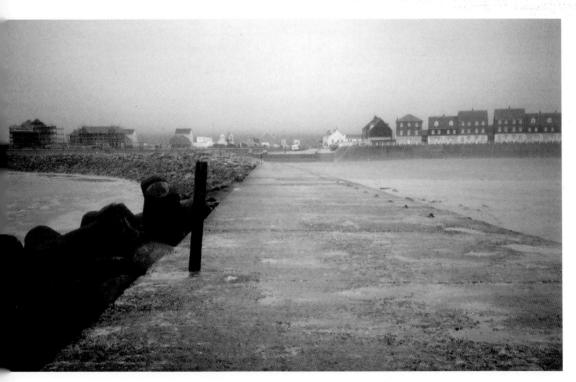

6 Aberavon Pier ceased to be a pleasure pier in the 1920s but the concrete breakwater was still accessible in September 2005 when this photograph was taken looking back towards the shore. (Marlinova Collection)

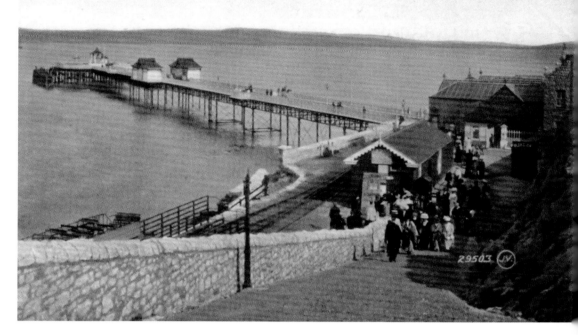

6 Mumbles Station and Pier pictured on a postcard by Valentines of Dundee *c.* 1910, showing how convenient the station was for those visiting the pier. (Marlinova Collection)

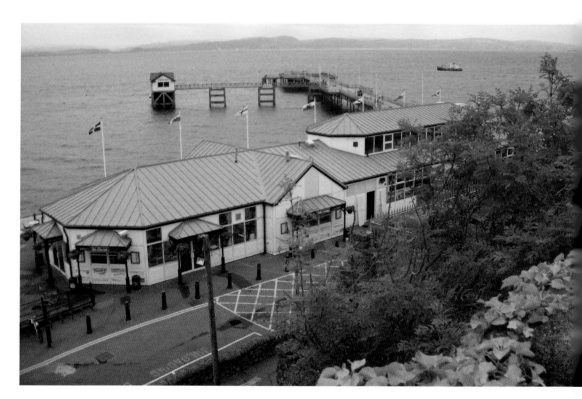

7 A June 2009 photograph of Mumbles Pier featuring the pavilion at the shore end housing the café and amusement arcade. (Marlinova Collection)

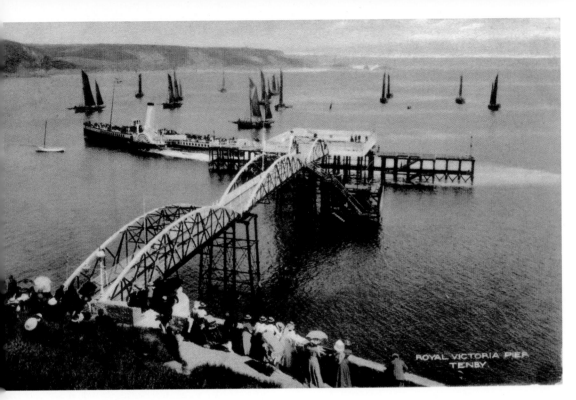

8 A P. & A. Campbell steamer pulls away from Tenby's Royal Victoria Pier *c.* 1905 watched by a crowd on Castle Hill. As the pier was the western limit of Campbell's steamer operations, services from the pier were infrequent. (Marlinova Collection)

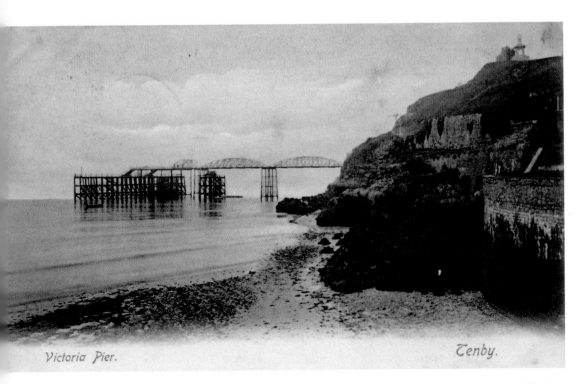

Victoria Pier. Tenby.

9 Tenby Royal Victoria Pier seen from the foot of Castle Hill *c.* 1904 with a view showing the unusual bridge-like construction of the pier. (Marlinova Collection)

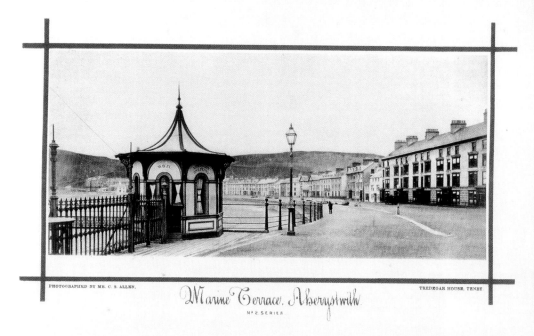

Marine Terrace, Aberystwith.
Nº 2. SERIES.

10 The entrance to Aberystwyth Pier and Marine Terrace *c.* 1880. The pretty little toll house has 'WAY IN' and 'ADMISSION ONE PENNY' painted on it. (Marlinova Collection)

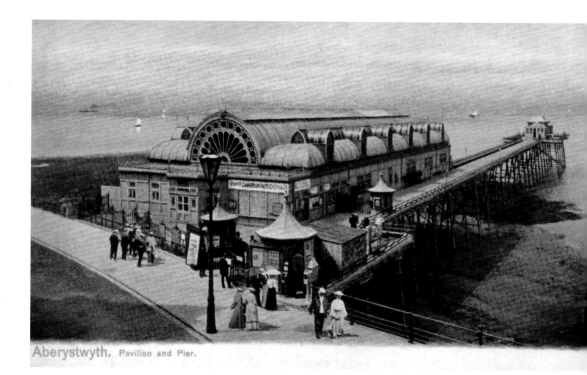

Aberystwyth. Pavilion and Pier.

11 A colour printed postcard in the Peacock Series showing Aberystwyth Royal Pier and Pavilion in 1904. The pavilion was opened on 26 June 1896 by HRH Prince of Wales and Princess Alexandra. (Marlinova Collection)

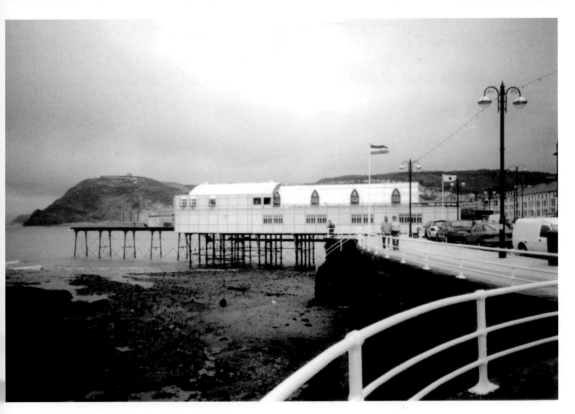

12 The surviving section of Aberystwyth Pier photographed in July 2003. (Marlinova Collection)

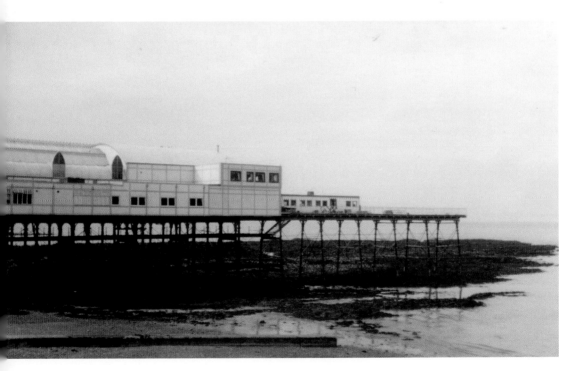

13 The sea end of Aberystwyth Pier at low tide. In 2010, the truncated pier neck was put back into public use for the first time in many years when picnic tables were provided on it. (Marlinova Collection)

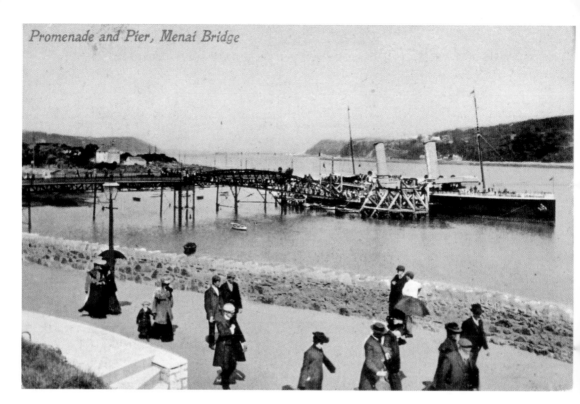

Promenade and Pier, Menai Bridge

14 Passengers stroll along the promenade at Menai Bridge having departed from the steamer seen at the end of the St George's Pier c. 1906. The pier was opened in 1904 and featured a floating landing stage with connecting bridge. (Marlinova Collection)

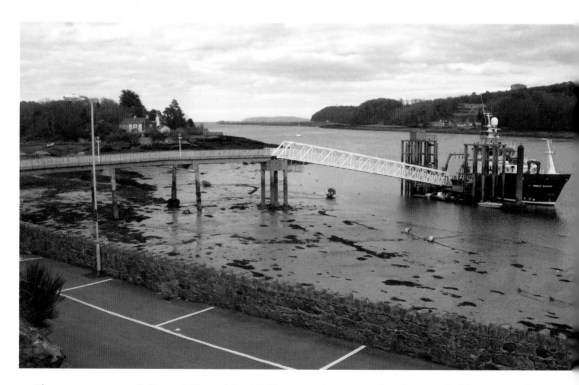

15 The current concrete St George's Pier at Menai Bridge opened in 1979 and is photographed here in March 2010. (Marlinova Collection)

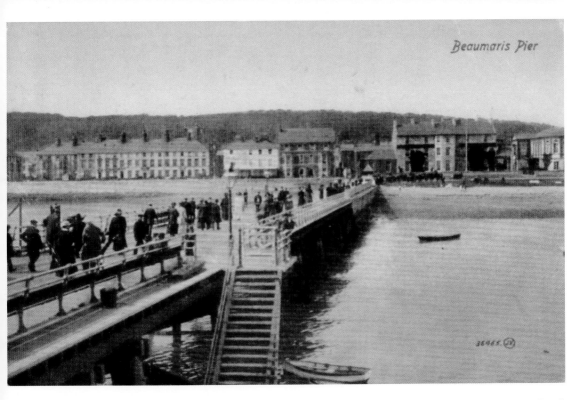

16 Beaumaris seen from the end of the pier *c.* 1905. The tall building on the right is the town's main hotel, the Bulkeley Arms. (Marlinova Collection)

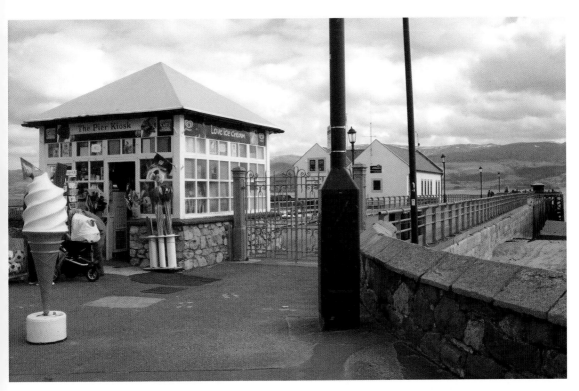

17 The entrance to Beaumaris Pier in March 2010 with the tollhouse now used as a refreshment and gift kiosk. The white building adjoining the pier is the lifeboat station. (Marlinova Collection)

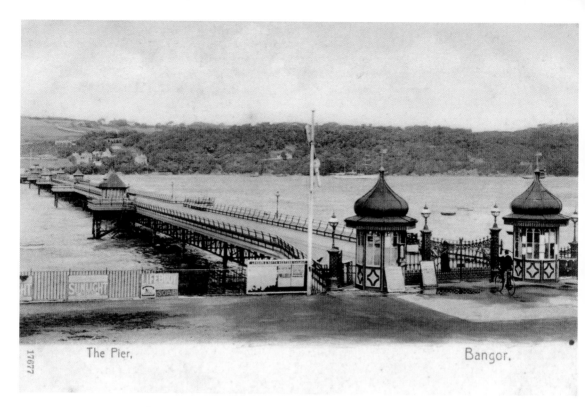

18 A postcard of Bangor Pier in 1902, six years after it had been opened. The pier stretched for 1,500 ft, almost halfway across the Menai Straits, and featured an attractive pair of kiosks at its entrance. (Marlinova Collection)

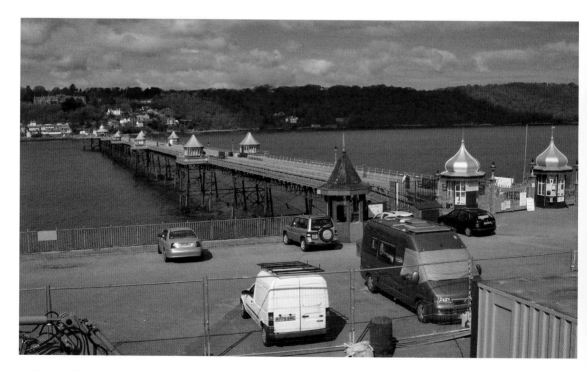

19 Bangor Pier photographed on a quiet day in March 2010, looking little altered from when it was built in 1896. (Marlinova Collection)

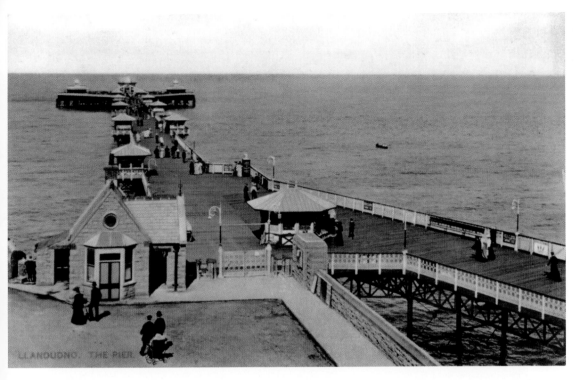

20 Llandudno is one of the finest of the Welsh piers and it is seen here in *c.* 1905 showing the original section opened in 1877. The extension of 1884 taking the pier to North Parade can be seen on the right. (Marlinova Collection)

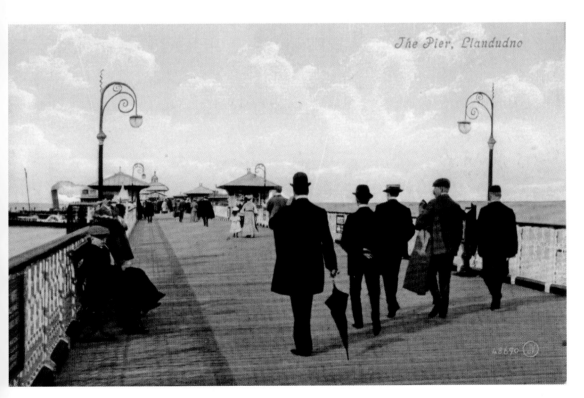

21 Edwardians strolling along the pier at Llandudno, perhaps on their way to catch the steamer, which can be seen on the left. (Marlinova Collection)

22 The North Parade entrance to Llandudno Pier in March 2010. This section of the pier up until it joins the original structure is given over to amusements and retail stalls. (Marlinova Collection)

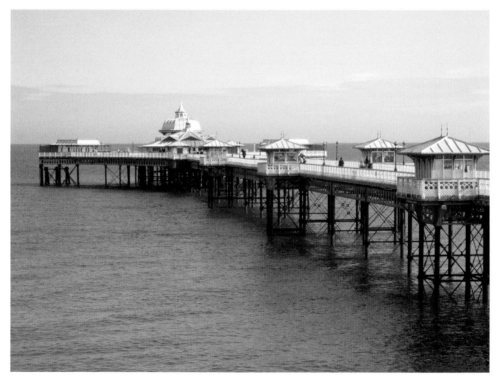

23 The superb outline of the sea end of Llandudno Pier, one of the United Kingdom's finest and prettiest marine structures. (Marlinova Collection)

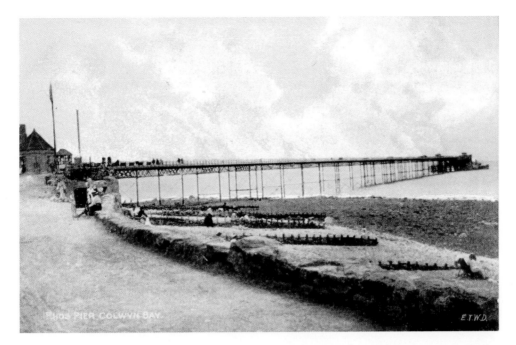

24 Rhos Pier Colwyn Bay. This E. T. W. Dennis postcard was taken in the first decade of the twentieth century before the railings and limestone gateposts were erected. Very few pictures of the pier feature any of the paddle steamers that called there. In this image, one such boat is berthed at the landing stage, possibly awaiting the passengers who are making their way along the deck. (DPT collection)

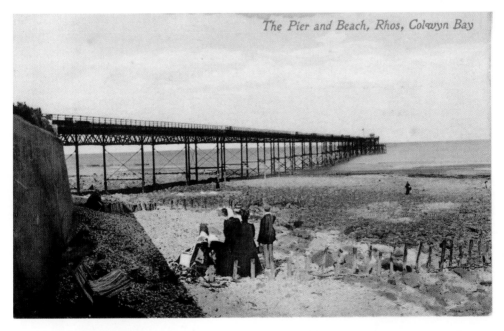

25 The Pier and Beach, Rhos, Colwyn Bay. This postcard, dating from before 1910, shows the very gentle slope of the beach necessitating the long length of the pier to reach deeper water. Years before the pier's erection, the beach was farmland and remains of tree stumps could be seen at low tide, until the erection of the breakwater in the 1980s. The area was known as Morfa Rhianedd; some believe that the original parish church was washed away when this land was engulfed by the sea. It is surprising this part of the beach was so popular with bathers; it was very rocky. (Marlinova Collection)

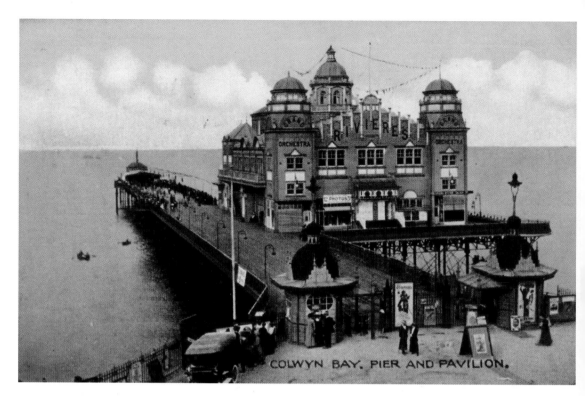

26 Colwyn Bay Pier and Pavilion featured on a postcard issued in 1920. The splendid wooden pavilion would be sadly destroyed by fire two years later. (Marlinova Collection)

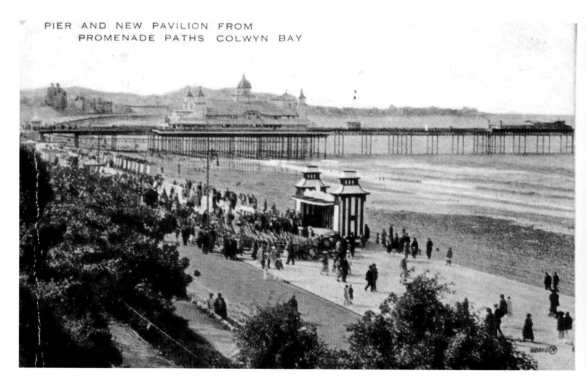

27 A postcard from 1923 showing the newly built second pavilion on Colwyn Bay Pier replacing the one that had been destroyed by fire the previous year. Also seen is the Bijou Pavilion at the end of the pier, and the concert party stage on the promenade. (Marlinova Collection)

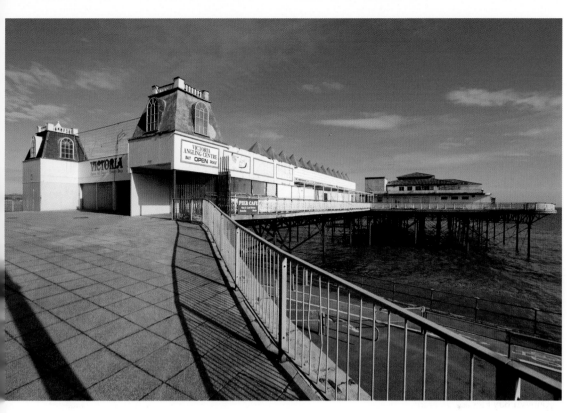

28 Colwyn Bay Pier in March 2010 closed up as debates rage about its future. (Marlinova Collection)

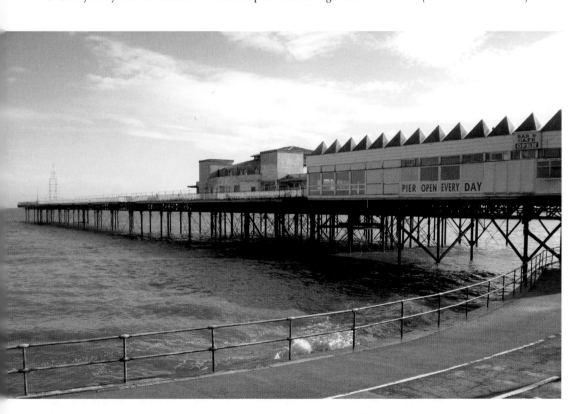

29 A further view of the closed Colwyn Bay Victoria Pier in March 2010. (Marlinova Collection)

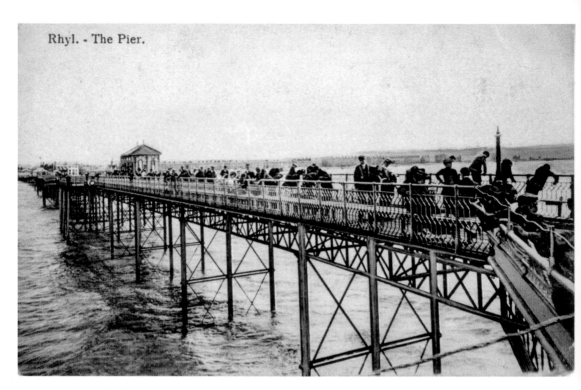

Rhyl. - The Pier.

30 Rhyl Pier was the longest pier in Wales, reaching a maximum length of 2,355 ft. This postcard view from *c.* 1905 was taken from the end of the pier looking back towards the shore. (Marlinova Collection)

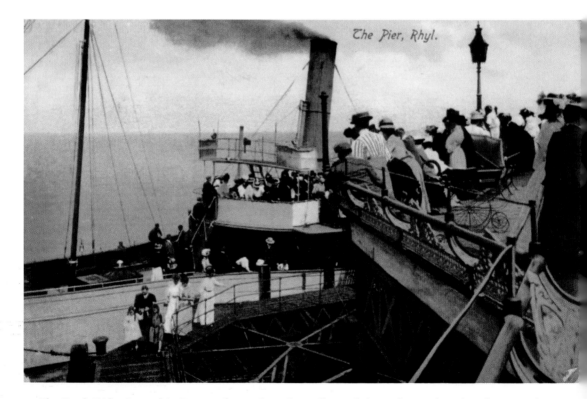

The Pier, Rhyl.

31 The North Wales Steamship Company's vessel *St Elian* calls at Rhyl Pier during the Edwardian period. Difficulties with tides and the condition of the pier led to sailings ceasing from Rhyl in 1911. (Marlinova Collection)

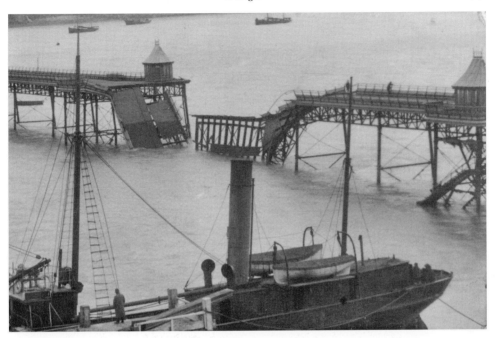

In December 1914, a 150-ft section of Bangor Pier was broken through by the vessel *Christiania*. A walkway was placed across the gap by the Royal Engineers but it was not until 1921 that the pier was fully repaired. (Marlinova Collection)

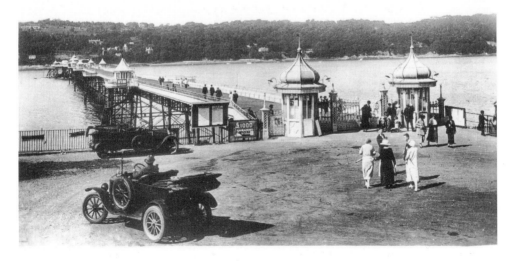

A fine vintage car fronts this postcard of Bangor Pier issued *c.* 1930 showing the pier fully restored following the *Christiania* incident. (Marlinova Collection)

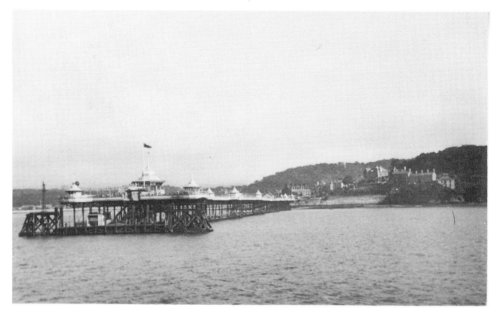

A view of Bangor Pier and its landing stage seen from a ferry in the 1930s. (Marlinova Collection)

after having opened the Cosy Corner Pavilion, which blended a mixture of variety entertainment with films. The pier management responded by boarding in the pier bandstand and adding changing rooms, which were termed the 'Pier Pavilion'. During the years up to the First World War, the pier yielded a surplus most years, but due to the loan charges that had to be paid, the council normally found itself with a yearly deficit of around £1,500. Nevertheless, there's no denying the benefit the pier gave to both visitors and locals during this period.

Unfortunately, in December 1914, the cargo vessel *Christiania*, whilst delivering materials for the pier from Liverpool, collided with it during a storm damaging a 150-ft section of the structure at the shore end. The Royal Anglesey Engineers constructed a temporary walkway across the gap to enable it to still be used. Repairs were not carried out until 1921, when it was discovered that one of the piles adjoining the gap was badly cracked and a central pile had settled 4 ½ in due to the weight of a concrete girder laid by the Royal Engineers in 1914. It took several months of work to straighten and re-align the deck of the pier. The pier tramway had been removed by this time. In 1922, the pier landing stage was remodelled with larger pontoons and the channel was dredged to clear silt accumulated since 1914. However, by this time the fleet of the Liverpool & North Wales Steamship Company, which included the *St Tudno*, *St Seiriol* and *St Silio*, drew deeper water and were often unable to call at Bangor. For two years in 1935-37, the Cambrian Shipping Company ran the *Lady Orme* between Llandudno, Bangor and Menai Bridge, but the vessel was subject to frequent breakdowns, leading to poor patronage. In 1937, the corroded pontoons of the landing stage were replaced by a series of side landings with an access bridge supported on a beam placed across the dolphins.

The ferry services to Beaumaris and Llandegfan also quickly declined during the early 1920s, largely due to growing use of local bus services. By 1926, the ferries were being described as a 'thing of the past' and, in March 1930, the council sold the Gazelle Inn for £1,000. The purchaser took out a five-year lease on the ferry service and brought *Cynfal*, one of the ferry boats.

The pier entertainments also declined during the interwar years, although there were occasional band and sacred concerts. Dare Devil Peggy dived off the pier during the 1930s

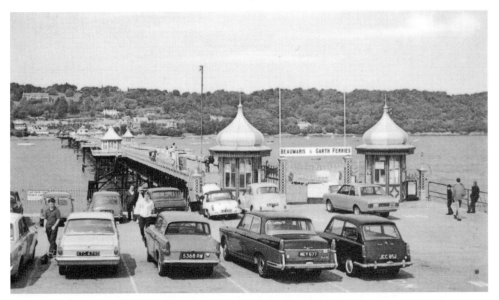

A fine collection of 1960s cars grace the car park at the entrance to Bangor Pier. (Marlinova Collection)

and was the inspiration for Tommy Handley's 'Don't Forget the Diver' character in *ITMA*, the hit radio show broadcast from Bangor during the Second World War. The pier began losing money heavily for the council and, by the early 1930s, was incurring an annual loss of at least £2,000. Councillors were openly questioning whether they could continue running an undertaking that placed such a burden on the rates. In 1937, they sponsored a Bill to amend the Bangor Corporation (Pier, etc.) Act of 1894, which would allow them to discontinue the ferry to Llandegfan and sell the pier. The Bill received public support, but was objected to by the County Councils of Anglesey and Caernarfon on the grounds that the ferry was needed in case the Menai Suspension Bridge was put out of action. The Bill was amended to meet the objections of the councils and in May 1938 became law; however, the onset of the Second World War led to the council having to forestall their plans.

During the war, part of the pier's decking was removed as an anti-invasion measure. The pier was in a pretty poor state by the end of the war and, in 1946, Bangor City Council expressed a wish to demolish it, although they were told it would require an Act of Parliament to do this. An attempt to sell the pier in 1947 fell through and two years later the council voted for £6,250 to be spent on essential repairs. Entertainments such as dances were organised on the pier during the summer months but the pier continued to be a loss earner, as much as £6,000 a year by the end of the 1960s. An approach to Trust House Forte, who had acquired the piers at Llandudno and Colwyn Bay, to buy Bangor Pier in 1968 was rejected due the pier's lack of revenue-earning potential.

A report on the pier's condition in the late 1960s highlighted its serious state of decay and it was estimated that £300,000 was needed to fully restore it. As the council did not have this money, they had no alternative but to close the pier in April 1971 for safety reasons. Three companies expressed an interest in the immediate purchase of the pier, but they withdrew after a structural survey revealed its poor state. Various alternatives were available to the council: complete demolition of the pier at a cost of £10,000; complete restoration of the pier to its original form, £400,000; or partial demolition (80 per cent), £9,000, and reconstruction up to and including the concrete deck at a cost of £150,000. The local population appeared to be split between restoration and demolition of the pier and it was decided to hold a referendum in June 1973 to let them decide its future. However, only 1,419 of the 10,000 people on the

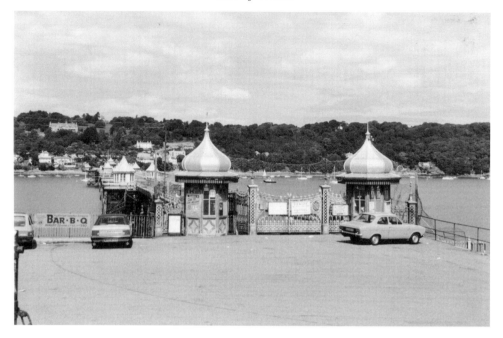

Bangor Pier was closed as unsafe in 1971 and remained shut off to the public eleven years later when this photograph was taken. However, funding from various sources enabled the restoration of the pier to commence in October 1982. (Marlinova Collection)

electoral role bothered to vote with 625 in favour of keeping the pier and 794 against.

Local government reorganisation in 1974 transferred responsibility of the pier to Arfon District Council, whose resolution the following year to demolish it was defeated by only one vote, that of Bangor's representative, Mrs Jean Christie. The Bangor City Community Council applied to the Welsh Office for Grade II* listing, which was granted, effectively preventing its demolition. A report carried out at that time by the Industrial Monuments Survey stated that Bangor, along with Clevedon and Brighton West, were the threatened piers most worthy of conservation.

In 1978, the pier passed into the hands of Bangor City Community Council for the nominal sum of 1p plus the guarantee that the pier would be restored. It was clear that the council had no funds to carry out the restoration. Fawcett & Partners, a firm of consulting engineers working on Menai Bridge Pier, carried out a full survey of the pier free of charge and estimated that £470,000 would be required. Fundraising began locally under the energetic leadership of Mayor Jean Christie and Town Clerk George Gibbs. Financial assistance was slow in coming, but a cheque from the Secretary of State for Wales acted as a catalyst for further support. The Welsh Development Agency, the National Heritage Memorial Fund, and the Historic Buildings Council for Wales soon followed suit, which enabled restoration of the pier to commence in October 1982 with labour assistance from the Manpower Services Commission. They set up a Community Task Force, which gave short-term work to local unemployed, including construction workers from the recently completed Dinorwig Power Station. Alfred McAlpine oversaw the project and L. G .Mouchel & Partners were the consulting engineers.

Unfavourable weather conditions caused costs to rise, so further funding for the restoration was required. This came from a sponsor scheme. To sponsor a plank cost £5, benches £100, kiosks £500, landing stage tiers £2,500 and lattice girders £1,000. One of the planks was sponsored by the folk group Fiddlers Dram, who sang 'The Day we went to Bangor', and another by Mayor Lindsay of New York. The pier head building

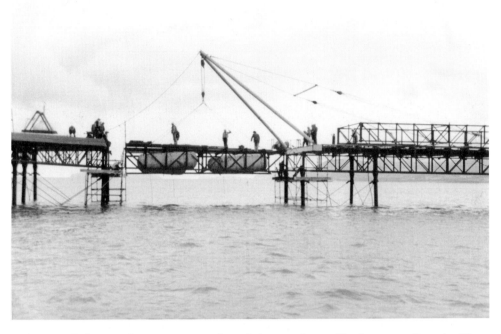

A photograph showing the restoration work carried out on Bangor Pier between 1982 and 1988. (Marlinova Collection)

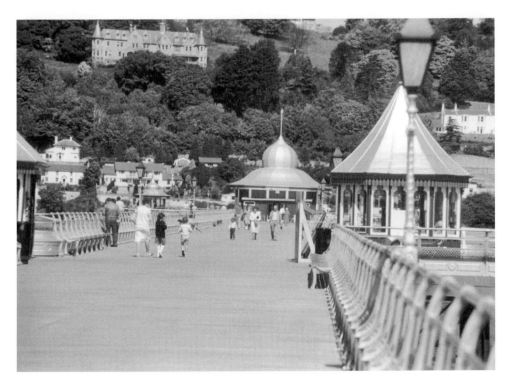

A photograph taken shortly after Bangor Pier was reopened on 7 May 1988 following a six-year restoration. (Marlinova Collection)

One of the splendid Victorian kiosks on Bangor Pier, photographed in March 2010. (Marlinova Collection)

was sponsored by Shell UK and the entrance gates by the Garth Hotel opposite the pier. Kervig, a hardwood from Malaya, was used for the decking and Scandinavian redwood for the pavilion, shelters and kiosks. On 8 July 1983, the Prince of Wales visited the pier and later awarded the restoration team a Prince of Wales Award. In 1988, the pier also won the Europa Nostra award for conservation. The pier was restored to its pristine Victorian condition at a cost of £3 million and was reopened by the Marquess of Anglesey on 7 May 1988.

The pier's main attraction is as a promenade out into the Menai Straits, although sailings have taken place occasionally from the landing stage. The pier head building houses a café and the kiosks, gift shops. Visitors should not miss the opportunity to sample the excellent scones, 'home-baked' daily in the pier café. Nevertheless, the pier's lack of real earning potential led to Bangor City Council putting it up for sale because they could no longer afford the annual upkeep. The pier remains in their hands.

DEGANWY

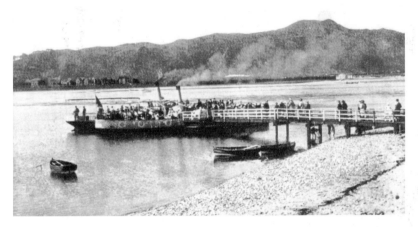

This settlement close to the west shore of Llandudno on the River Conwy was a stopping point for steamers services between Llandudno and Conwy and then on to Trefriw, which had a popular chalybeate spa. A small pier was erected in 1847 to receive the steamers of the St George Steamship Company *St Winifred* and *St George*. The company continued to run the River Conway service until 1940, and their other vessels included *New St George, Prince George, King George, St George II* and *Princess Mary*. Two other companies also ran services on the river: the Queen of Conway Company between 1891 and 1903 using *Queen of Conway*, and the Trefriw Belle Steamship Company from *c.* 1895 to 1910 using *Trefriw Belle* and *Jubilee*. The jetty was dismantled following the ceasing of steamer services on the river in 1940.

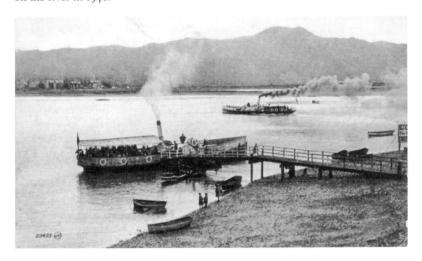

LLANDUDNO

The upper classes had always been inclined to travel and explore, but the advent of the coastal steamer extended this privilege to the middle classes. The first day-trippers to Llandudno travelled from Voryd (Foryd), near Rhyl, on 29 August 1837. The second steamer called a decade later in March 1847, when the Dublin-based *Erin-Go-Bragh* diverted from her usual Liverpool – Caernarfon trip to drop off a team of boilermakers bound for work on Robert Stephenson's tubular bridge across the River Conwy. Those travellers would have had to wade ashore.

Llandudno Pier, which is thought by many to be one of the finest Victorian seaside piers, is now Grade II listed. It was preceded by an iron and timber jetty built in 1858 for the St George's Harbour and Railway Company, which had received parliamentary approval five years earlier to develop a harbour for the Irish service. The company brought the railway branch line to Llandudno also in 1858, but the shorter sea route offered by Holyhead meant that the Llandudno scheme was eventually dropped. The structure was 242 ft long and 16 ½ ft wide and had cost just £250 to build. A small hut was placed at the entrance for the toll collector, Robert Jones. However, on 26 October 1859, the jetty was seriously damaged in a gale that wrecked many vessels in the area, including the *Royal Charter*, which foundered off Anglesey with the loss of 459 lives and a fortune in gold. The structure was patched up and continued in operation for a few more years, enabling Great Orme limestone to be loaded as well as the landing and embarking of passengers.

The idea of a pier for the resort was first considered in October 1862, when a special meeting of the Town Commissioners was held to deliberate on a plan by Eugenius Birch for a 1,300-ft pier commencing near the location later selected for the war memorial. However, the idea was rejected because it was considered that a pier would interfere with the existing Marine Promenade and the beauty of the setting. In September 1865, there was a further proposal for a pier which was to commence on the promenade, skirt the sea wall as far as the baths and then branch out to deep water to enable it to be used by steamers at all states of the tide. This time, the plans were drawn up by Peter Bruff, of Charing Cross, London. (He went on to design the pier for Clacton-on-Sea.) This plan shows the pier in two distinct sections: the seaward end having an entrance and toll house leading from Marine Drive and a landward section with a separate entrance. This was to be a long pier, stretching out 2,584 ft into the bay. At the pier head was a 'shelter head and cant'. This was an L-shaped landing stage, of about 500 ft in length, with the angle to the pier less than 90 degrees. The promoters received Board of Trade approval and the scheme was generally favoured by the town, but it was then left to lie.

Things got going again in 1869 with the Llandudno Pier Company Limited offering £5 shares and listing in their advertisements the name Lieutenant-Col Mawson as their engineer. He had built the Central Pier, Blackpool, two years previously (his only pier); also listed was Mr E. Blane, 'promoter of Blackpool and other piers'. Once again nothing was built. The Town Commissioners' Minutes, dated June 1873, record discussions regarding the erection of a handsome promenade pier further towards the centre of the

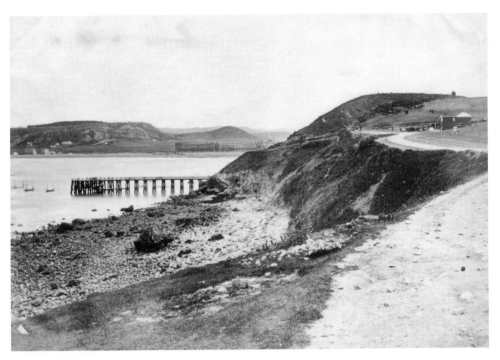

The predecessor of Llandudno Pier was the St. George's Pier, opened in 1858 by the St George's Harbour and Railway Company to a length of 242 ft and used for both passenger and goods landings. The pier was demolished during the building of the new iron pier, opened in 1877. (Marlinova Collection)

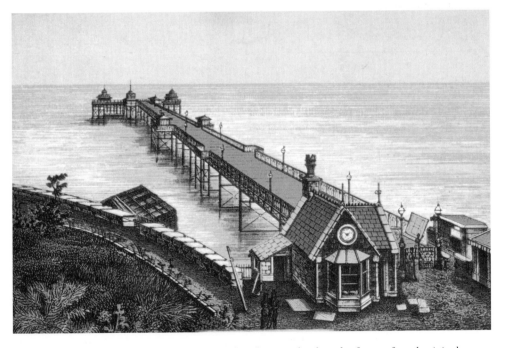

An engraving showing Llandudno Pier in its first form with a length of 1,234 ft and original entrance and toll house. (Marlinova Collection)

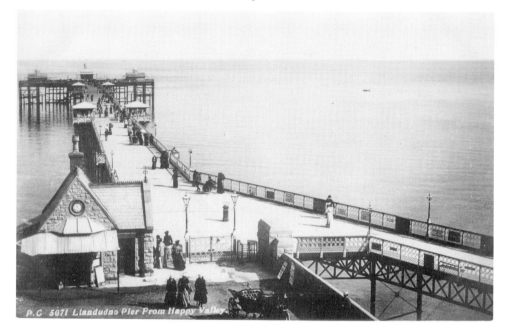

In 1884, Llandudno Pier was extended past the Grand Hotel to the promenade, bringing its length to 2,295 ft. This postcard from *c.* 1905 shows the original entrance and the extension on the right. (Marlinova Collection)

bay; this was to be a pleasure pier, as there was to be no landing stage. Once again, there was no further progress.

Eventually, in January 1876, the Llandudno Pier Company put forward their scheme for a pier similar to that proposed in 1865 by Bruff, which found general favour, although only part of the original design was initially implemented. The eminent pier engineers, James Brunlees, who had designed Southport and Rhyl piers, his partner, Alexander McKerrow, and his assistant, Charles Henry Driver, designed the iron structure, and, on 15 August 1876, a great ceremony was held. Lord Hill Trevor, after giving a short speech, pulled a rope connected with the first pile, underneath which detonating powder had been laid. The ironwork was cast at Walter MacFarlane's Elmbank Foundry in Glasgow. The work processed smoothly under the care of contractor John Dixon, and, on 1 August 1877, the pier was informally opened to the public, having cost £30,000 to build.

The structure was 1,234 ft long with a T-shaped pier head; at its entrance was a stone toll house. The following specification was added to the description of the opening: 'The main deck of the pier is carried on lattice girders four feet two inches deep, supported on hollow cast iron piles twelve inches in external diameter, built in lengths of about eleven feet and strongly braced up by a series of eleven inch diagonal wrought iron tie-bars.' Four square kiosks lined the pier deck in recesses and two octagonal kiosks were placed on the pier head, along with a bandstand. There were plans for a pier head pavilion and a landing stage, but these were the subject of a separate contract. Over 30,000 people paid to promenade on the pier during the first few weeks after its opening. The old, dilapidated St George's Pier, which was purchased from its then owners, the North Western Railway Company, by the Pier Company for £1,250, was pulled down as part of the new pier contract, and the following December, John Dixon made available all its timbers and metalwork for auction. Tyler's Band was engaged to perform at the pier head and the seven uniformed bandsmen were 'playing selections which were happily chosen and artistically executed' during 1877/1878 (*North Wales Chronicle 3 August 1878*).

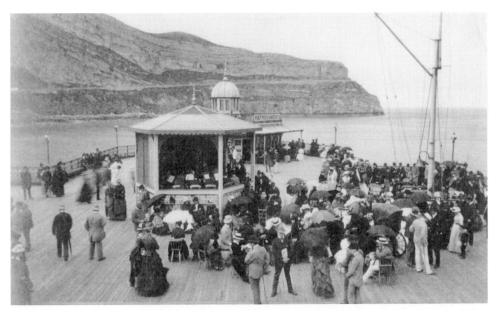

Listening to the band concert on Llandudno Pier in the 1880s. Beyond the bandstand is the refreshment kiosk, and in the background is the Great Orme. (Marlinova Collection)

A new pier order was gained in 1880 to extend the pier by 909 ft. Thus, the original (Bruff) plan for the pier was completed in 1884 when it was reverse-extended past the Grand Hotel to North Parade, taking its length to 2,295 ft (including the landing stage). An attractive 4,000-seat pier pavilion, designed by B. Nelson, was also added at the shore end of the extended pier. Construction on the building had commenced in 1881 but was then delayed after the original glass roof was blown off during a south-westerly gale on 26 January 1883. This caused considerable financial embarrassment to the Llandudno Pier Company, who dismissed their engineer and contractor. Messrs Handysides of Derby were induced to rectify and complete the building, which was eventually opened in September 1886. The main entrance into the pavilion was from the pier, although it could also be accessed from the rear via a balcony from Happy Valley. The length of the building was 204 ft and its width varied from 84 to 104 ft, and at one end the Egyptian Hall was placed, complete with hieroglyphics on its wall decorations. An ornate cast iron veranda ran along the seaward side of the building. The pavilion also originally sported Britain's largest indoor swimming pool in the basement. Its short life was beset with problems: the water was very cold, being sourced from the sea, but leaks in the floor meant that bitterly cold water from a spring beneath made the water even colder than the sea outside, and the council continually objected to the outfall pipe from the pool which sent water onto the foreshore and caused erosion. In 1889, the bath was divided into ladies' and gentlemen's sections to enable both groups to swim simultaneously. This improved the numbers of swimmers, but the other problems persisted, so the pool was filled in with rubble from the demolished Baths Hotel in 1900 and the space was later used as a cinema and then as an amusement arcade. The pavilion had more troubles; the glass roof made the pavilion cold and it leaked in wet weather, so during 1890, the glass was removed and replaced with zinc. Daily pierrot and orchestral performances were given from the hexagonal bandstand at the pier head. A spacious shelter was provided to give cover in poor weather, to audiences of up to 2,000 people. During the 1880s, a plan was drawn for an outdoor swimming bath, to be accessed from the pier via a metal gangway. The bath was to be a floating structure on the south-east side of the pier, supported by four long-legged towers, one at each corner of the 190 x 110-ft rectangular pool.

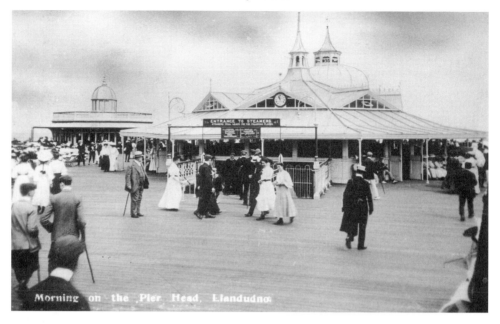

An Edwardian postcard captioned 'Morning on the Pier Head', which gives us a good view of the band pavilion and the entrance steps down to the landing stage for the steamers. (Marlinova Collection)

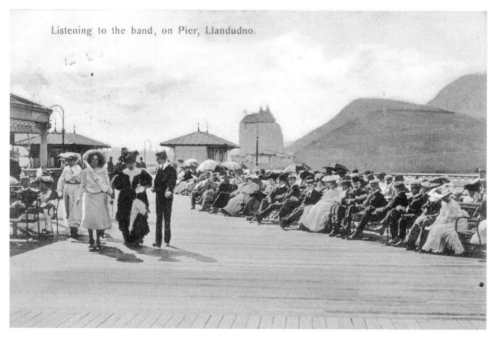

A popular summer rendezvous for visitors to Llandudno was listening to the band on the pier head, as seen on this postcard from *c.* 1907

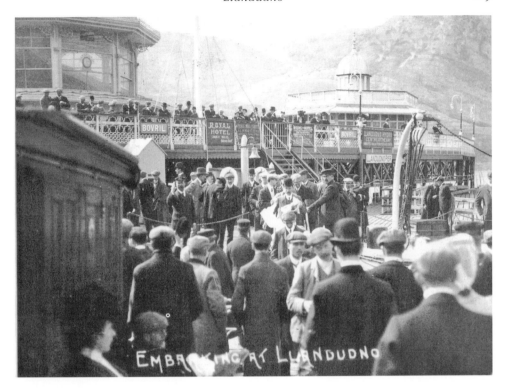

A fine photograph showing passengers embarking at the landing stage of Llandudno Pier during the Edwardian era. The pier offered regular steamer services to Liverpool, Blackpool, the Isle of Man and other resorts along the Welsh coast. (Marlinova Collection)

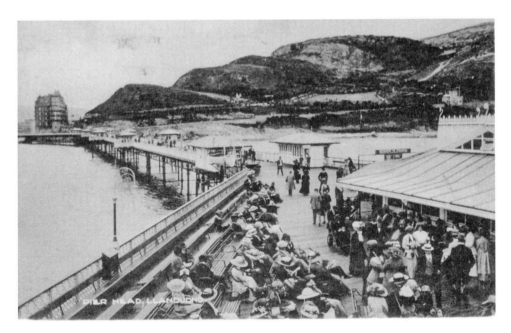

A view taken from one of the octagonal kiosks on the pier head looking back along the pier towards the Grand Hotel *c.* 1910. In addition to the band pavilion on the pier head, other improvements to the pier since it opened included additional kiosks added along its length. (Marlinova Collection)

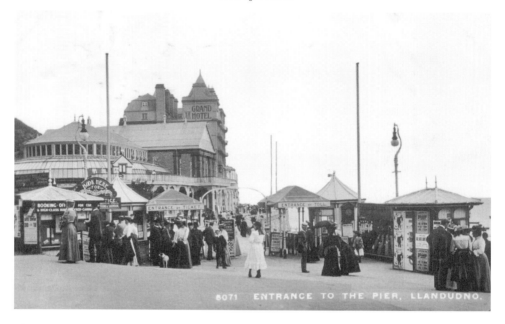

The North Parade entrance to Llandudno Pier with the Pier Pavilion and Grand Hotel seen
beyond, pictured in 1910. On the left can be seen the booking kiosks for the steamers and there
are separate entrances for ticket holders and toll players. (Marlinova Collection)

The plan, which was never implemented, is now at Conwy Archives; it was stamped by
the Board of Trade, 21 September 1887.

The Pier Company opted not to declare a dividend for the first twelve years, but revenue
increased steadily. During 1888, almost half a million people paid to enter the pier and the
steamers were increasingly busy. At that time, there was only space for one paddle steamer
at a time to land at the pier, and only in good weather. A proper landing stage was required.
The directors were also worried because there had been several fatal theatre fires in England
and overseas, and they began to envisage problems for their own pavilion should fire break
out. One factor making the building especially hazardous was the gas lighting. The Edison
Swan Company's tender of £1,116 for the installation of electric lighting was accepted; the
work was undertaken in stages and completed by the end of the century. The area around
the pier entrance was widened during the 1890s. The advice of James Brunlees was sought
on whether this could be achieved without hindering the use of the pier. A method of
inserting additional piles was devised enabling the deck width to be doubled whilst the pier
remained open. There were plans to widen the whole length of the pier, but, during the
1890s, the price of metals increased dramatically, putting the plan out of reach.

In July 1891, new plans were announced at a special meeting of the pier company. It
was proposed to build a theatre on land adjacent to the pier pavilion; the plot had already
been purchased and Midlands architect Daniel Arkell had been engaged to prepare plans
for a £7,500 structure suitable for theatrical and operatic performances. The pavilion was
considered unsuitable for these as it was too large. A moderately sized theatre would
provide a more intimate atmosphere and would be cheaper to heat. The meeting ended
with an overwhelming vote in favour of the project. Nine companies submitted tenders
for the contract to build the theatre, the lowest of which was just under £8,000. The Board
of Trade gave their approval, but the Llandudno Board of Commissioners refused to grant
permission. Initially, the council stated that their refusal was because of an entrance to the
building on the Parade. Eventually the matter went before the Queens Bench and the plan
was again refused because the Llandudno Pier Act did not give rights to construct a theatre.

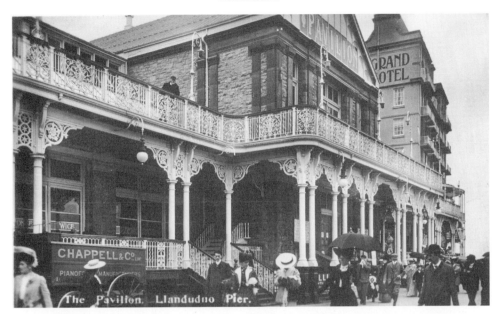

The splendid Llandudno Pier Pavilion photographed about 1910. The pavilion was opened
in September 1886 and originally featured the world's largest indoor swimming pool in the
basement. The wrought ironwork of the balcony railings and supports was particularly impressive.
(Marlinova Collection)

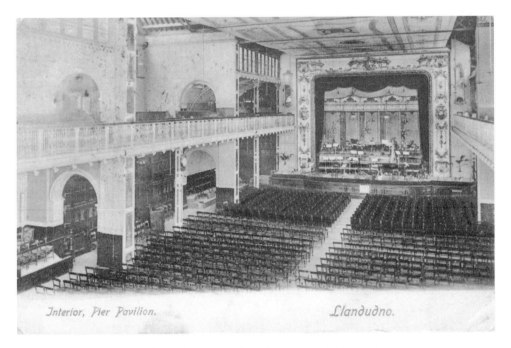

The interior of the Pier Pavilion, photographed in about 1903, which could seat up to 4,000 people
on the two levels provided. The building was 204 ft long with a width ranging from 84 ft to 104 ft.
(Marlinova Collection)

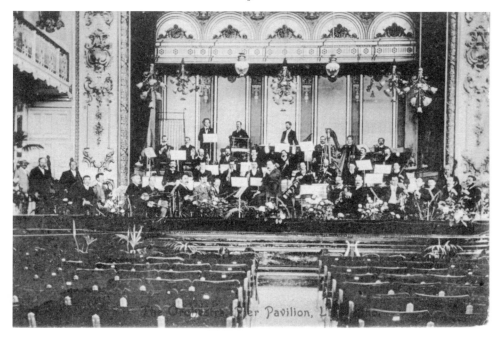

The Llandudno Pier Orchestra photographed inside the Pier Pavilion in 1905. They were
conducted by Arthur Payne and numbered between thirty-four and forty-four musicians.
(Marlinova Collection)

Dr Malcolm Sargent succeeded Arthur Payne as
conductor of the Llandudno Pier Orchestra in 1926
and brought in new blood to increase the size of
the orchestra. He stayed for only two seasons before
going on to greater glory. (Marlinova Collection)

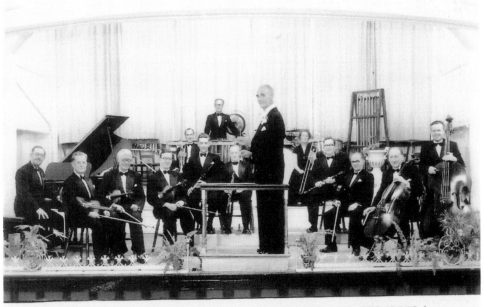

JOHN MORAVA AND THE LLANDUDNO PIER ORCHESTRA

The main orchestra in the Pier Pavilion was disbanded in 1936, but between 1938 and 1974 John Morava led a smaller orchestra in the Pier Head Pavilion. (Marlinova Collection)

A 1960s programme for John Morava and the Llandudno Pier Orchestra at the Pier Head Pavilion. They performed twice a day, at 11 a.m. and 7.45 p.m and consisted of fourteen musicians. (Marlinova Collection)

PIER HEAD
PAVILION
Llandudno

GENERAL MANAGER - T. TURNER PILLING

John Morava and

The Llandudno Pier
Orchestra

Leader:
GILBERT BOSLEY

PROGRAMME · PRICE SIXPENCE

If that was what the pier company wished to do, they would have to apply for a new Provisional Order. They had in fact sought legal advice before submitting their plans and were told that this was not thought necessary. The theatre was never built.

Paddle steamer excursions to Liverpool, Douglas and other resorts along the North Wales coast were a popular feature of the pier from the outset. From 1891, the ships of the Liverpool & North Wales Steamship Company brought thousands of visitors to the pier every year until the company's demise in the 1960s. The pier had acquired a new landing stage in 1891, which was rebuilt in 1904 and 1910, and divers such as Professor Beaumont sometimes entertained the crowd from it. During bad weather in January 1908, the derelict Irish schooner *William and Henry* dragged her anchor and crashed into the pier, taking out several piles at the seaward end. Crowds of people watched and waited, fearing a real disaster, but luckily the schooner travelled right under the pier, nudging several more of the piles, but causing little more damage. The directors inspected the structure and had an interview with the engineer, John James Webster, who declared the structure safe to use as a promenade and for use by steamers, despite the damage. The pier was insured and so was eventually repaired and refurbished.

The pavilion became renowned for the quality of music and other entertainment it provided. It had its own orchestra, which over the years was conducted by a number of well-known and flamboyant conductors. The first was Jules Rivière, who came to Llandudno in 1887. Rivière was born in France in 1819 and became a violinist and bassoonist in the 12th Regiment of Light Infantry before he rose to become the conductor of an eighty-piece orchestra based in the Champs-Elysées. In 1857, Rivière came to England and established himself as a music publisher in partnership with a gentleman named Hawkes, later part of the well-known music publishers Boosey & Hawkes. Rivière himself composed a number of polkas and operettas. In 1871, he formed an eighty-piece orchestra to play promenade concerts, which also had a chorus of forty voices and a forty-strong military band. Following a successful season at Covent Garden in 1874, Rivière took his orchestra on a nationwide tour, and four years later they performed four grand orchestral concerts at the Westminster Aquarium. However, his promenade concerts at the Queens Theatre the same year were a financial failure and the orchestra was disbanded, enabling Rivière to become conductor of the Blackpool Winter Gardens Orchestra in 1881.

When Rivière took over the Llandudno Pier Orchestra in 1887, it numbered twenty-eight instrumentalists, who could not all fit into the open-air octagonal bandstand on the pier head. Rivière proposed that the orchestra should perform inside the pier pavilion and got his way in spite of the reluctance of the pier directors, who thought audiences would not want to be shut indoors on fine summer's evenings. The concerts in the pavilion proved to be a great success and the orchestra flourished. Rivière became an honoured citizen of the town and was presented with an inscribed silver punch bowl and ladle. The conductor's showmanship was described by Henry Wood (who fashioned his own flamboyance on Rivière's) in his autobiography *My life in Music*. He wrote,

As I took my seat, I saw an elderly gentleman seated in a gilded armchair, facing the audience. He was elegantly dressed in a velvet jacket on the lapel of which reposed a huge spray of orchids more fitted for a woman's corsage (Rivière had so many floral offerings from his admirers his coat had a special collar to hold at least twenty button holes). He held a bejewelled ivory baton in his hand from which dangled a massive blue tassel (handed to him on a silver salver by a uniformed and beribboned commissionaire wearing white gloves). This he wound round his wrist. He bowed ceremoniously to the audience and tapped loudly on his golden music stand. Still seated (and still facing the audience), he began his overture to 'Mignon'.

After numerous disagreements about the length of the season, Rivière, who was rather a prickly character, fell out with the directors of the Llandudno Pier Company in 1893 and

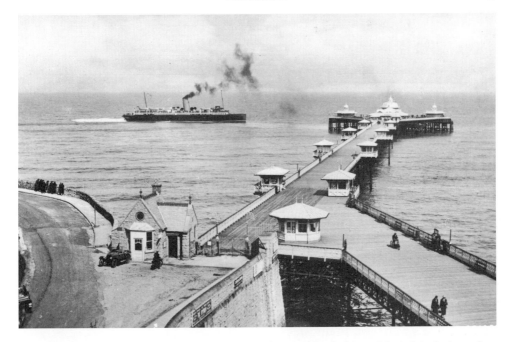

The *St Tudno* approaches Llandudno Pier in the mid-1930s. The decking of the original pier and the extension are clearly differentiated. (Campbell McCutcheon)

left to form a company to build his own 'Rivière's Concert Hall'. This was opened as the Victoria Palace in 1894, and in the company's original plans, a pier was also proposed (see 'The Piers That Never Were' chapter). Rivière ended his association with Llandudno in 1900 when he left to conduct the orchestra in the new pier pavilion at Colwyn Bay, which had emblazoned across its frontage the name of its prestigious conductor. Unfortunately, Rivière died at Christmas, 1900, but his name remained on the Colwyn Bay Pier Pavilion until it was burnt down in 1922.

There were ambitious plans during the early years of the twentieth century to widen the pier. Problems arose when late passengers were rushing down the pier to catch steamers and a queue of concert-goers was crowded around the pavilion awaiting entry for a concert. The two parties frequently became entangled and upset. The council, local boatmen and members of the public opposed the scheme, fearing that the shingle and sand of the beach would be destroyed. However, the pier company promised this would not be the case as their engineers had devised a cantilever system, whereby the deck would be widened without the need for further supports. The scheme did not go ahead because of lack of finance. However, the rather plain, octagonal bandstand on the pier head was replaced by an ornate band pavilion with decorative awning.

Llandudno Pier was targeted by Suffragettes on the eve of the outbreak of the First World War. There was an attempt to set the pier alight, which was fortunately unsuccessful. This was their last act of defiance; once the war had begun, the organisation called a halt to their unlawful activities and supported the war effort.

Gwyllym Crowe had succeeded Rivière and was soon followed by Arthur Payne, during whose time the orchestra size varied from thirty-four to forty-four. Payne gained an enormous following in the town and when it was announced, at the end of the 1925 season, that he was to be replaced, locals raised £1,200 as a testimonial to him. Payne was replaced by Dr Malcolm Sargent, who soon caused some ill-feeling by getting rid of some of the old stalwarts in the thirty-four-piece orchestra and replacing them with younger

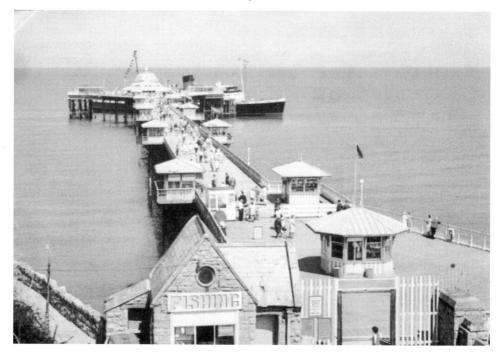

The Isle of Man steamer calls at Llandudno Pier in the early 1970s. A new landing stage had been provided for the service in 1969. Note the barrier across the pier before the first pair of kiosks. (Marlinova Collection)

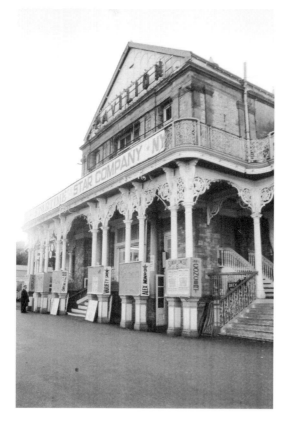

Llandudno Pier Pavilion in 1975 when *Startime* was that season's show. The summer shows ended there in 1984 and sadly this lovely building was destroyed by fire ten years later. (Marlinova Collection)

A photograph taken in March 2010 showing one of Llandudno Pier's pretty kiosks selling Welsh gifts and crafts. (Marlinova Collection)

players, increasing the strength of the orchestra to forty-two. He also scrapped the sacred morning programmes in favour of Beethoven symphonies, which led to protest meetings and a torch procession up and down the Great Orme. However, Sargent soon won over the doubters with the quality of his musicianship, but stayed at Llandudno for only two seasons. Concerts were held at the pier head building each morning at 11, and then in the pavilion at 8 p.m. Horace Fellows, who also conducted the Scottish Orchestra, was the Deputy Conductor under Sargent. Accomplished musicians were often invited to the play with the orchestra: such as at Easter 1927 when the distinguished Russian violinist Lena Kontorovitch appeared as a special attraction. (Sargent was knighted in 1947 for his services to British music.) George Cathie was the final conductor of the Llandudno Pier Orchestra; he had continued the flamboyancy of the orchestra's conductors by having thick, flowing hair and wearing a black sombrero and scarlet-lined black cloak off stage. The orchestra disbanded in 1936 when the pavilion sought to put on variety shows instead.

A number of well-known variety stars appeared in the pier pavilion from the 1930s, including Arthur Askey, Clarkson Rose, George Formby, Ted Ray and the Beverley Sisters. The venue was also used for political rallies and party conferences. Almost every politician of note spoke there, including David Lloyd George, Ramsay McDonald, Oswald Moseley, Stanley Baldwin, Neville Chamberlain, Winston Churchill, Clement Atlee, Anthony Eden, Harold MacMillan, Edward Heath and Margaret Thatcher. During the Second World War, the pier was used for Home Guard training.

The pier head bandstand provided light musical entertainment, military bands and pierrot shows before becoming the home of John Morava and his Orchestra between 1938 and 1974.

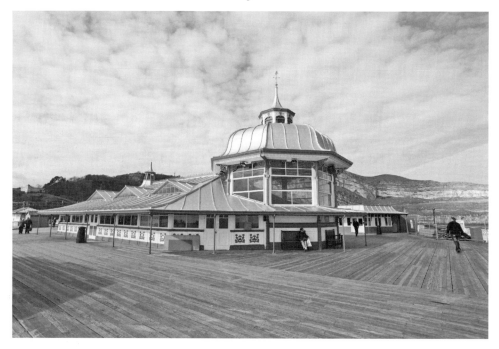

The splendid Pier Head Pavilion on Llandudno Pier, now an amusement arcade, photographed in March 2010. (Steve Thomas)

The old landing stage was replaced in 1947 by a new three-deck landing stage. This had greenheart piles with two berths to enable a minimum depth of ten feet of water at low tide.

In 1948, Margaret Thatcher attended her first political conference in the pier pavilion and was inspired there to embark on a career in politics. In the 1950s, shows at the pavilion took on a lighter note. Norman Evans and his Laughter Show were a popular attraction in the pavilion in the 1950s and Mike and Bernie Winters were the star acts of the 1955 season. Russ Conway was the main attraction in Big Night Out, also featuring Bill Maynard, and Cyril Fletcher presented the musical Magpie Masquerade. The pier's other attractions in the 1950s and 1960s included speedboat rides from the pier head and the amusements under the pavilion (which featured shooting, hoop-la and a scoota-car track).

In 1968, the pier was acquired by Trust House Forte, who provided a new concrete and steel landing stage for the Isle of Man service the following year. Amongst the first users of the new landing stage were Prince Charles and Princess Anne when the Royal Yacht *Britannia* anchored in the bay on 2 July 1969 just prior to the Investiture of Prince Charles at Caernarfon.

During refurbishments in 1969 in the basement of the pavilion, a ghost train ride was being erected in the former swimming baths. These works revealed a previously forgotten plaque commemorating the construction of the pier. It read:

<div align="center">

Engineers:
James Brunlees, C.E.,
Alexander MacKerrow, C.E.,
Resident: H Neal C.E.
1878
John Dixon, C.E., London
Contractor

</div>

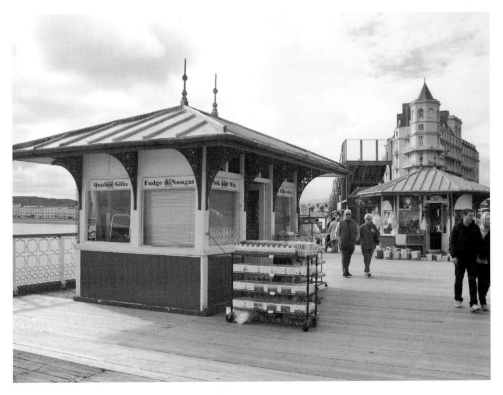

Llandudno Pier in March 2010 featuring two of the attractive kiosks selling traditional seaside confectionary and gifts. Beyond can be seen the Grand Hotel. (Marlinova Collection)

The Golden Gate amusement arcade was added at the shore end of the pier in 1981. This signalled the end of the summer shows in the pavilion, which ceased in 1984. The building was refurbished and used as a horror waxworks and amusement arcade until 1990, when it became empty and dilapidated. In January 1992, the pavilion passed to the London-based Launch Sign Limited, who aimed to restore it. However, on 13 February 1994, the building was sadly ravaged by fire, leaving just the wrought iron supports standing. The site remains undeveloped and is an eyesore.

The pier is currently owned by Six Piers Limited and still retains its very elegant Victorian appearance with its uncluttered deck and attractive octagonal kiosks with their overhanging eaves, housing gifts and refreshments. This has led to the pier being used for Victorian period television programmes and films. The amusements on the pier are all based at the shore end. The pier's landing stage is currently out of use, having been declared unsafe. The pier won the coveted National Piers Society's 'Pier of the Year' Award in 2005.

RHOS-ON-SEA/
LLANDRILLO-YN-RHOS

Rhos-on-Sea Pier has for many years been disregarded in books on the history of our piers, as it has been thought to have been purchased second hand from Douglas, Isle of Man. This has been the established view since 1952 when F. C. Thornley in his book *Past and Present Steamers of North Wales* first made this claim. Despite extensive research, no evidence has been found from either the Isle of Man or North Wales sources to support this.

The idea for a pier in the locality was mooted in the 1860s and was referred to as Llandrillo-yn-Rhos Pier, named after its ancient parish church. The area near to the proposed site was then in Caernarvonshire and boasted just a handful of buildings; it had no name of its own. In fact, it was well into the first decade of the twentieth century before the name Rhos-on-Sea was officially accepted. An Act of Parliament (the Llandrillo-yn-Rhos Pier Act 5 July 1865) gave permission for the erection of a landing pier for use by passenger steamers from Liverpool and other growing resorts on the coast of North Wales. However, for unknown reasons, the date for completion of the pier passed and the idea faded for almost thirty years (see the chapter 'Piers That Never Were').

In 1891, John Merryweather Porter, a Colwyn Bay surveyor, was engaged by William Bostock, a local resident, to speak to John Lewis Parry Evans offering to purchase Rhos Fynach Farm. William Bostock was head of the consortium of businessmen whose intention was to develop a resort at Llandrillo-yn-Rhos. As Llandrillo-yn-Rhos was such a long name and there was no other name back in 1891, the consortium named their company, rather confusingly, the Colwyn Bay Pier Company Limited (the Victoria Pier at Colwyn Bay did not then exist). Shares were issued and a board of directors, most of whom were family members or close acquaintances, was formed. Rhos Fynach Farm was purchased, plans were drawn by H. Thorndyke Percival, of Liverpool, and the Colwyn Bay Pier Act was passed on 20 May 1892. In March the following year, a contract was signed with London-based contractor Alfred Thorne for the construction of the pier. The foundation stones were laid two months later, in May 1893. The original architectural plans for the pier had been approved in 1892 for the Act, but were subsequently replaced when small changes were made a year later. These later plans, now in a very fragile condition, are held at Conwy Archives (*Marine Plans Ref 6369*) and appear to show the pier exactly as the one which was built. At this time, the Iron Pier at Douglas was still standing in Douglas Bay. Rhos-on-Sea pier was well underway by the time the Iron Pier was demolished and its structural parts were offered for sale as scrap in March 1894. A contemporary newspaper report of June 1894 indicated that Rhos Pier would be opened as a promenade the following month. This didn't happen and work was still progressing when winter began.

Trouble was brewing for the structure. William Bostock's sugar refinery, at Garston, Liverpool, suffered an explosion in October 1894, which resulted in fatalities. This inevitably distracted Bostock's attention and money began to run out. His health suffered and he suddenly died in February 1895, aged only fifty-five. The pier was still unfinished, so the new pier company chairman, W. D. Houghton, agreed to pay Alfred Thorne a small sum of money there and then and to pay the remainder which was owed with 150

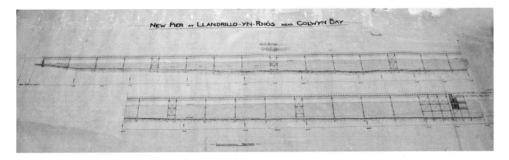

The plans for the pier at Rhos-on-Sea were drawn by Henry Thorndyke Percival. These plans, dated 1893, replaced a set drawn a year earlier. These show the pier as built. (Conwy Archives)

preference shares. Thorne was given a short date for completion and the promise of a mortgage on the pier should further costs incur. A mortgage for the sum of £2,171 was subsequently agreed.

The news of the pier's opening was at last announced, in the *Weekly News and Visitors Chronicle* 5 April 1895: 'The new pier at Rhos-on-Sea is to be opened for promenade purposes during the Easter holidays. The pier, which starts from a point near the ancient fishing weir at Rhos, is a substantial structure of iron about 1,400 feet long, and the cost of construction has exceeded £10,000.'

Although opened for visitors to promenade on Thursday 11 April 1895 for the Easter weekend, the pier was incomplete (it was lacking the landing stage for shipping use) and thus had not yet complied with the Board of Trade regulations. The opening was attended by small numbers of people, the busiest day being Good Friday, when over 600 passed through the turnstiles. The only entertainment was on the Saturday when a band of the Royal Welch Fusiliers played at the pier head. On 19 April 1895, the *Weekly News and Visitors Chronicle* reported,

The new seaside resort, Rhos-on-Sea, has commenced a new era this Eastertide, in the providing for the reception of her visitors, in the opening of the new pier for promenading, etc. ... How delightful it is to promenade over the sea, and witness the grandeur of the picturesque scenery all around, – the coastline along from the Little Orme's Head to Rhyl, Colwyn Bay looking gloriously bright with its background of dark foliage of every hue, the lime-quarries ... adding to the attractiveness of the scenery. Then looking inland, we have in view the Ancient Church of St Trillo, Bryn Euryn, the Caernarvonshire mountains, and the Snowdonian Range, the sun shining bright on Bryn Euryn. Further on, are seen the snow-capped peaks of Carnedd Llewelyn and Moel Siabod.

From the very first day, demands were made that their pier company should further extend the 1,400-ft pier by another 700 ft or so to enable steamers to call at all states of the tide. The pier company was in no financial position to do this. When the pier had been opened, the area surrounding the entrance was a muddy mess, yet to be developed. A short time afterwards, local contractors were invited to tender for its drainage and surfacing. However, the company which was awarded the contract was not paid. Many of the pier company's assets were put up for auction in the months following the opening, but little cash was raised. Their bankers wanted their money, as no interest was being paid and so, by Easter 1896, the bank had put the pier and the pier company's remaining acreage up for auction and much of the land in the district owned by the late William Bostock, was also for sale. The majority, including the pier, was sold by the Colwyn Bay Pier Company to William Horton, a Midlands solicitor, who had first visited the area a short time previously for the benefit of his health.

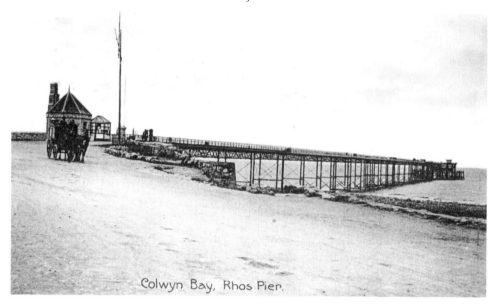

Colwyn Bay, Rhos Pier.

The entrance to Rhos Pier. In the photograph, the landing stage is present and the shelters are located at the seaward end of the pier; the booking office for use by shipping companies is also in position. These date the postcard to between 1900 and 1910. (DPT collection)

William Horton had grand plans for finishing the pier and developing a high-class residential and holiday resort. He acquired a house in the district and set about the laying out of his residential estate. At this time, the Rhos Abbey Hotel, which was situated adjacent to the pier, began advertising in the local newspaper. Amongst its attractions for visitors was listed its position: 'facing the Iron Pier'. This may have been what started the belief that the pier was in fact the old pier from Douglas, which was known as the 'Iron Pier'.

The reduced Colwyn Bay Pier Company was forced into liquidation in the summer of 1896. It was to be the start of a prolonged series of court cases and problems that dogged the pier's new owner for the following fifteen years. The winding up process saw the former directors seeking the return of their money and questioning the validity of William Horton's purchase of the pier. The pier company was eventually wound up and it was ordered by the liquidator that all papers relating to it (apart from the winding up statement) should be destroyed. The name John Caister Dixon appears in a margin of the statement and may have given rise to the belief that John Dixon, the original contractor of the Iron Pier, Douglas, in 1869, dismantled and rebuilt the Iron Pier at Rhos. (The Dixon connection was first made by Simon Adamson in his book *Seaside Piers* in 1977 and reinforced by Cyril Bainbridge in 1986 in his book *Pavilions on the Sea*.) This was impossible: the Douglas Iron Pier was blown up with 'potentite', the parts sold for scrap, and John Dixon had died in 1891. John Caister Dixon was the liquidator.

Eventually, William Horton's purchase of the pier was confirmed and he gained consent to extend the pier and to add a landing stage. In November of Queen Victoria's Diamond Jubilee year (1897), Colwyn Bay announced its intention to build a pier of its own just over a mile along the coast from Rhos. This was to be named the Victoria Pier and was subsequently carefully referred to as such; William Horton's pier was from then on named Rhos (or Rhos-on-Sea) Pier. The Victoria Pier was designed to create an entertainments venue for the town and was never intended to be used by steamboats, even though some thought this highly desirable. The two piers were thus not really in competition with one another.

The new century saw the inauguration of steamboat services from Rhos Pier. The first was the *St Trillo*, a 240-ft paddle steamer capable of carrying 1,000 passengers. In August 1900, William Horton threw a grand party for Liverpool business people to announce the formation of his Rhos-Colwyn Steamship Company. They sailed to Rhos on the *Heather Bell* and were entertained for lunch at William Horton's new Rhos Abbey Hotel (adjacent to the old hotel of that name, and even closer to the pier). In the following year, the Liverpool & North Wales Steamship Company extended its services to include calls at Rhos Pier. Most of the trips westward commenced at Rhos, either picking up passengers at Llandudno, or Rhos passengers transferred to larger boats there and sailed on into the Menai Straits for trips around Anglesey or to Beaumaris, Bangor, Menai Bridge and Caernarfon.

William Horton's move into shipping brought him further troubles. He was constantly in court over non-payment of bills or squabbles over contracts. However, 1901 saw the final completion of works to the pier. He established a new company in May 1903 – this was the Colwyn Bay & Liverpool Steamship Company, set up to 'acquire vessels and boats of every description ... in the conveyance of passengers, mails, merchandise and goods to and from Colwyn Bay and Liverpool or any other part of the United Kingdom'. William Horton was again at the helm. Two mortgages were secured for the purchase of boats. The first was the *Rhos Colwyn*, the company's flagship, acquired for the 1903 season. She was just four years old and was the subject of great pride. A host of promotional material was issued, including a colour postcard, poster, guidebook and handbills. The ship was to carry its passengers in first-class hotel style, in quiet comfort. Destinations of trips included all of those mentioned above, plus Blackpool, Douglas, Isle of Man, Bardsay Island, Bull Bay and Chester. Ever keen to save money, William Horton sought cheap methods of advertising his trips, which altered at intervals to allow for changes in tides. He sprang upon the idea of using handbills. These were hung on strings and placed in shops and hung on trees and lamp-posts throughout the district. This led to a nasty argument with the Colwyn Bay District Council, which objected to having to clear up the resultant rubbish. A farce ensued with Horton's employees trying to outwit council workers by hanging the bills in bizarre locations and in the properties of 'sympathisers'. The latter was soon brought to an end when the council warned that it would increase the rates of any properties displaying the steamship company's handbills. After almost a year, it all eventually ended in the courts – each side backed down and agreed to pay its own costs.

The second mortgage was for the purchase of the *Prince Leopold*, an older paddle steamer, whose name was soon changed to *Rhos Neigr* to fit in with the North Wales 'fleet'.

In 1905, after all the troubles, William Horton sold his steamships. A new company was formed, the following year, the Mersey Trading Company, with a new set of shareholders and management. It had bought the *Rhos Neigr* and purchased two new vessels. The first was to be named the *Rhos Colwyn* (2), and the second the *Rhos Trevor*. Services began during the 1905 season alongside the sailings of the Liverpool & North Wales Steamship Company (L&NWSSCo). Trouble wasn't long in coming once again.

Early in 1907, the L&NWSSCo took William Horton and the Mersey Trading Company to court in response to repeated rises in tolls to the former company for the use of the pier for mooring and the landing and embarking of passengers. Charges had increased annually and the company felt that favouritism was shown to the Mersey Trading Company when it was granted a lease on the pier in 1907. They went as far as to suggest that this company was a dummy and that William Horton was running it behind the scenes. A very lengthy battle ensued. In the meantime the L&NWSSCo's passengers were advised to run the length of Rhos Pier in an attempt to avoid paying the landing fee. Sections of the pier were roped off to make avoidance difficult; it was all rather ugly. William Horton eventually lost the case, but in the process, even more problems came to light.

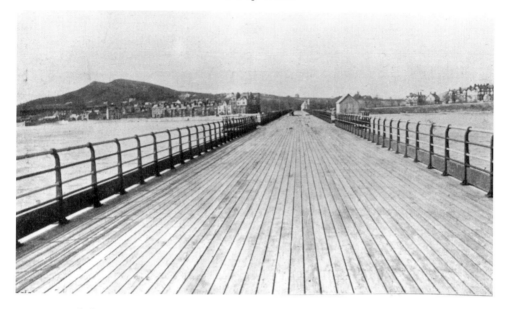

Most postcard photographs of this pier were taken from the land. This shows almost the entire length, from the seaward end. It was taken before the steamship booking office was added *c.* 1906, by local photographer and publisher J. W. Thomas of Colwyn Bay. (DPT collection)

STEAMSHIP SERVICE FROM RHOS PIER AND NEW BRIGHTON Friday June 19th Special Sea Excursion to New Brighton for Tower Grounds, Wild West Show, Scenic Railway, &c. Leaves Llandudno 10am, leaves Rhos Pier 10.30 Arrive New Brighton 1.0pm, Leave New Brighton 3.30pm Arrive Rhos Pier 6.0pm Arrive Llandudno 6.30pm. Return fares 2/6; first saloon 1/- extra

Mersey Trading Company advertisement
Weekly News and Visitors' Chronicle, 19 June 1908.

The L&NWSSCo called into question the status of the pier itself. They claimed that it was an illegal structure on which neither William Horton nor the Mersey Trading Company had any right to charge tolls at all. There is a large archive of papers concerning the case at the National Archives, Kew; local and national newspapers carried full reports.

There was a problem over the completion date of the pier. William Bostock's early death and the original pier company's money problems had resulted in the pier not being completed to the 1893 design – the landing stage had not been built. A completion date, five years from the date of the Act in 1892, passed during the first year of William Horton's ownership and the pier was not completed until around 1900. This meant the pier was never awarded the Board of Trade certificate which would have allowed tolls to be collected. As a result, the pier was indeed an unauthorised structure and *The Times* on 5 June 1908 reported that it was found by the High Court to be a 'public mischief'.

Another problem was even more serious. The original plans marked out the position of the proposed pier, and allowed on either side of its width, limits of deviation. Unfortunately, most of the pier was found to be outside these limits. Only about 80 ft at

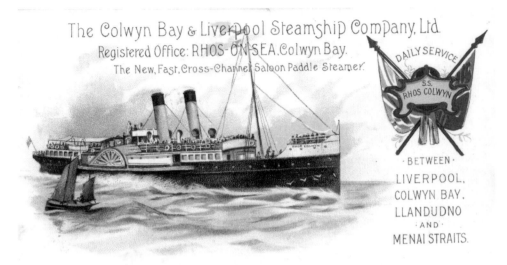

The SS *Rhos Colwyn* (1) was the Colwyn Bay & Liverpool Steamship Company's flagship. She provided hotel-class service on her trips between Liverpool and the North Wales coast. This is now a rare postcard because the *Rhos Colwyn* (1) was only based at Rhos Pier for a short time. (DPT collection)

The Colwyn Bay & Liverpool Steamship Company issued this poster advertising their sailings from Rhos Pier. The top half of the poster shows the relaxed atmosphere aboard the *Rhos Colwyn* (1); below is an image of a wonderfully calm day at Rhos and a map of the many excursion trips on offer. (Denbighshire Record Office)

the landward end of the pier was within the lines, the seaward end being 400 ft outside. William Horton's survey confirmed this. There was never any mention that the pier was not the structure shown on the plans (or that it was a second-hand pier from Douglas). One can be sure that if that had been the case, it would not have escaped the notice of the opposing barristers.

In the midst of the court case, the Mersey Trading Company's *Rhos Neigr* was wrecked just off Rhos Pier in July 1908. Luckily, no lives were lost and rescue was quickly enabled by men and boats from the *Rhos Trevor*, which was moored at the pier at the time. It was hoped that the vessel could be saved; all items of value were removed and plans were made to have her towed to the Mersey for repairs. The Board of Trade enquiry into the accident was held in Caernarfon the following September. The steamer was deemed to have been in good condition with adequate lifebuoys, lifebelts and lifeboats aboard. Divers had found an 18-ft gash in the ship's side, but could not confirm what had caused the damage. No issues of malpractice were found. Before arrangements had been made to remove the ship, the tides took control and she sank. The wreck was visible at low tides for almost 100 years, until Trinity House had it broken up further. Its remains are now marked with a green buoy.

The Mersey Trading Company was already in financial difficulties and was fined in October 1908 for overcrowding the *Rhos Trevor*. Its managing director had moved to Mexico and was able to offer little support. Its remaining ships were sold, the *Rhos Colwyn* (2) to Walter Hawthorne of Rhyl and the *Rhos Trevor* eventually became part of the L&NWSSCo fleet, afterwards, bearing the name *St Trillo* (1). The company was subsequently wound up.

Towards the end of 1908, the L&NWSSCo v Horton case at last came to a conclusion. It was judged in favour of William Horton. This enabled him at last to make plans for the future. His pier was unauthorised and it was in the wrong place, but a new Act of Parliament could put all of that right. He announced ambitious plans in December 1908, to add a pavilion capable of seating 3,000 people, a seawater bath 250 ft long, from six to three feet in depth, and much needed Turkish baths.

The relationship between William Horton and the L&NWSSCo settled down and the pier was well patronised. The only way William Horton could rectify his problems with the pier was to have a new Act of Parliament. The cost of achieving this was approximately double the cost of constructing the original structure. Not only were there costs to bring the Act to Parliament, a host of paperwork had to be found and copied, multiple copies of accurate drawings of the existing structure were required, plus multiple copies of plans for the redevelopments. The latter have survived, drawn by local engineer J. L. Owen. These show the position of the pier outside its sanctioned limits and the intention to massively increase the landward width of the pier to accommodate a later pavilion. There was to be a semi-circular Marine Bath on the south side of the pier and an additional 200-yard length of deck allowing access to deeper water for shipping. The Rhos-on-Sea Pier Act is dated 29 June 1911; that this was the first pier Act with the name of 'Rhos-on-Sea' has caused confusion over the years.

It should have been all systems go for William Horton, having got all of his problems sorted after fifteen years, but, unfortunately, this was not the case. The pier was having its busiest times, there is no doubt. But there were no new developments. Once again, William Horton's plans were thwarted, this time by the government. The Liberal party's recently enacted old age pensions had to be paid for, so taxes on the wealthy were greatly increased. This reduced the cash available for investment, so entrepreneurs countrywide looked for a guaranteed return on their money. Piers were a notoriously risky businesses so insufficient funds were available. Instead, William Horton collected his tolls legally for the first time, and built just a small landing jetty parallel with his pier on the south side. This was ready for the 1914 season. But once again, trouble was looming; in the first week of August, Britain declared war after Germany had invaded Belgium. Life was put on hold; Rhos would never be the same again.

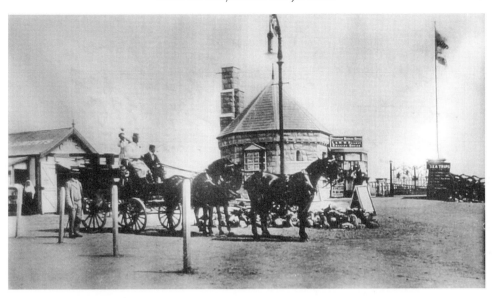

Pre-First World War postcard showing the entrance to Rhos Pier after the addition of the tearoom and amusements hut. If tickets for steamships were booked in advance, a carriage would collect passengers from their hotel and take them to the pier. Once the electric tramway was operating, this service ceased and passengers were advised to leave the tram at the pier stop on the promenade. (DPT collection)

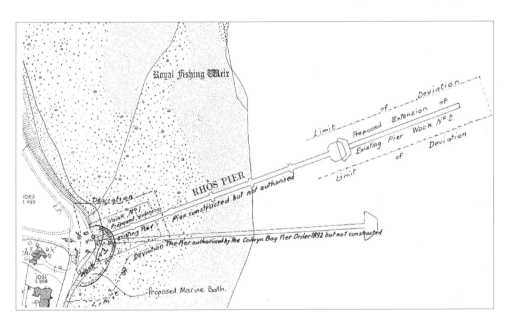

William Horton had plans drawn of his proposed improvements to the pier in 1911. These were to be lengthening of the structure, widening of the landward end to provide space for a pavilion and a marine bath under and to the south of the pier for swimming. The map shows the new works and the extent of the deviation from the approved lines during the pier's 1890s construction. (NA LRR01/3452 114063)

STEAMERS - LIVERPOOL AND NORTH WALES
Daily Sailings from Llandudno and Rhos Piers.
Week ending 27th July 1912
PS La Marguerite (Fitted with wireless telegraphy) daily at 1pm
for Menai Straits and 5.15pm for Liverpool.
Sunday 21st July at 1.30pm PS St Elian for Rhyl (2 hours ashore)
At 3pm PS St Elvies for Menai Straits (not to land)
At 3.30pm PS St Trillo for Beaumaris Bay (not to land)
PS St Tudno at 11.30am on Monday round Anglesey
PS St Tudno at 10.20am on Wednesday round Anglesey and Bardsey Island
PS St Elvies at 8am on Monday and 9.30am on Friday
and 10am on Saturday to Liverpool and back
At 10am on Tuesday and Thursday to Douglas, Isle of Man & back.
PS Snowdon each weekday at 11am for Menai Straits and Carnarvon.
Every day (Sunday excepted) at 11.15am towards Rhyl.
Every day (Sunday included) at 3pm for Menai Straits.
Frequent sailing to and from Rhos Pier (Colwyn Bay) also Rhyl. *Steamer or car
connection for all sailings leaves Rhos Pier (Colwyn Bay) 40 minutes earlier.
NB These sailings are subject to weather & other circumstances permitting.
For particulars apply to Arthur Parton, North Wales Agent, Pier Gates,
Llandudno (Tel 141); or GW Ashton, Iron Shop, Colwyn Bay (Tel 171),
or Rhos Pier (Tel 126)

Liverpool & North Wales Steamship Company advertisement 1912.

The majority of the steamships were requisitioned for military use as soon as war began. The *Snowdon* remained on the coast until the end of the 1915 season and the *St Trillo* worked throughout the season of 1916 before being requisitioned as a minesweeper. At Rhos, the pier was put into service by the coastguard service, but sailings were allowed to continue. The shortage of manpower resulted in a very low level of maintenance. It was the custom to remove the deck of the landing stage when the season was over to reduce the possibility of the stage being tossed about by the action of winter storm waves beneath it. As the war dragged on, manpower was in such short supply that the decking had remained in position. On a wild January day in 1917, a very high tide, coupled with gale-force winds, lifted the landing stage and detached it from the pier. It was wrecked on the beach later in the day. A shortage of finance meant the structure was not replaced and so the steamers never again called at the pier. It was the steamships that had brought the pier to life and without them the pier fell into a cycle of ever-decreasing popularity with revenues spiralling downwards.

The visitors returned to the seaside for their holidays after the war, but subtle changes affected the pattern of holiday-making. During the 1920s, more and more visitors travelled by car and stayed at each location for shorter periods. Gone were the days when families booked an apartment house for a month, or even for a whole season. Excursion trains continued to carry full complements of passengers once the railways got back to normal, but holiday accommodation at Rhos had been mostly provided by the apartment houses. The war and the Depression of the 1920s also took their toll on the recreational development of Rhos. The focus shifted more sharply towards residential development. The pier was leased to others during the 1920s and at least one of the lessees had plans for developments. The Colwyn Bay Council was tempted to purchase the pier from about 1927 when William Horton offered it for sale. A price was fixed at £8,000 for the pier,

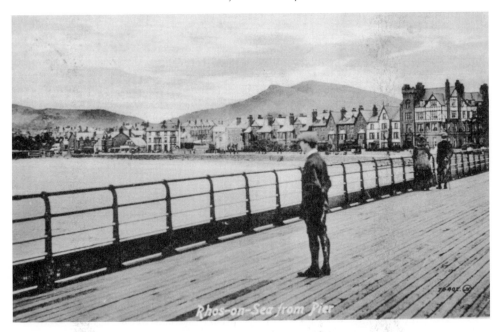

Rhos-on-Sea from the Pier. The pier was lacking in amenities, fixed seating was sparse, although deck chairs could be hired from the Pier Master. There was no fixed lighting, no electricity and no water supply. The fashions on display indicate an early-twentieth-century date, but the number of buildings in the distance suggests a date nearer to 1920. (DPT collection)

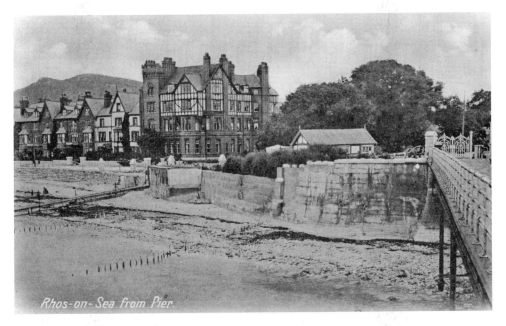

There are many postcards with views of Rhos taken from the pier, but few show details of the pier itself. This postcard shows the entrance turnstile, a section of the plain railings and the handsome gates. Limestone was used extensively in walling and gateposts as well as for the pier toll house. (DPT collection)

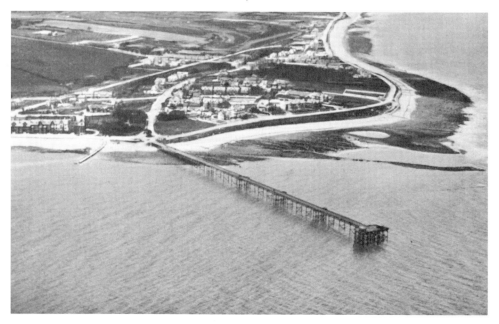

Rhos-on-Sea from the air. This photograph was taken around 1920. The pier lost its landing stage during a storm in January 1917. The total absence of any amenities on the pier, apart from two shelters, can be clearly seen. William Horton had built the small jetty south of the pier in 1914 for the benefit of small boats. Rhos was still very rural at this time. (DPT collection)

the Royal Fishing Weir, St Trillo's Chapel, the Marine Drive and a plot of land. The price seemed too high and so the District Valuer, Caernarfon-based David Evans, was called in.

The report he produced for the council contained a brief history of the pier, making no mention of any Douglas connection. He gave, for the first time, the pier's actual measurements and details of its construction:

The pier is [now] approximately 1,300 feet long by 21'3" wide between railings. There are ten side bays, each 14'6" x 9'0" and the head of the pier is 88'2" x 52'6" having two shelters at the end, 18'6" x 8'9". The depth from decking to beach at the landward end is 16 feet and at the seaward end 45'6". The main piles are ten inch hollow cast iron in pairs 18 feet apart and are braced with 1½ inch round iron and cross joists. These are spaced 50 feet apart with an additional pair under the five sets of bays; the cross joists being carried on lattice girders 4'8" deep. The timber decking rests upon bearers supported by 7" x 4" joists with 4'2" centres. At the entrance to the pier there is an octagonal limestone building 18' wide, together with a Booking Office with turnstile, small refreshment room, Store-room, and a Hut, all the latter being constructed of timber with galvanised iron roof. [These measurements and materials do not match up with those for Douglas.]

The District Valuer estimated that a considerable sum of money would be required in order to get the pier back up to standard and to replace the landing stage, which was considered essential if the pier was ever to break even. He sought the accounts for the pier when the steamships were calling at the pier and was informed by William Horton that

when the pier was in full working order the takings amounted to about £1,000 a year, as shown by the following particulars: The tolls were fixed at half the usual amounts – that is to say 1 ½d for landing passengers and 1d for promenaders. During the 1911 season the Liverpool and

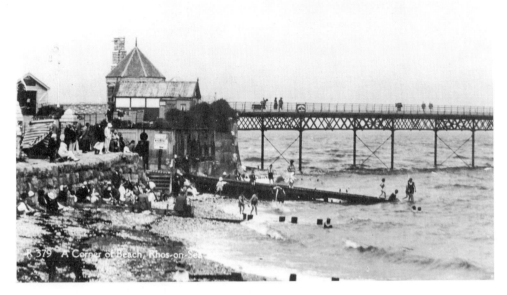

A corner of beach, Rhos-on-Sea. Deckchairs could be hired from the Pier Master, although none are evident in this shot. The sign board was to warn bathers not to swim between the pier and the jetty, as several swimmers had drowned there over the years. This area of beach was rocky and strong currents ran under the pier. (DPT collection)

North Wales Steamship Company booked 39,726 passengers which at 1½d totalled £248.5.9 and in addition, they paid for the use of the office £25.0.0. The 1912 season was not so good, and the amount paid by that company was only £187.15.0 but during the season of 1913, they paid me £275.0.0. The Mersey Trading Company paid an inclusive rental of £500 a year for the general use of the pier and offices for all their steamers. The incidental receipts from automatic machines, advertising plates, bathing jetty and café, etc totalled about £280/£300 ... There was also some income obtained from chairs on the beach.

William Horton did not supply accounts for the seven years preceding the District Valuer's report, stating only that they were 'nominal and do not call for any special attention'. No wonder they were not encouraging. Only a few pounds had been spent each year on maintenance and tolls averaged £130 per annum during the period 1920 to the end of 1927. (During the five years following this date, the average toll receipts fell still further to below £70 per annum.)

David Evans' conclusion was that to purchase the pier would be an on-going liability, not an asset and so the matter was dropped. Another lessee took on the pier for a ninety-nine-year term from 1930, but gave it up six years later. New schemes were announced occasionally, but only one came to fruition. This was the development of a seawater swimming pool. William Horton sold a plot of land in the rear gardens of the Rhos Abbey Hotel to the Bay of Colwyn Sun Bathing & Swimming Pool Company which had been formed by a group of locals and headed up by the Lord Lieutenant of the county. Works began quickly and, at the end of July 1933, the pool was opened by Jack Peterson, heavy-weight boxing champion of Great Britain, who took the first dive into the pool. It was a great success. It brought visitors to this part of the town, and may have encouraged a few of them to walk on the pier whilst in the area.

A near disaster was averted in July 1935 when a fire was spotted at the seaward end

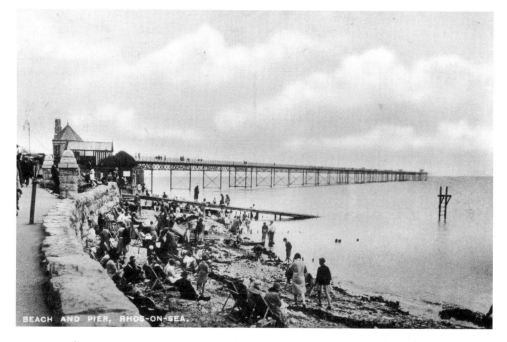

Beach and Pier, Rhos-on-Sea. Hopefully the tide was on its way out when this photograph was taken. The beach is very crowded with people and their deckchairs. The image is probably from the 1920s. (Marlinova Collection)

of the pier. There were no buckets or hydrants on the pier, and the firemen tackling the blaze had to roll out their hoses to their full extent to reach the blaze from the land. A stiff breeze had fanned the flames, but in the end there was little damage. A month later, a visitor wrote to the local newspaper:

The promenade is dull and unattractive ... the huts and kiosks near the pier are of no credit to any promenade ... A miscellaneous collection of out-of-date automatic machines should be scrapped ... The pier is a wonderfully healthy spot, but at first glance, it is absolutely lifeless and uninviting. There does not appear to be any publicity calling on visitors to use the pier ...

There was another outbreak of fire at the pier in August 1939, thought to have been caused by a carelessly discarded cigarette. Unfortunately, as the fire engine arrived on scene, a woman stepped out into its path as it reached the pier entrance and she was killed. The fire was quickly extinguished. At the outbreak of war the following month, the pier was closed and, in common with most other piers, had a fifty-yard section of its planking stripped at the landward end in case invading Germans might have wanted to land there. As the residents were called to 'Dig for Victory' and to contribute their metals for the war effort, the almost inevitable letter was sent to the *North Wales Weekly News* on 8 January 1942: 'With regard to the pier – a useless structure, surely this would serve a good purpose for melting down for munitions. It would be much more valuable than garden railings.'

William Horton died in early 1944, just short of his ninetieth birthday. He had owned the pier for forty-eight years. Following his death, the local council again discussed the possibility of purchasing the pier, but quickly dropped the matter. In the spring of 1946, much of William Horton's estate was put up for auction. Cockroft Hotels Ltd bought the Rhos Abbey Hotel, Rhos Fynach, five marine houses, Rhos Pier and William Horton's home, the mansion, Bryn Dinarth. It is not known what the purchaser's plans were for

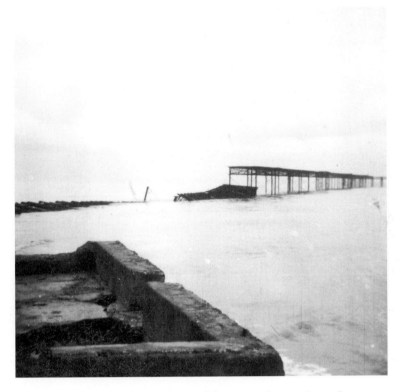

Rhos Pier – the very end. Demolition of the pier took several months to achieve. The clear up was complete by the summer of 1954. These photos were taken on a small box camera by John Anderson. (DPT collection)

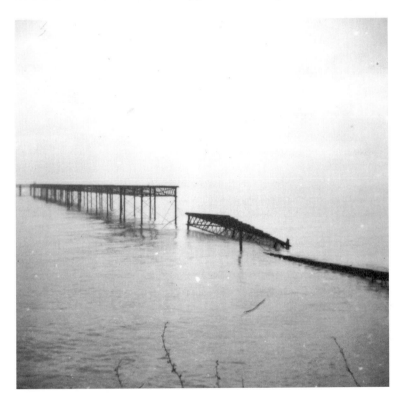

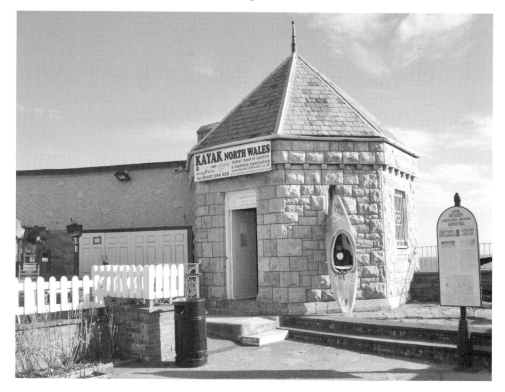

The stone toll house of Rhos Pier survived the demolition of the pier and is seen photographed in March 2010. Formerly in use as the 'Smallest Museum in Wales', it is now Kayak North Wales. (Marlinova Collection)

these properties, but a year later all the lots apart from Bryn Dinarth were auctioned again. The report in the *North Wales Weekly News* on 24 April 1947 read:

Rhos Pier Sold. Among properties sold by auction at the Rhos Abbey Hotel on Thursday was the Rhos on Sea Pier, café and Promenade approach. An initial bid of £2,000 was immediately raised to £2,250 at which price the pier was bought by Mr Denson, a Chester businessman. In answer to a question regarding future use, Mr Denson said it would be developed in accordance with the amenities of the district ...

However, once again, the ownership of a run-down pier did not live up to expectations and so just seven months after his purchase, the pier was put up for sale. His agents approached the council, who expressed no interest. On 9 December 1947, the pier was sold to John Rennie; no details of the sale have been found. The new owner, in common with local authorities and individuals throughout the land, had great difficulty in acquiring any building materials for repairs. Priority was given to the building of houses. After John Rennie had been in possession of Rhos Pier for eighteen months, in August 1949, he was in court and surprisingly was glad to be there. He was being prosecuted for failing to exhibit a red light at the seaward end of the pier as a warning to shipping. Rennie pleaded guilty, but asked the judge to take into account certain mitigating circumstances. On 25 August 1949, the *North Wales Weekly News* reported,

He had had considerable difficulty in getting a light installed. A ... gap in the planking, made as a wartime measure, still existed and the only way to cross it to reach the end of the pier

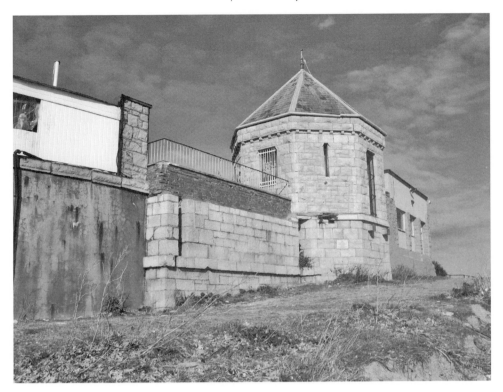

The entrance to Rhos Pier seen from the beach in March 2010. Small fragments of wood and iron remain embedded in the stonework. (Marlinova Collection)

was along a girder eight inches wide. On one occasion, Mr Rennie fixed an oil lamp on the end and engaged a man to refill the lamp. Owing to the gap, however, the man could not get to the end of the pier. Mr Rennie had been trying to get a permit for the timber to fill the gap.

He hoped the publicity would reach the Ministry of Works and enable him to get the materials required to restore the pier.

Another correspondent to the local newspaper complained that 'a state of decay had set in' and urged the council to spring clean the pier approach and to make the pier 'an asset to the district'. Then came more bad news, as reported in the *North Wales Weekly News* on 20 October 1949:

Men of the Colwyn Bay detachment of the Fire Service scrambled along the girders at the side of the 50-yard gap in Rhos Pier ... to put out the fire which had broken out on the end of the structure. Between 50 and 60 square feet of planking were destroyed in the fire, the cause of which remains a mystery ... firemen had commandeered a boat and rowed out in order to see whether the fire could be attacked from the sea. They saw that it was impossible to fight the flames from sea level and were unable to scale the pier supports. They later crawled across the gap, high above the sea, dragging equipment after them with the aid of ropes.

There were no improvements to the pier. In Rhos, the Ratepayers Association presented a petition to the council requesting the pier's refurbishment. Other local groups also campaigned for a new future for the pier; the Young Conservatives and the Townswomen's Guild included. Rumours were rife and conflicting reports of imminent demolition alternated with council denials. In October 1952, John Rennie was declared bankrupt. A short while later, the Colwyn Bay council purchased the pier and foreshore for £3,500. It

was at this time that F. C. Thornley's book, *Past and Present Steamers of North Wales*, was published triggering the Douglas legend. This was a specialist book on coastal steamers and was probably only a small seller in the town. The pier's future was still uncertain and was summed up in this 'poem', which was published following the announcement of sale:

> Sing a song of thousands, we've gone and bought a pier
> Don't ask us why we've bought it – we're not so very clear.
> We may decide to pull it down and chuck it in the sea,
> It might provide the bridge they want across the River Dee.
>
> Of course, we may resolve, if we give it serious thought
> To splash more money on it – indeed I think we ought –
> To strengthen its anatomy, renew its structure, old.
> Or why not scrap the most of it and re-erect in gold?
>
> So sing a song of thousands, and maybe thousands more;
> We've got some wooden shanties and "rights" upon the shore
> An open view, a lot of wind, a sound investment when
> *You understand our rates are only twenty-three and ten.*

North Wales Weekly News, 27 November 1952

The poem was anonymous, just signed 'Economist'. It probably summed up the thoughts of many. Notices warning that trespassers would be prosecuted and the removal of more of the deck ensured that only the bravest or most foolhardy would venture onto the pier. The newly revealed structure below the planking confirmed the fears of many that restoration of the pier would be beyond the means of the council. Of much interest locally was Norman Tucker's *Colwyn Bay: Its Origin and Growth*, which was published to coincide with the Coronation. Norman Tucker was a highly respected local journalist and author with a long association with the area. He gave a brief history of the pier, including the names of William Bostock and William Horton, but nowhere in this book or in his archive at Bangor University is Douglas mentioned.

Time passed; in September 1953, the council voted by a majority of two to cut its losses and to offer the whole length of the pier to demolition contractors. It had been 'a blot on the landscape', 'a conglomeration of old iron jutting out into the sea and spoiling the landscape' for too long, and 'the purpose of piers had now become outdated', the council stated. Some called for the decision to be reversed. There was a fear among residents that coastal erosion would threaten their properties and that flooding would worsen if the pier was removed. However, in November 1953, a tender for demolition was accepted. The Demolition & Construction Company of St James's Square, London, was contracted to demolish the pier and clear the site. For this, the council agreed to pay £1,421 16s 0d.

By the summer of 1954, nothing remained of the pier except the stone toll house, which is still in use. The pier entrance was eventually tidied up and some small structures erected; the area, now named Rhos Point, has hardly changed since. The fears of many locals that the demolition of the pier would lead to flooding and erosion proved correct. The combination of high tides and an easterly wind brought the sea over the wall south of the pier on many occasions. The removal of the pier and the neglect of the groynes meant that the beach was no longer stable and was subject to accelerated erosion. Most of the sandy beach at Rhos was lost. In the 1980s, it was decided to construct a breakwater off shore to protect the Victorian sea wall. This has reduced flooding, has created an area of beach where the tides do not reach and has provided a harbour for fishing and pleasure boats.

Books about piers written in the second half of the twentieth century and into the twenty-first continued to relate the Douglas connection. Now Rhos Pier has its own story.

COLWYN BAY/BAE COLWYN

Colwyn Bay was a late starter in its bid to become a seaside resort; development of a residential and resort town only began following the sale of the Pwllycrochan estate in 1865. The earliest settlements on this part of the coast were Colwyn, to the east, which is now known as Old Colwyn and the vast, but little-populated, parish of Llandrillo-yn-Rhos to the north-west. After the sale, the town grew rapidly. It had witnessed, in 1895, the building of a pier at Rhos which was to become a part of the Liverpool – North Wales steamer route. Colwyn Bay looked on anxiously as Llandudno, only five miles away, increased its visitor attractions annually and the town decided it needed a pier of its own if it ever hoped to progress. In the mid-1890s, Colwyn Bay had just one small indoor entertainments venue, the Public Hall. This was in the centre of town, but could never aspire to the quality of entertainments the town craved to offer. A pier with a grand pavilion was the only answer.

The Victoria Pier & Pavilion (Colwyn Bay) Company Ltd was incorporated on 9 November 1897, after several false starts caused by the local council making difficult demands. Firstly, the council wanted an agreement that it could seize the pier works if they were not completed within the two-year period specified by the Board of Trade and more seriously, presenting a problem which would hinder the pier company for a considerable time, no intoxicating liquor was to be allowed to be sold on the pier. Eventually, the seven directors, who were, with the exception of two Lancashire men, local tradesmen, overcame the first condition. Some of the necessary finance was raised through a share issue, and it was decided that the erection of the pier should be undertaken in two stages. First to be built was to be a 350-ft section with a pavilion, and then later, when finance permitted, a further extension to 1,050 ft to reach deeper water would be provided. A design for the new structure was accepted from the Manchester architectural and engineering firm of Mangnall & Littlewood, while the contract for its assembly went to the Widnes Iron Foundry, who specialised in pre-fabricated pier parts. The contract for the erection of the Pavilion was awarded to Messrs William Brown & Son of Salford. At this stage, it was announced that the new structure would not be a landing pier 'because of the inordinate length required to reach deep water' and because of the fear that 'regular steamers would probably bring in that objectionable tripper element ... injurious to the tone of a select seaside resort'. The project was to provide 'a handsomely designed pavilion, the prettiest on the coast'. The contract had a penalty clause attached, that the deck should be completed by August to allow its use by visitors that season and the pavilion by the January following.

The pier company held a ceremony to accompany the sinking of the first of the iron columns, attended by board members and representatives of the design and construction companies. At 4.45 on the afternoon of 1 June 1899, director George Bevan took charge of the steam winch and set the engine in motion to screw in the first 16-ft pile.

When the pier was finished, plans were made to open it with great ceremony on 1 June 1900, a year to the day since work began. Though the pier was initially a very short structure, constructed in the traditional manner with cast iron columns, steel girders and wooden decking, it boasted a magnificent wooden pavilion that could house up to 2,500 persons.

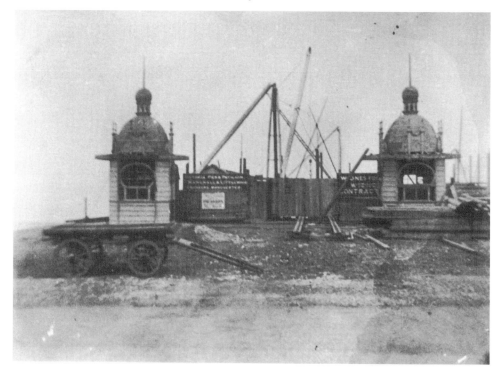

Colwyn Bay Pier under construction in 1899. The pier was erected by the Widnes Iron Foundry using pre-fabricated parts and the pavilion was built by William Brown & Son of Salford. (Marlinova Collection)

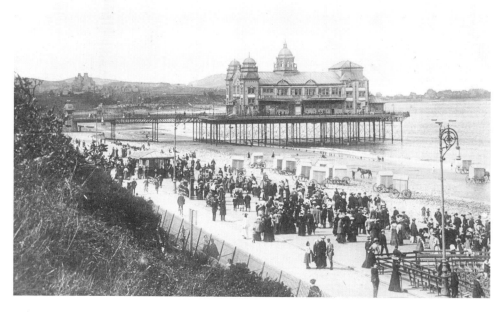

A fine study of Colwyn Bay Pier and seafront on a busy summer's day in 1903. The postcard shows the pier's original length of 350 ft, as well as the bathing machines being pulled by horses on the beach. (Marlinova Collection)

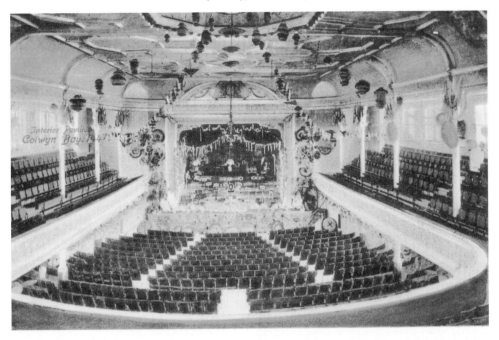

The interior of Colwyn Bay Pier Pavilion *c.* 1904, which could seat 2,500 people and featured a 48-in electric cooling fan in the ceiling dome. (Marlinova Collection)

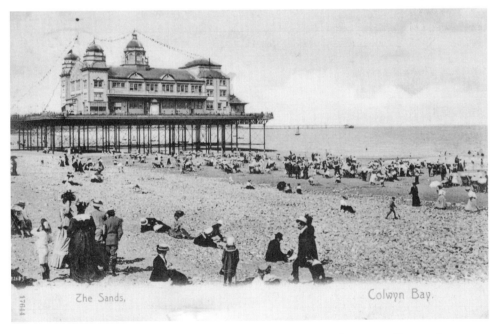

An Edwardian summer's day on the beach at Colwyn Bay *c.* 1903. The pier pavilion can be seen dressed in bunting, while Rhos Pier is visible on the horizon. (Marlinova Collection)

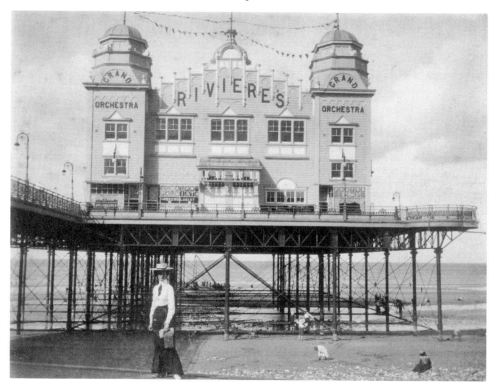

The elegantly dressed Edwardian lady is seen posing in front of the pavilion on this photograph taken in 1904. Little shops can be seen in the pavilion, including one for a photographer and another occupied by a palmist. (Marlinova Collection)

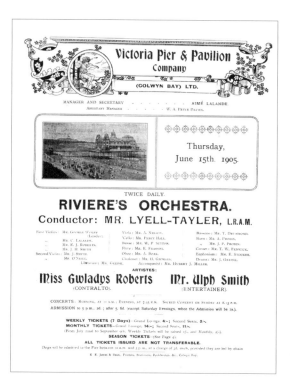

The programme for the performances of Rivière's Orchestra in Colwyn Bay Pier Pavilion on 15 June 1905, which took place at 11 a.m. and 7.45 p.m. Jules Rivière had been the original conductor of the pier orchestra but had died in December 1900 and H. Lyell-Taylor was conductor for the 1905 season. (Marlinova Collection)

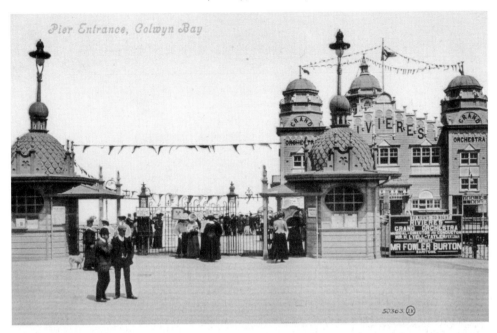

The entrance to Colwyn Bay Pier and Pavilion *c.* 1905 with its distinctive 'pineapple'-roofed kiosks. The board on the right is advertising a performance of Rivières Grand Orchestra conducted by H. Lyell-Tayler and accompanied by baritone Mr Fowler Burton. (Marlinova Collection)

The twin ticket offices were in Moorish style and led onto the 40-ft-wide deck of the pier. The pavilion was housed on a bay to the right of the main promenade, fifty yards from the entrance. The pavilion was designed on the latest principles, including a sloping floor to enable the orchestra to be seen, and velveteen, tip-up first- and second-class seats. Both the pier and pavilion were lit by electricity and in the dome a 48-in electric fan was fitted for the comfort of patrons. Draughts were reduced by having double doors to the outside. Internal decorations were by Messrs Goodall & Company, Liverpool, and were in a 'free Renaissance style'. The stage was designed for high-class concerts, theatrical plays and operas. Fire hydrants were incorporated and a number of escape routes provided so that the building could be evacuated in three minutes in the case of fire. The first resident conductor of the new Pier Orchestra was Jules Rivière, who had left Llandudno Pier under a cloud after falling out with the management. However, he must have remained a much-respected figure, for there are roads in both Llandudno and Colwyn Bay named after him. The deputy conductor, M. Henri Verbrugghen, was also highly regarded, being acknowledged as one of the finest living violinists. M. Aimé F. Lalande, a Parisian by birth, was engaged as the pavilion's manager and secretary.

The formal opening of the pier took place on Friday 1 June 1900. By seven o'clock in the evening, a great crowd had gathered at the pier entrance to witness Mr Littlewood, of Messrs Mangnall & Littlewood, present a gold key to the Chairman of the Pier Company. One side the key had an illuminated view of the pier and pavilion, while the other side bore the inscription: 'Presented to W. F. Mason Esq., by the architects, on the occasion of the opening of the Victoria Pier and Pavilion, Colwyn Bay, June 1st 1900 J. & W. H. Littlewood, Architects & Engineers.' Then the Reverend W. Venables Williams formally opened the new Victoria Pier and Pavilion with a prayer and a blessing. Almost 3,000 people passed through the turnstiles to inspect the new pier and pavilion. They were 'pleased beyond measure' with what they saw.

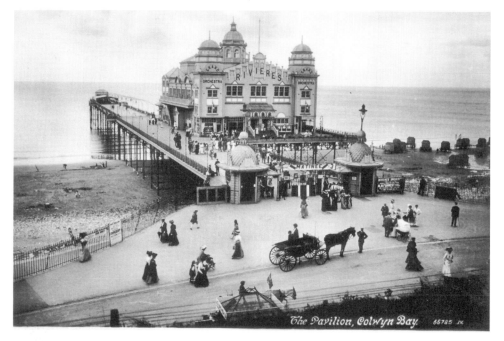

A postcard of Colwyn Bay Pier and Pavilion *c*. 1910. The join between the original pier of 1900 and the extension of 1904-05 can clearly be seen. At the end of the pier is a small concert party stage and canvas awning. (Marlinova Collection)

On the following day, Madame Adelina Patti sang in the Pavilion after being given a civic reception, complete with red carpet, on her arrival at the railway station. The Chairman of the Council presented her with an album of local scenery views with the inscription: 'Presented on behalf of the town and members of the District Council of Colwyn Bay and Colwyn by George Bevan Esq J.P. to Madame Adelina Patti (Baroness Cederstrom) as a memento of her visit to Colwyn Bay, North Wales, on the occasion of the opening concert of the new Victoria Pier – June 2nd 1900.' Madame Patti was then driven through the decorated streets to prolonged cheering from the large assembled crowds to the pier, where she performed Gounod's 'Jewel Song' from *Faust* and concluded with her signature tune 'Home Sweet Home'.

Entertainment provided in the Pier Pavilion during its first year included sacred concerts on Sundays, admission 6*d*, 'where the audience is respectfully desired to refrain from applauding'. During the morning and evening every weekday, the 'Novelty Bohemians' presented a programme of duets, trios, quartettes, humorous songs, ballads, facial mimics, child imitators, grotesque dances and comedy. The pavilion also housed a café-lounge, refreshment room and shops.

At the end of the calendar year, the first annual meeting of the shareholders was held. A profit of £269 had been made. The accountants explained that the figure was small owing to the large sum of £3,884 being spent on the orchestra and artistes. Receipts from tolls had been pleasing, at £4,376. It was hoped in the following year to reduce expenditure. At the meeting, the death of Jules Rivière the previous day had been announced. This was a great blow, but M. Henri Verbrugghen had agreed to take over as conductor. At the end of the second year, the profit had only increased slightly, to £561 15*s* 5½*d*. The figure would have been higher, if not for the purchase of the Rivière Music Library and the installation of heating to encourage greater attendance at the winter concerts. The time was not considered opportune to lengthen the pier. There was general disappointment that few of the town's

The crowning of the Colwyn Bay's May Queen was held on the pier and the holder of the crown in 1913 was Miss Dorothy Edwards. (Marlinova Collection)

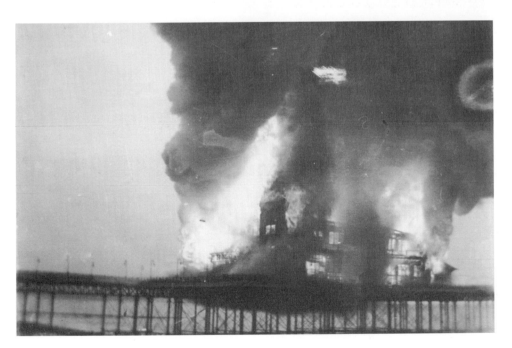

A dramatic photograph showing the destruction of Colwyn Bay Pier Pavilion by fire on 27 March 1922. The photo was taken by A. & F. Wrigley and issued as a postcard. (Marlinova Collection)

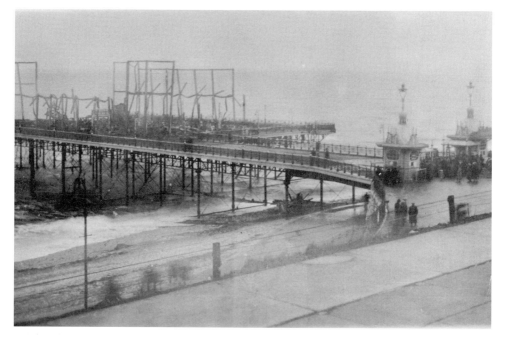

The skeletal remains of the pier pavilion at Colwyn Bay after the fire of 27 March 1922. All that is left is the twisted and charred steel frame of the building. (Marlinova Collection)

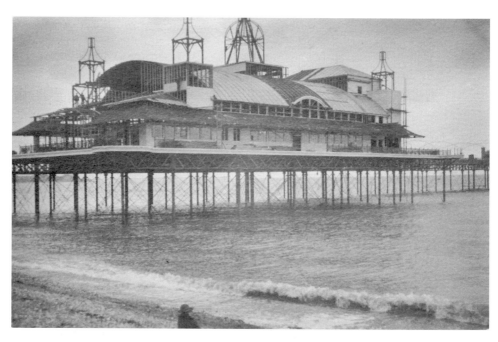

Following the 1922 fire, the pier was acquired by the council, who engaged Messrs Braithwaite to construct a new pavilion. This unique photograph, taken on 21 May 1923, shows the work nearing completion. (Marlinova Collection)

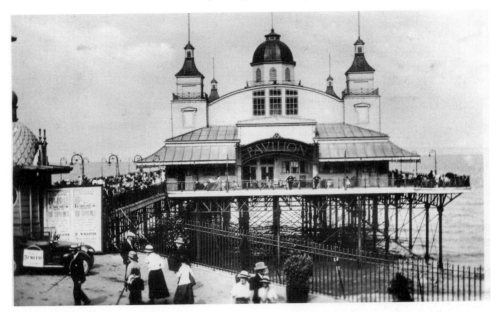

Colwyn Bay's second pier pavilion was opened on 23 July 1923 and this postcard by local photographer Alfred Haley shows it newly built. The pavilion could seat 1,350 people. (Marlinova Collection)

residents attended the pavilion concerts, and in a letter to the local newspaper of December 1902, M. Aimé Lalande, the manager and secretary of the Victoria Pier and Pavilion, begged for their support. If this was not forthcoming, he suggested that 1*d* should be put on the rates in an effort to increase the town's attractiveness as a winter resort. The third year was, however, similarly disappointing and, in the annual report, the blame for the poor results was put firmly on the council's continued refusal to grant a licence permitting the sale of alcohol. The weeks from Easter to the third week of July had run at a loss and only those from the last week of July to the second week of September made any profit. Figures continued to be disappointing the following year, but a 2 ½ per cent dividend was declared. The pavilion's licence was granted for the first time in February 1904.

Work began on the extension to the pier in the spring of 1904. The two companies who originally designed and constructed the pier were again employed. To celebrate the finished extension five weeks later, *al fresco* concerts were held throughout the first day. The structure was too short to receive steamers (the neighbouring piers at Rhos-on-Sea, Llandudno and Rhyl were all lengthy in order to reach the deep water) and a landing stage was never planned. The annual reports of January 1905 confirmed a 'fairly satisfactory' year during which the pier had been painted. In spring 1905, the pier was lengthened again; the extensions then totalled 140 yards. Another opening ceremony was held, on the pier's fifth birthday, this time with Adeler & Sutton's Pierrots performing on the pier head, a 'confetti fête' and fancy dress competition. H. Lyell-Taylor was conductor for the 1905 season and had an orchestra of eighteen musicians. Performances were held daily at 11 a.m. and 7.45 p.m., with a sacred concert on Sundays at 8.15 p.m. Lyell-Taylor was a charismatic conductor with his long, blond hair and would shout at anyone who interrupted his concerts by coughing or leaving their seats. Attempts to raise numbers attending the winter concerts failed and so, by the winter of 1907/08, they were suspended. The frequency of cold, windy evenings was blamed and once again, the town began its discussions about the need to provide a winter entertainments venue.

This snapshot shows us a partial view of the rarely photographed Bijou Pavilion at the end of Colwyn Bay Pier, built in 1916 but destroyed by fire on 28 July 1933. (Marlinova Collection)

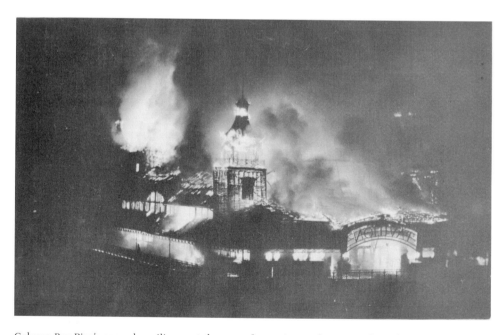

Colwyn Bay Pier's second pavilion met the same fate as its predecessor, when, during the night of 16 May 1933, it was totally destroyed by fire. Local photographers A. & F. Wrigley once again photographed the disaster and issued a set of postcards. (Marlinova Collection)

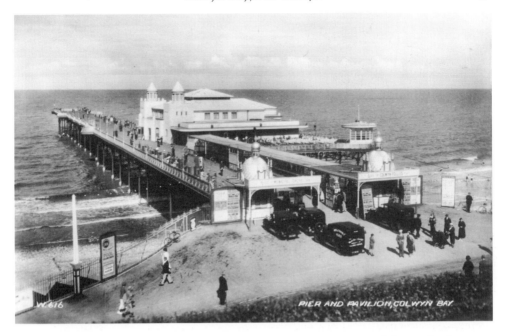

A postcard showing Colwyn Bay's third pavilion, opened on 8 May 1934 and designed to be fireproof to prevent it going the same way as its two predecessors. A bandstand was added at the same time, which can be seen on the right of the pier. (Marlinova Collection)

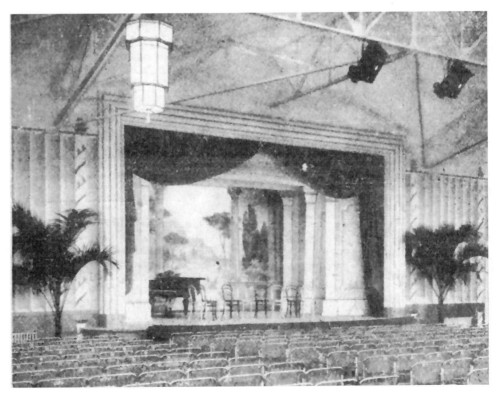

The interior of the third pavilion as newly built in 1934 and designed by Mary Adshead in a tented style. The new pavilion could seat 700 people. (Marlinova Collection)

Reginald Steed and the Colwyn Bay Municipal Orchestra photographed on the pier in 1940. They performed in the Pier Bandstand at 3 p.m. each afternoon and at 8 p.m. in the Pier Pavilion. (Marlinova Collection)

The pier's profitability began a slide and so, in September 1911, the pier was put up for sale. No buyer was found. In 1913, the council published plans for a winter garden to be built adjacent to the pier entrance, but the idea faded. In November that year, the pier was offered to the council for a sum of £15,000. A week later, the pier was put into the hands of Peter Gregson, who was appointed as Manager and Receiver of the pier company. The council was again offered the opportunity to purchase the pier for £15,000, which was a bargain considering £45,000 had been spent on the pier in the previous few years. The townspeople were against the purchase, viewing the pier as a 'white elephant'; discussions continued for a while, but when war was declared the following summer, discussions were abandoned *sine die*. Not long afterwards, the pavilion found itself under threat, not from the enemy but from a 'dastardly attempt' by members of the Suffragettes to burn it down; the attempt failed and resulted in only £12 worth of damage. The pier management struggled on. On the end of the extended pier, a canvas shelter was provided for band concerts, which in 1916 was transformed into the Bijou Theatre with a capacity of 600 persons. The Bijou quickly established itself as a popular concert party venue; with the 'Supremes' and 'McAllister's Follies' being two of the most popular attractions.

In the night of 27 March 1922, a fire completely destroyed the pier pavilion and all its contents. The conflagration could be seen from miles around. Included on the list of losses was the Rivière Music Library, which fell into the sea, two pianos and other musical instruments, many signed photographs of past artistes and the safe and its contents. The only survivor was the pier's fire insurance policy! The main promenade deck was saved and in early April the structure was offered to the council for £10,000. The pier accounts since its opening were published but they were not tempting to any would-be investors. In the years up to and including 1908, the pier had made small profits, but in 1909, 1910, and 1911 there had been sizeable losses. The pier had been in liquidation since 1913. The pier company had nowhere to go and so steps were taken to wind it up. The liquidator offered the pier to the council for £5,000 and the council made some enquiries, but on finding

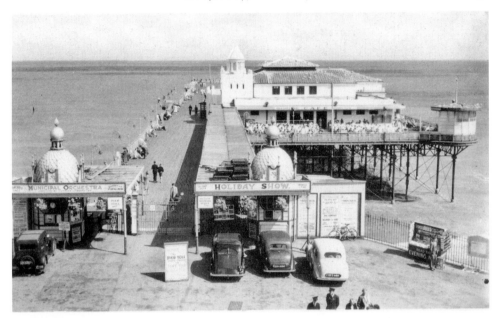

A postcard issued in the mid-1950s mistakenly titled 'Entrance to Pier and Erias Park Pavilion, Colwyn Bay'. The Municipal Orchestra were still an attraction at this time, although they were eventually disbanded in 1962, and the season's other main feature was the Holiday Show. (Marlinova Collection)

that a new pavilion would cost at least £25,000; the idea was given up again. However, in August, it was announced that the council would buy the pier for £4,750. The purchase went through in September 1922 and the pier company was officially wound up on 19 December. The Council's engineer, Mr J. W. Dunning, organised the works to the pier and supervised the construction of the new pavilion by Messrs Braithwaite & Co. The total cost of the works and purchase of the pier was £45,000. Work proceeded well and the completion date was met. The opening celebrations on 23 July 1923 included a five-hour programme of events. These were kicked off by a reception and banquet for 130 invited guests at the Metropole Hotel. Following the meal, the guests proceeded to the pier, where Councillor Joseph Dicken, JP, Chairman of the Pier and Entertainments Committee, formally opened the new pavilion. The contractors presented Mr Dicken with a silver afternoon tea set to mark the occasion. The day was rounded off with a Grand Gala Night in the new Pier Pavilion concert hall, which was designed to seat 1,350 people. In addition, the building accommodated a café, refreshment room and lavatories. The structure was again built of timber, but was on a steel frame. The concert hall had a large stage for theatrical performances and dressing rooms for the cast. The velvet plush tip-up seating was made to be removable over two-thirds of the floor area, to allow for dancing. The exterior of the building was illuminated, and crowds of people lined the promenade to watch guests arriving and to marvel at the brightly lit scene. The accounts for the following year, the first when the pier was totally under the control of the council, showed a large deficit. This was to be expected, the council explained and there was no need for ratepayers to be alarmed; this had been an experimental period. The winter concerts ceased, but otherwise the pier continued to be run on similar lines and was as popular as ever during the summer months.

However, ten years later, on Tuesday 16 May 1933, a driver of a goods train on the midnight run saw flames billowing out of the second structure and sounded the alarm by repeating sharp blasts on the whistle of his engine. By the time the fire brigade arrived on

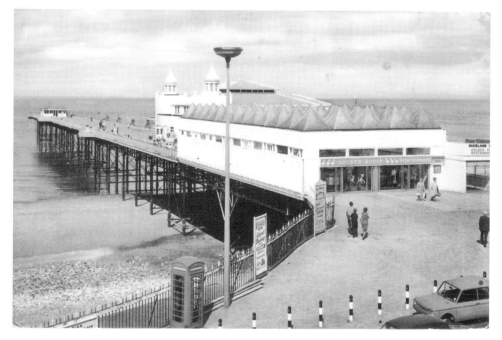

Colwyn Bay Pier in the 1970s following the addition of the Golden Goose amusement arcade and the conversion of the pavilion into the Dixieland Bar. (Marlinova Collection)

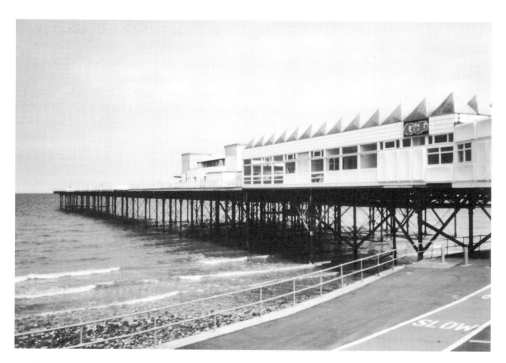

By the time this photograph was taken in 1996, the sea end of Colwyn Bay Pier had been closed for some years, but the then owners Mike and Anne Paxman had managed to restore the former Golden Goose amusement arcade, which housed a restaurant, bar and shops. (Marlinova Collection)

the scene, the pavilion had been totally destroyed. Gossip raged about the possible cause of the fire; was it the work of a madman, the result of a carelessly discarded cigarette or an electrical fault? The Chief Constable of Denbighshire was called in to calm the townspeople. He declared the two fires to have been a coincidence and the cause of both was most likely accidental. The fire confirmed the beliefs of all those calling for an on-land entertainments venue. But the council was determined to go ahead with a replacement pavilion and called in Professor Stanley Davenport Adshead of London University, who was an expert on civic design and fireproofing structures. Llandudno Pier staff were increased threefold at night as a result of the Colwyn Bay fire, and for the first few nights afterwards, the pier master and his deputy took it in turns to keep watch all night.

To make matters worse for the town, ten weeks later, in the early hours of Friday 28 July 1933, the 600-seat Bijou Theatre at the pier head, which had escaped the earlier fire, was completely destroyed. This fire was discovered about 4 a.m. by Mr Hugh Hughes, signalman, who was on duty in a box near the station. He shouted the alarm through a megaphone, and succeeded in attracting the attention of sorting staff at the nearby post office. They summoned the Fire Brigade, which arrived on the scene in twelve minutes. Nothing was left of the small structure and some of the planking beneath was burnt through. A sum of £5,000 was estimated for repairs. Jack Rowlands' Summer Revellers lost clothes, props, magic tricks, scenery, music and scripts in the fire and were given a temporary canvas structure for subsequent performances. A new pavilion, built principally of concrete in Art Deco style, was officially opened on Tuesday 8 May 1934. David Lloyd George was asked to perform the opening but was unavailable; Seymour Hicks and Douglas Fairbanks were also approached, but without success. In the end, Mrs Hyde, Deputy Chairman of the council chaired the opening, which was performed by Councillor W. G. Knowlson, JP. Housing around 700 seats, the building by Messrs Horseley Bridge & Thomas Piggott Ltd, had cost less than half the previous structure. The new building was declared as near fireproof as possible. It was the result of collaboration between Professor Adshead, Mr W. G. Dunning, the Council's Surveyor and the Council Entertainments Manager, Louis Kilkenny. Its construction was described as unique; a light steel structure rigidly framed and latticed. Asbestos sheeting was applied directly to the steelwork, making an 'absolutely fireproof' roof. The floors were of the best maple and protected by thick layers of asbestos sheeting. The design for the interior of the pavilion was drawn up by Mary Adshead (the professor's daughter). It suggested a tent or marquee supported by ornamental poles and ropes and decorated by a number of abstract motifs inspired by musical and marine themes. The tented theme carried through to the seating, which was metal framed with canvas seats. The ocean floor was the inspiration chosen by Eric Revillious for the tea-room where his murals depicted pink and green seaweed floating through the ruins of a submerged palace. The third pavilion opened to the public with a special holiday attraction – Ernest Binns and his company presenting 'Bits and Pieces'.

Despite these calamities, the increasing popularity of the pier during the 1930s led the council to impose a 2d entrance toll (free after 6.00 p.m.) to 'prevent indiscriminate lounging on the pier'. The toll included the use of a deck chair and the pleasure of listening to a band. Admission to the Pier Pavilion to see Ernest Binns' Colwyn Follies was extra, with seats ranging in price from 6d to 2s. The pavilion remained open during the winter for the engagement of the six-piece Municipal Orchestra under the direction of Reginald Stead; admission 2d, including the free use of newspapers and periodicals. During the summer months, the orchestra performed in the bandstand on the pier at 11 a.m. (3 p.m. Sundays), chairs 3d. On 25 September 1936, George Robey, the famous music hall comedian, appeared in the pavilion, but it was reported 'everyone present did not unreservedly enjoy the type of humour for which Robey is so famous'.

The pier's comparatively safe position on the west coast of Britain enabled it to escape breaching during the Second World War, although some decking was removed, and the pier pavilion remained open throughout the hostilities. The town's first evacuees from

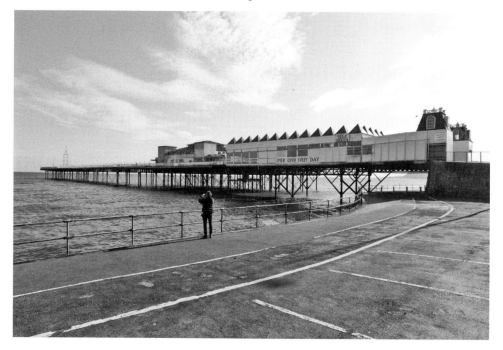

Steve Hunt acquired the pier from the Paxmans in December 2003 but so far his hopes of restoring the pier have not come to fruition and here it is seen closed in March 2010. (Steve Thomas)

Liverpool were assembled in the pavilion for their first meal at the seaside. One of the more 'unusual' forms of entertainment was a display of tactics by the Cheshire Home Guard, who climbed the 35-ft-high supports of the pier, removed the decking behind the backs of the 'patrolling sentries' at the pier entrance and hoisted down a swastika flag flying over the pavilion!

Peacetime pleasures returned to the pavilion following the end of the war, yet, by the middle of the 1950s, the traditional variety shows were playing to ever-falling audiences and the season was shortened. Eventually, in 1958, they were discontinued altogether and were replaced by cheaper forms of entertainment. The Pier Orchestra managed to struggle valiantly on until 1962, but with its membership having fallen from eleven to three it was time to call it a day. The replacement entertainment included bingo, wrestling, talent shows and dancing.

The end of the orchestra appeared to signal the end of the pier's golden days and from then on its fortunes began to decline sharply. Entam Ltd, a subsidiary of Trust House Forte, acquired it from the council in 1968 for £53,766 and carried out a number of alterations. These included converting the pavilion into Dixieland Showbar and building the Golden Goose amusement arcade at the shore end. The pier passed to Entamatics Ltd in September 1973, but, three years later, they incurred the wrath of local people by seeking planning permission to demolish the unproductive sea end, despite the fact the pier had gained Grade II listing status a year earlier. In June 1979, the pier changed hands once again when it was acquired for £115,000 by Parker Leisure Holdings, a Rhyl-based leisure company, who caused further outrage a few months later by booking a Danish topless rock and roll group!

Regrettably, the aims of the new owners proved to be no different from that of their predecessors – namely to concentrate matters on the profitable amusements at the shore end of the pier and let the seaward end deteriorate, which was eventually declared unsafe

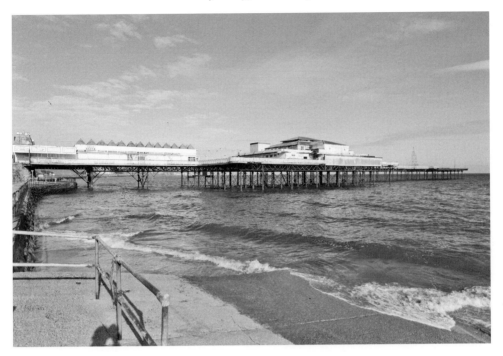

The closed and dilapidated Colwyn Bay Pier in March 2010. (Marlinova Collection)

after it was revealed £250,000 would be needed to restore it. A further attempt to demolish the stricken sea end in 1987 following storm damage was refused, and a scheme in 1988 by Rosart Limited of Exeter to include the pier as part of a new leisure complex predictably fell through.

While the pier continued to decline, Parker Holdings and the council continued to remain at loggerheads, despite the council finally agreeing in February 1993 that the seaward end could be demolished; an action that prompted the formation of the 'Victoria Pier Action Group'. Matters were only moved forward following the acquisition of the pier in September 1994 by Mike and Anne Paxman, who wanted to actually restore it, not pull most of it down. As a condition of the insurance taken out on the structure, the Paxmans were obliged to live on it and therefore moved lock, stock and barrel into part of the old Pier Pavilion. Despite a number of setbacks, including failed bids for grant aid from the Welsh Office and Millennium Commission, the Paxmans staunchly endeavoured to get the pier up and running, and, on 5 April 1996, opened a bar, café and shops in the shore end building (later joined by water sports and record shops, and an amusement arcade).

In the autumn of 1999, a Pier Trust was set up with the ultimate aim of purchasing the pier from the Paxmans to enable it to qualify for grant aid. The trust proved unsuccessful in their aim, and during the summer of 2003, the pier was put up for auction on the internet site eBay. Some fifty-four bids were registered, but they failed to reach the reserve price. However, on 11 December 2003, the pier passed to thirty-one-year-old Steve Hunt of the Antique Amusement Company, who had a background in coin-operated machines. Protracted arguments between the owner and the county council have resulted in the pier's closure. A public meeting was held in January 2010 to discuss options for the pier. Over 500 people attended. As a result, a petition is being collected (March 2010), asking for a public enquiry into the council's handling of the pier case. In the meantime, the pier has received no maintenance for many months; the decision about the pier's future seems to be left to the elements.

RHYL

The arrival of the Chester & Holyhead Railway in 1848 prompted the promotion of Rhyl as a seaside resort, and its large sandy beach soon ensured a growth in popularity and the erection of a promenade and seafront properties. In addition to the railway, steamers also brought visitors to Rhyl, using Voryd (Foryd) Harbour, but this was not available at all states of the tide. This led to the formation, in 1862, of the Rhyl Promenade Pier & Assembly Room Company (soon renamed the Rhyl Promenade Pier Company) with a capital of £20,000, initially in 2,000 shares of £10, and then 4,000 shares of £5, to provide a promenade pier and steamer landing stage on the promenade opposite the Belvoir Hotel, along with an assembly room and baths. The chairman of the company was the Honourable Colonel Rowley MP. Plans for the proposed pier were supplied to the Board of Trade in January 1863 and, on 10 October 1863, the Crown leased the foreshore for the pier site for a term of ninety-nine years at an annual rent of £8. The Provisional Order for the construction of the pier was granted in January 1864 and the Rhyl Pier Bill received the Royal Assent eight months later.

Because of the tidal conditions at Rhyl, a long pier would be needed to enable steamers to call at most states of the tide. A pier of 3,168 ft in length was drawn up by engineer James Brunlees, who had designed the even longer pier at Southport. However, the construction of the pier was delayed as more shareholders were sought to finance it. Tenders to construct the pier were advertised in December 1864 and the chosen contractor was Robert Laidlaw of Glasgow, who had constructed Blackpool North and Deal piers and was in the process of erecting Brighton West; all three for engineer Eugenius Birch. Laidlaw became the largest shareholder in the Rhyl Promenade Pier Company in part payment for his work. However, it was not until 25 May 1866 that the foundation stone was laid by Peter Ellis Eyton MP and the first girder set in place, against which Miss Twiston smashed a bottle of champagne. The pier was to consist of slender cast iron piles, supporting wrought iron girders complete with wooden decking. The pier stood 11 ft above the high-water level and was 16 ft in width. Seating ran along both sides of the pier and there were several little shelters, which rather resembled wooden railway station buildings, and ladies' and gentlemen's toilets. A covered entrance building, to be available as a public room, was part of the original plans for the pier but was dropped in favour of a pair of wooden toll houses.

Work on building the pier was carried out at a quick pace and, by September 1866, 1,500 ft had been constructed, of which 750 ft had received its balustrade. The first section had been opened to the public, but disaster struck on the night of Tuesday 11 September 1866, when a severe storm destroyed 900 ft of the pier. The directors of the Rhyl Promenade Pier Company blamed Brunlees for design faults with the structure and replaced him with R. D. Morgan, who was paid two guineas per week. The pier was rebuilt 7 ft higher than before and strengthened with stronger piling; it was also decided to reduce its length to 2,250 ft, a decision that was to cause difficulties for visiting steamers, which could only call at medium and high tides.

The pier was officially opened with great ceremony on Monday 19 August 1867, in front of a large crowd of visitors, including some people from Liverpool and Manchester, who

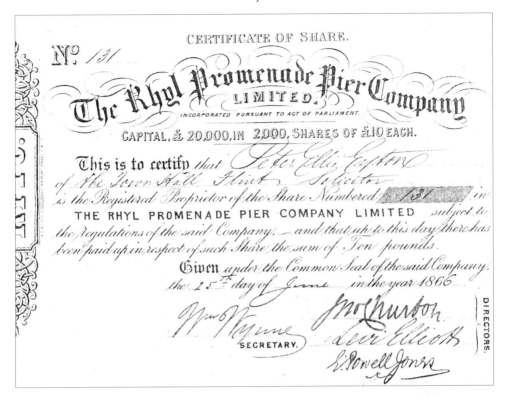

A share certificate of the Rhyl Promenade Pier Company issued to Peter Ellis Eyton on 25 June 1866. A month earlier, Eyton, who was an MP, had laid the foundation stone to commence the building of the pier. (Marlinova Collection)

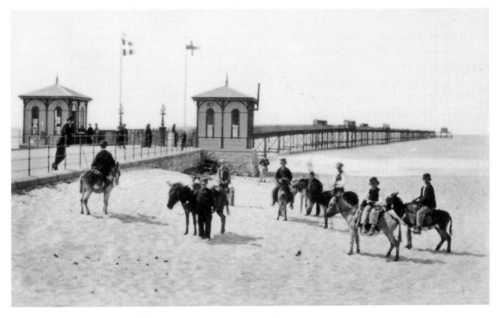

A view of Rhyl Pier in *c.* 1870, some three years after it had been completed. The photograph gives a good idea of the pier's long length, and also Rhyl's glorious sandy beach, perfect for the donkeys. (Marlinova Collection)

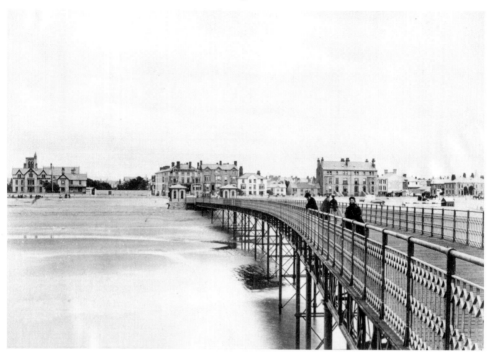

This view of Rhyl taken from the pier *c.* 1870 shows the unusual curve in the pier deck at the shore end and its rather plain appearance. (Marlinova Collection)

viewed the official procession led by the Rhyl, Mold and Ruthin Volunteers and Flintshire Rifle Engineers. At the pier entrance, the procession halted to hear the speeches and toasts held beneath a large banner with the words *Success to the Rhyl Promenade Pier Company*. Following maritime tradition, the pier was officially launched with a bottle of champagne being thrown against an iron pillar by Miss Rowley and a cannon salute from the steamer *Colombus* off shore. The procession then proceeded through a large archway to the end of the pier and watched a regatta. Throughout the evening, dancing took place on the pier head followed by a firework display.

The pier was officially known as the Victoria Pier and its total cost was £23,000. Facilities on the pier at opening, included shops, a café and a bandstand on the pier head whilst on a clear day Mount Snowdon could be viewed from the pier head. On 16 March 1874, the *Liverpool Mercury* reported that Ellis Eyton had offered to build a concert hall at the entrance to the pier. A building had been designed by Mr Hornblower and work was to begin immediately. However, it appears that the work failed to take place, although a small tramway was added to the pier in 1875 at a cost of just over £100. This was principally used to transport baggage to the steamers, although passengers also appeared to be carried and was controlled by a man who sat in the rear car: a rise in the admission charge to 2*d* helped pay for the work. The landing stage was also enlarged and steamers ran from the pier to Liverpool and resorts along the North Wales coast. On 1 June 1875, the Mostyn Colliery Company's steamer *Swiftsure* left the pier at 9 a.m. for a trip to Llandudno. Further improvements were made to the pier in 1877 when a pavilion and baths were added. The pavilion became known as the Bijou and variety acts became its staple fare. The Rhyl Promenade Pier band performed there in wet weather and in the pier bandstand when fine. In 1883, the *Mermaids* were the attraction in the pavilion and the Johnson family, featuring the 'Champion Lady Swimmer of the World', gave diving and swimming exhibitions at the end of the pier.

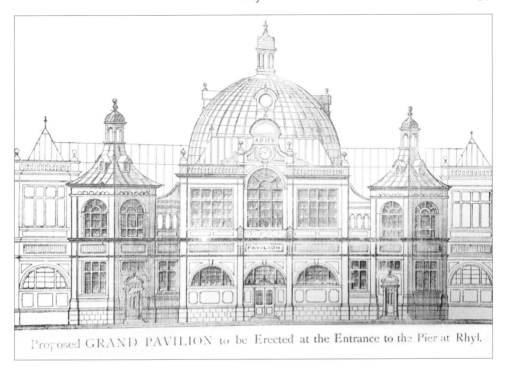

Proposed GRAND PAVILION to be Erected at the Entrance to the Pier at Rhyl.

In 1891, the pier was acquired by the Rhyl Pier & Pavilion Company, whose aim was to build the Grand Pavilion at the entrance to the pier. This was the original design, featuring a large central dome that was not built. (Marlinova Collection)

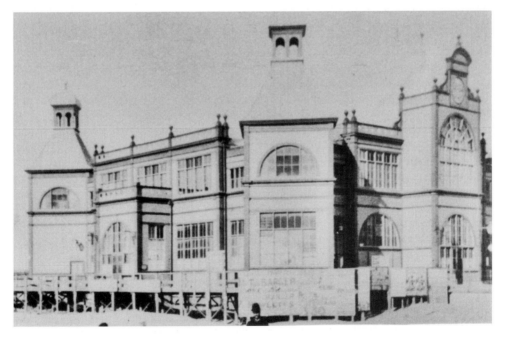

This is the Grand Pavilion as eventually opened by Lady Fiorentia Hughes on 12 September 1891. Designed by Messrs Darbyshire & Smith in the shape of a Maltese cross, the building was erected in only fourteen weeks and featured the world's largest organ, the Grand Jubilee Organ. (Marlinova Collection)

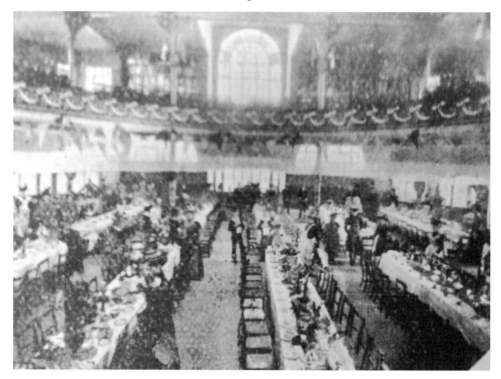

A rare interior view of the Grand Pavilion, decorated for Queen Victoria's Diamond Jubilee in 1897. (Marlinova Collection)

However, the long length of the pier, and the resulting high maintenance costs, ensured that it was not a particularly profitable exercise for the Rhyl Promenade Pier Company. They were unable to fully pay for the pier when it was built, which resulted in Robert Laidlaw, the contractor, becoming the chairman and major shareholder. Small dividends were paid out in the early years of operation: 1 ½ per cent in 1869, 3 ½ per cent in 1875, 4 ½ per cent in 1877, 1 ½ per cent in 1879 and 2 ½ per cent in 1880, but very small profits in the succeeding years meant that further dividends were out of the question. The *North Wales Chronicle*, in its edition of 13 April 1878 reported that

some time ago, the Directors of the Rhyl Promenade Pier Company called in E. Birch [the noted pier engineer Eugenius Birch] *to advise them as to improvements to the pier. They included the improvement of the entrance, enlarging the present pavilion, increasing the number of paths, substituting pretty glass shelters for the presently unsightly ones, changing the position of the refreshment room and enlarging and ornamenting it, and rebuilding the end of the pier to enable steamers to call at all states of the tide.*

The lack of finances meant none of Birch's recommendations could be carried out for now, and to compound matters, the pier was damaged by the vessel *Lady Stuart* on 12 December 1883. She was a schooner on her way from London to Saltney with a cargo of phosphate, but mountainous seas whipped up by a terrific gale led to her bulwarks being smashed and boats and skylights being carried away, allowing water to burst through into her hatches. The crew struggled to get tarpaulins over the hatches, but to no avail. The schooner had become waterlogged and her signalling flags could not be got at and her crew took to the rigging as she began to sink 500 yards off Rhyl, close to the pier.

In the absence of distress flares, the onlookers on shore didn't realise the seriousness of the situation until the ship was buffêted into the pier. During the third buffeting, the *Lady Stuart* went broadside through the pier, carrying away 180 ft of the structure. Miraculously, three of the crew clinging to the rigging managed to leap onto the section of pier still connected to the shore as the boat struck it. However, two others jumped onto the severed seaward end. Having gone through the pier, the vessel was carried eastwards with two men still clinging onto the rigging, until she was beached 200 yards from the pier.

The lifeboat crew finally appeared after forty-five minutes. The delay was caused by having to fetch a horse to pull the lifeboat, which then proved difficult to launch because the receding tide provided an insufficient depth of water. Many willing helpers eventually got her launched and received a drenching for their efforts. Despite great difficulties, the crew managed to get the two stranded men from the vessel ashore, whilst the two on the isolated section of pier were rescued when the tide ebbed.

The *Lady Stuart* was a total wreck and her loss was recorded as £1,200, with her cargo valued a similar amount, whilst the repair bill to the pier was £300. Unfortunately, further calamity struck the pier in 1884 when the Norwegian steamer *St Olaf* seriously damaged the pier head. Repairs were carried out the following year when a new west wing was added along with a triangular-shaped landing stage, which extended the pier's length to 2,355 ft.

Robert Laidlaw resigned as chairman of the company in 1884 and was succeeded firstly by Major Wright, then, in 1887, by Mr Murdock. He had to deal with the issue of £336 in toll money going missing, although the thief was found and promised to repay the amount. Nevertheless, by this time, the Rhyl Promenade Pier Company, suffering from serious financial difficulties, had gone into liquidation and, on 16 January 1890, the pier was put up for auction at the Belvoir and Pier Hotel, when it was stated that it was held on a lease for eighty years from Her Majesty's Commissioners of Woods and Forests, at a rental of £10 per annum. The pier was sold to some of the former company's shareholders (including Robert Laidlaw and Mrs Porter, a large debenture holder) for £6,010, who in turn sold it on for £7,250 in May 1891 to the newly formed Rhyl Pier & Pavilion Company, which had a capital of £25,000 in 5,000 shares of £5.

The new owners were formed to add a large pavilion at the entrance to the pier and work began on erecting the structure at the beginning of June 1891. However, as the work was progessing, the pier suffered another calamity when it was hit by the Rhyl & Vale of Clwyd Steamship Company's vessel *Fawn* on 31 August 1891. Owned by a local consortium, the *Fawn* carried both passengers and cargo between Liverpool and Rhyl, usually from Voryd Harbour, but also occasionally from the pier. However, her manoeuvrability was restricted by her single propeller, and on one journey from Liverpool with a new captain at the helm, she got stuck on a bank outside Voryd Harbour and the passengers had to be rescued by lifeboat. She was repaired and put back into service before striking the pier. Fifty people had to be rescued from the stricken vessel by lifeboat. The pier suffered further damage during a storm on 13 October 1891 when a heavy iron seat was torn from its fastenings and a recess shelter was damaged.

The pier was repaired and its old pavilion, the Bijou, renovated. The building measured 56 x 36 ft and had a gallery at one end and elevated seating for 450 people. Pierrots and concert parties were the main fare provided in the Bijou and it was also used as a dining room. The new pavilion, the much larger Grand Pavilion, was added at the pier entrance on the shore and was officially opened by Lady Fiorentia Hughes on 12 September 1891. Designed by Darbyshire & Smith of Manchester in English Renaissance Style and in the shape of a Maltese cross, the pavilion was erected in only fourteen weeks by Holme & Green of Liverpool. The ground floor of the building had an area of 91 x 61 ft and a horseshoe gallery above measured 135 x 31 ft; altogether, 3,000 people could be accommodated. The building featured the world's largest organ, weighing 25 tons and housing 3,095 pipes. It was known as the Grand Jubilee Organ and had been a feature of the 1887 Jubilee Exhibition in Manchester. The cost of the new additions to the pier was nearly £6,000.

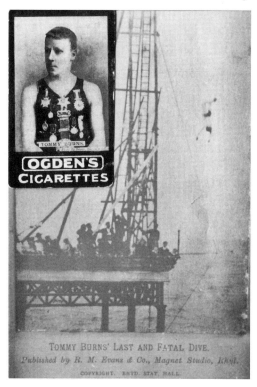

The fatal dive off Rhyl Pier by Tommy Burns on 6 July 1897 is captured by local photographer R. M. Evans of the Magnet Studio. Burns, who was a highly decorated diver, was commemorated on an Ogden's cigarette card. (Marlinova Collection)

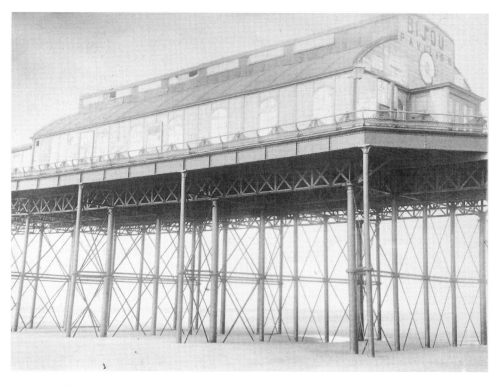

There was also a pavilion on the pier itself, erected in the 1870s and known as the Bijou Pavilion. The building was home to variety entertainments and also a café, and this view of it was taken in 1898 during a photographic survey of the pier. (Marlinova Collection)

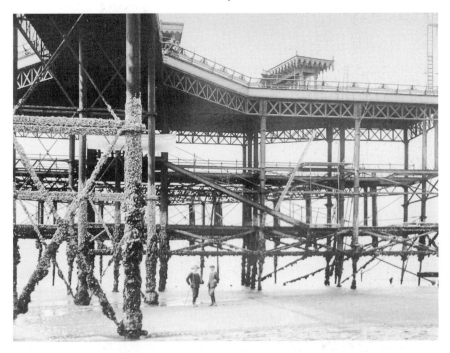

This view was also taken during the 1898 photographic survey to show the poor condition of the pier head supports. As can be seen, the pier was left high and dry at low tide. On the far right can be seen the diving stage, scene of Tommy Burns' fatal accident a year earlier. (Marlinova Collection)

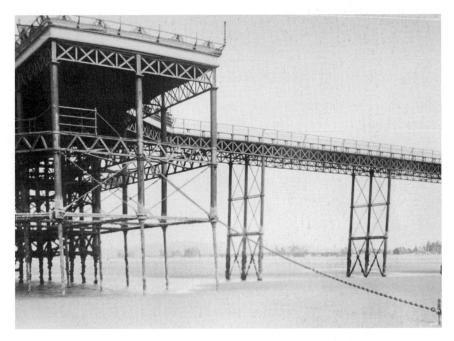

A further 1898 view of the pier head, showing the metal chain staked into the beach to help stabilise an unsafe supporting column. The pier underwent repairs within the next few years but remained generally in a poor condition. (Marlinova Collection)

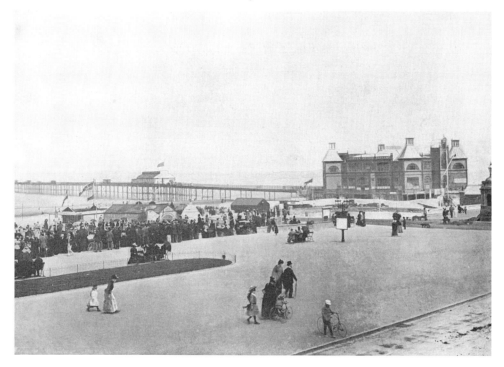

A photograph of Rhyl Pier taken in the 1890s showing both the Grand Pavilion at the entrance and the Bijou Pavilion on the pier. The crowd on the promenade is watching a concert party performance, perhaps by the popular E. H. Williams and his Merrie Men. (Marlinova Collection)

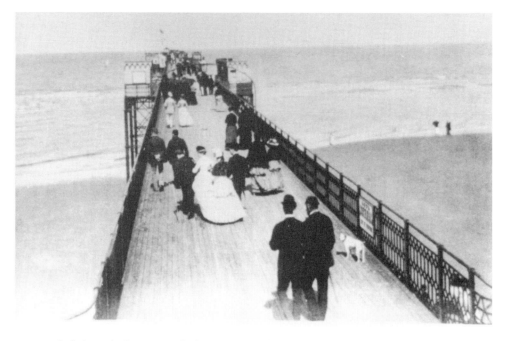

A view of Rhyl Pier looking towards the seaward end taken from the Bijou Pavilion in the 1890s. Note the narrowness of the pier and the railway-style architecture of the buildings. Amongst the strollers is a little white dog. (Marlinova Collection)

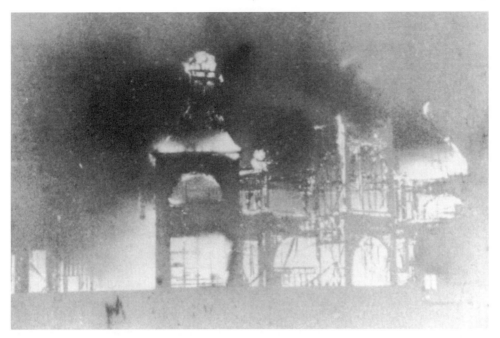

The sad destruction by fire of the Grand Pavilion during the night of 13 September 1901. (Marlinova Collection)

A less costly addition to the pier was the addition of a coastguard station in 1893.

The Grand Pavilion was built to attract a more select audience and its first Musical Director was the 'world's greatest flautist', Edward de Jong. Attendances were disappointing, however, and within two years, the orchestra size had been reduced and de Jong was replaced by Charles Reynolds. By the 1890s, Rhyl was becoming the 'Southend of Wales' and lower sights had to be set for the Grand Pavilion, so it began to be used for dances, and conferences during the off-season. In 1893, a proscenium was added for the introduction of dramas and comedies, and music hall acts and Sunday sacred concerts were also featured. Jules Rivière, formerly at Llandudno Pier Pavilion, was Musical Director for a time. Nevertheless, audience numbers remained small and the Grand Pavilion was proving to be a loss-making venture. Furthermore, the Rhyl Pier & Pavilion Company was being sued by the contractor, Holme & Green, for non-payment. The difficulties with the pier and pavilion led to considerable friction within the company and for a time it had two opposing chairmen and secretaries. In March 1895, it was recorded that the company had become insolvent, partially owing to the cost of litigation, and, as a result, the Grand Jubilee Organ was put up for sale. Divers continued to entertain the crowds at the pier head using a large diving board erected on the eastern side. In 1889, it was Professor Beaumont, his wife and child, 'Little Alice', who provided the exhibitions and, in 1896, it was Frank Sinclair. The world champion swimmer and diver Tommy Burns was engaged to dive off the pier on 6 July 1897 and heavy advertising of the event ensured that great interest was shown by both locals and visitors. Burns claimed to be the 'National King and World's Champion High Diver, Long Distance Swimmer, Tank Performer and Pedestrian.' In his announcements, he laid claim to being the winner of over 500 prizes and to be the holder of the Royal Society's humane medals and addresses for saving forty-three lives. The following list of his performances was circulated freely in the town:

... the nine days wonder who dived off Runcorn Bridge, swam eighteen miles to Liverpool Landing Stage, ran to London, dived off Tower Bridge and than ran back to Liverpool

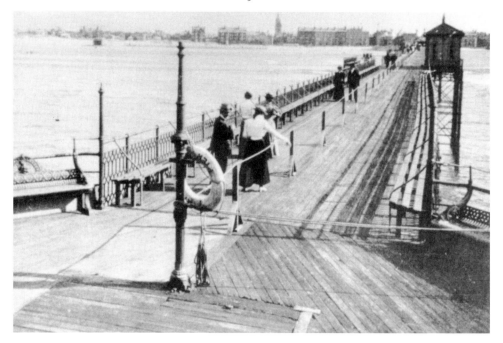

A photograph of Rhyl Pier taken in 1900-01 when the western side had been cordoned off owing to it being unsafe. This section of pier was reopened in 1902 after repair work had made it safe. (Marlinova Collection)

inside nine days. Dived among the sharks and saved the life of Professor Tom Allcroft, the Concertina King, at Cerar, South America in 1881. Dived off London Bridge twice in 1889. Dived off Runcorn Bridge (when the tide was out) from a height of 100 ft into water 5 ft 10 in deep. Dived off the roof of a carriage on the Liverpool Overhead Railway when in motion into the docks. Dived off the Forth Bridge, 21 December 1896. Dived off the Tay Bridge, 29 January 1897.

For his performance at Rhyl, a large number of people paid admission to the pier, while others took up their position on the shore and promenade or on the corner of the streets through which he was due to pass on his projected run to Rhuddlan Castle and back after a fifteen-minute entertainment in the water at the pier head and prior to his sensational high dive. It was stated that a wager of £50 had been laid that he would not carry through the allotted programme in the time stipulated.

Burns was late arriving at the pier and when he alighted from his carriage it was realised he had been 'imbibing freely' (he was drunk!). After a further delay, he mounted the diving board and dived from a height of nearly 60 ft. For more than half the distance, he retained a correct diving position, but when level with the framework of the pier, he appeared to turn over on his back; probably due to the strong wind. His body made a huge splash as it entered the water, but it did not appear to sink more than a foot below the surface. Burns appeared to recover himself after his head had been under the water for a few seconds but his face was purple when he reappeared. He did not attempt to reach the pier but started swimming about, apparently without any definite intentions. Gradually he went away from the pier using the breast stroke and then side stroke, and at times floating on his back.

After Burns had been in the water close on half an hour, it was observed that his head had dropped. No appeal for help had come from Burns but it was clear he was not himself.

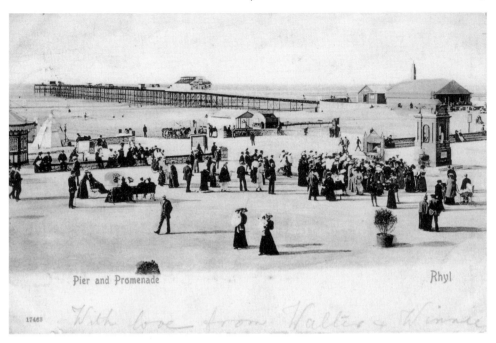

Pier and Promenade Rhyl

A postcard from 1902 showing Rhyl Pier after the destruction of the Grand Pavilion. The wooden buildings erected on its site were much derided as eyesores and were eventually demolished in 1907. (Marlinova Collection)

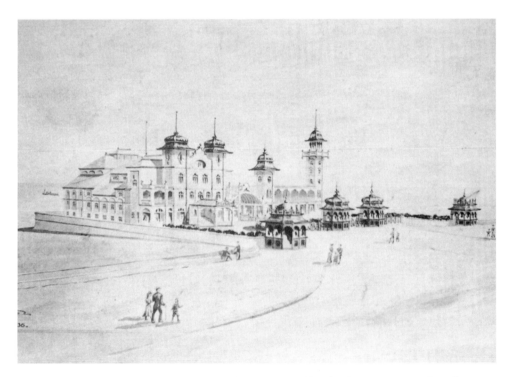

This elaborate building was drawn up by architects Maxwell and Tuke in 1905 to replace the Grand Pavilion but the precarious finances of the pier owners ensured that it was never built. (Marlinova Collection)

The eventual replacement for the Grand Pavilion was the much plainer Pier Amphitheatre, unusually seen here from the pier, after it was opened in June 1907. (Marlinova Collection)

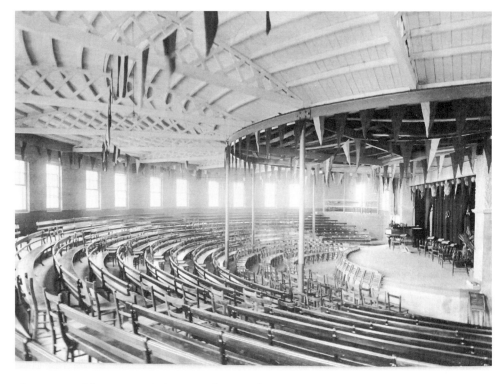

The interior of the Pier Amphitheatre in the year that it opened, 1907. Adeler & Sutton's Pierrots were the feature act in that first season, having previously performed outside at the entrance to the pier. (Marlinova Collection)

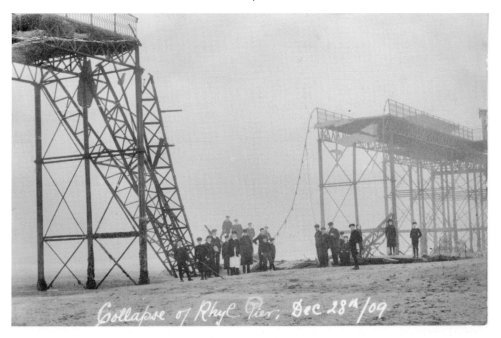

The collapse of a 90-ft section of Rhyl Pier on 28 December 1909 due to a weak supporting pile is vividly captured on this postcard by the Magnet Studio. A ship had gone through the same section of pier some years earlier. (Marlinova Collection)

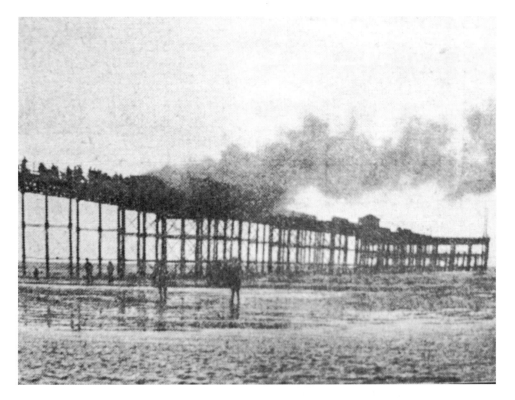

On 30 August 1911, the pier suffered a further calamity when one of the shops on the pier caught fire. (Marlinova Collection)

The original wooden exterior of the Pier Amphitheatre, seen here in 1921 just before it was rebuilt in brick at a cost of £4,000. (Marlinova Collection)

Professor Baume went over the side of the pier and, after reaching Burns, he was heard to call for assistance. Mr A. MacCanna, a member of Rhyl Swimming Club, entered the water and after a hard swim reached the two men. The two rescuers gradually succeeded in bringing Burns to the side of the pier, where a lifebuoy and a couple of ropes and a lifeline were lowered and William Thomas went down to help.

Burns was hauled up onto the pier and Captain Veale, Inspector Williams and the coastguard, with the help of others, did all they could to restore life, but after twenty minutes it was clear that Burns was dead.

The news spread like wildfire around the town and within a short time Mr R. M. Evans developed a 'splendid' negative he had secured of Burns' last dive. A print was exhibited in his shop in the High Street at an early hour and throughout the evening it was almost impossible to pass along the pavement by the Magnet Studio, so great was the crowd of people anxious to see the picture.

At the inquest, a verdict of accidental death was returned. It was revealed that Tommy Burns was born at Liverpool on 21 January 1868 and was in his thirtieth year when he met his death. He saved forty-four lives in total; including Mr W. Gale, a well-known steeplechase jockey, and was the first and only man to dive from the roof of the Royal Aquarium into a tank only six feet deep. He was laid to rest in his home town, where his body was carried from the Pier Head to the railway station by members of Tom Woods' minstrel troupe, followed by his widow and one of her friends. A coffin was provided by the pier, but a collection had to be taken up for the penniless Mrs Burns. She also received funds from a benefit performance of diving held by Professor Heaton at Rhyl Pier on 26 July 1897, rather garishly described as a 'dive from the death board'. Heaton remained at the pier for the 1898 season and swam between Rhos and Rhyl piers.

A similar diving fatality almost occurred off the pier in 1903. Miss Beaumont, 'Lady Diver and Aquatic Parachutist', almost came to grief after she parachuted off the pier in a force eight gale, but luckily she was rescued by a boat.

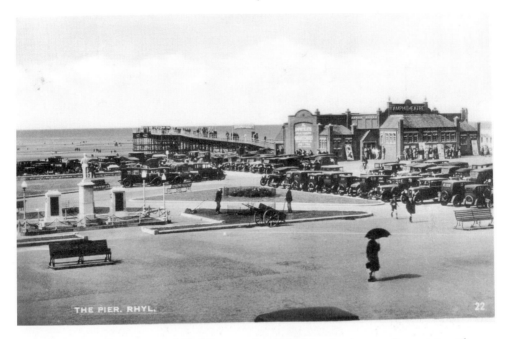

During the 1920s, the majority of Rhyl Pier was demolished, leaving just 435 ft remaining. The remainder was reopened in 1930. The pier is seen here in the mid-1930s, along with the Pier Amphitheatre as rebuilt in brick. (Marlinova Collection)

In 1898, Rhyl's early film maker Arthur Cheetham showed his 'living pictures' to a packed audience in the Grand Pavilion, which by this time was sporting large advertisements on its exterior, to much criticism. Attractions on the pier in 1899 included a water carnival with swimming races, diving competitions and walking the greasy pole. Frank Sinclair dived off the pier, and the Royal Pierrots performed in the Bijou Pavilion, admission 3d. Adeler & Sutton's Pierrots appeared outside the New Kiosk at the entrance to the pier.

Despite the big improvements they had made to the pier, the Rhyl Pier & Pavilion Company had made a loss during each year of their ownership. In 1896, the pier passed into the hands of the mortgage holders Greenhalgh and Geary, who were owed £15,303. The Rhyl Pier & Pavilion Company was declared bankrupt and was dissolved on 26 July 1899.

The pier passed into the hands of Messrs Carter and Warhurst, of Manchester, on 10 January 1898. Warhurst had been a director of the Rhyl Pier & Pavilion Company and the pair took on the £4,162 mortgage owed by the company, and called themselves the Victoria Pier & Pavilion Company. However, the pier was reported to the Board of Trade as unsafe and so it was inspected. (Maintenance of the pier had been carried out by the Pier Master, F. Jones, who was previously an ironworker and had served his apprenticeship during its construction.) The pier was found to be generally safe, but when examined again in 1900 the report was damning. The wooden decking was found to be rotten in many places, and underneath the pier head, a number of the piles were 9-12 in out of perpendicular and many diagonal bracings were broken off. A chain and stake and an iron strut had been driven into the sand to help stabilise the pier head, although the owners of the pier claimed that the pier head piles had been out of perpendicular when erected. In August 1900, the whole of the western side of the pier was declared unsafe and was cordoned off and pier head attractions were no longer allowed. In June 1901, parts of the barrier were opened to allow access to the lavatories, shops and Bijou Pavilion and, following repair work, in 1902 the whole of the pier was reopened.

The pier appeared to be jinxed. On 27 July 1899, a fire broke out in a kiosk used by Professor Vernon, a palmist. A high wind spread the flames quickly, but the pier staff

For forty-three years from 1921 to 1964, the very popular Billie Manders' Quaintesques were resident in the Pier Amphitheatre. This programme from 1931 shows Billie dressed as a female impersonator. (Marlinova Collection)

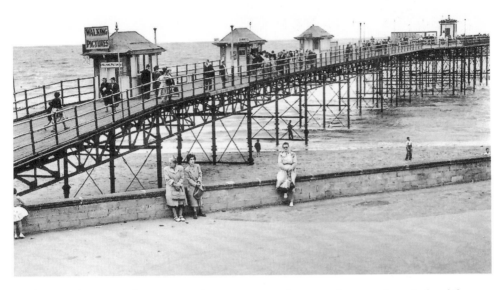

Rhyl Pier in the 1950s, when its attractions were a man demonstrating muscle control and the three little shops. (Richard Riding)

began fighting the blaze and, assisted by Rhyl Fire Brigade, soon had the fire out. On 27 February 1903, a kiosk was overturned and railings were destroyed during a severe storm. However, the biggest disaster to affect the pier in the early years of the twentieth century was the destruction by fire of the Grand Pavilion. Although the outer walls were double-walled and waterproof, they were sadly not fireproof and, on 13 September 1901, the building, and its Jubilee Organ, were completely destroyed in a night-time blaze. A scheme to replace the Grand Pavilion in 1905 with an elaborate domed pavilion in a classical style by the well-known engineers Maxwell & Tuke failed to materialise and a plain wooden building, erected after the fire and much derided by the council as an eyesore, was left on the site until it was demolished in January 1907. This was replaced in June 1907 by another rather unassuming building known as the Pier Amphitheatre, erected by Messrs Stirling & Hughes. This became home to Adeler & Sutton's Pierrots, who had previously performed by the pier entrance kiosks. The Amphitheatre was the first stage of another grand Maxwell and Tuke plan for the pier entrance with the design of a courtyard of Tudor-styled buildings incorporating shops, tearooms and a billiard hall, none of which was built. In January 1910, Maxwell and Tuke (under the guise of the North Wales Maritime Works Limited) submitted a plan to encase the pier in ferro-concrete, widen by 26 ft and lengthen it by 1,950 ft, incorporating a 600-ft landing jetty, at a total cost of £52,780. They formed the Rhyl Pier Company with a capital of £70,000 in £1 shares and gained authorisation to carry out the work with the Rhyl Pier Order 1910. In addition to enlargement, the order also authorised a dining room for 300 persons and a licensed refreshment room on the site of the Bijou Pavilion. A 2,000-seat pavilion was to be placed at the entrance to the pier, along with twenty-five shops, tearooms and a visitor's club, which would be free from toll. On the new pier head, a bandstand and sheltered accommodation would be provided. The Rhyl Pier Company intended to purchase the pier from Samuel Warhurst at a cost of £16,193 (£9,193 in cash and £7,000 fully paid-up shares of the company).

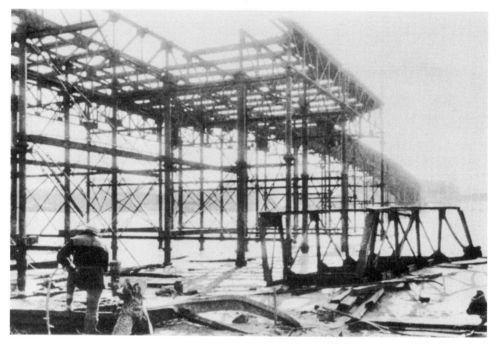

The demolition of Rhyl Pier in March 1973, seven years after it had been closed to the public for the final time. (Marlinova Collection)

Needless to say, the purchase never took place nor was the work carried out, although the pier deck from the Bijou Pavilion to the pier head was re-laid in ferro-concrete and the section from the shore to the pavilion with tarmac. The pier's length at this time was measured at 2,238 ft, of which the deck was 1,947 ft and the land part, 291 ft.

The pier suffered a further calamity on 28 December 1909, when a succession of storms caused the disintegration of a pile in an already weak point, leading to a 90-ft section of the pier collapsing into the sea. This was the same section of pier that had seen a steamer cut through some years earlier. On 30 August 1911, there was more damage when a blaze broke out in one of the shops.

By 1910, steamers only ran from the pier at the height of the season and at the end of the following year they ceased altogether. The pier was losing money heavily, having not made a profit since 1907, and having become dilapidated, was declared unsafe in 1912 with £50,000 worth of repairs needed. For a number of years the council had expressed a wish to buy the pier but were not prepared to meet the asking price, although in 1912 they had applied to the Local Government Board for a loan of £7,250 to purchase the pier. When this was not forthcoming, Warhurst (the sole owner since Carter's death in January 1905) put the pier up for auction on Tuesday 18 February 1913 with the advertisement:

To be sold by auction at the Albion Hotel, Piccadilly, Manchester, with land herewith, also 3,611 square yards of building land on Rhyl foreshore. The pier is about 2,000 ft long with a deck area of 4,954 square yards, refreshment room, Bijou Theatre and spacious Amphitheatre seating 600 with a holding capacity of 1,000. At the pier head is a jetty providing landing accommodation for steam ships.

However, no bids were made and Rhyl Council stepped in to purchase the pier for £1,000. Ratepayers had previously been asked to sanction the purchase of the pier, but only 542 votes were received from the 2,317 balloted.

The pier was condemned and closed to the public, while the council considered what to do with it. One proposal was to take it down and rebuild half of it opposite the Pavilion. In January 1915, the council received an estimate of £15,750 to take down the Bijou Pavilion, remove the pier head and jetty and construct a new pier head. However, the pier, particularly the sea end, continued to suffer damage by storms and by 1917 was in a very dilapidated condition with parts of the ironwork missing. The buildings on the pier were all ruinous, including the Bijou Pavilion, which had not been used for over ten years and the Pier Amphitheatre, with its stucco walls and felt roof, was described as a 'miserable place'. In 1918, the Ministry of Munitions enquired to the council whether the pier was available for scrap iron. The pier's only usage during the First World War was when the crew of a captured German submarine were landed on it.

In 1919, the council applied to purchase the freehold of the foreshore upon which the pier stood. A sale was agreed in March 1920 whereby a payment of £674 was made upon the signing of the agreement and an annual payment of £388 10s was to be paid for ten years. The Pier Amphitheatre, meanwhile, was rebuilt in brick in 1921 at a cost of £4,000 and featured seating for 800 in raked benches surrounding a semi-circular stage. Billie Manders' Quaintesques were a regular feature at the Pier Amphitheatre from 1921 to 1964.

After toying with the idea of restoring the pier and extending it by a further 1,800 ft, the council decided to retain half and demolish the rest, along with the Bijou Pavilion. Demolition commenced in 1923 and, in December of that year, a fire hit the seaward end during dismantling. It was believed that the blaze was caused by acetylene gas cylinders stored in buildings on the pier. In March 1924, a further 60-ft section was demolished by a steam tug. By May 1924, the outward half up to the coastguard lookout had been removed for scrap. The council intended to restore the remaining half and, in 1927, applied to the Ministry of Health to borrow £11,180 to carry this out. However, before this could take place, a further section of the pier was damaged by gales during the winter of 1927/28. In 1928, the council applied once more for a loan, this time for £21,000, which would cover the cost of the restoration (£12,580) and the addition of an open-air swimming pool, children's cycling track and public conveniences.

In 1930, the pier was finally reopened to the shortened length of 647 ft (including the 202 ft amphitheatre). The pier featured shelters, shops and a camera obscura. For a time, it was home to a miniature circus, and also a man displaying muscle control. However, the council's lack of commitment to the structure was highlighted in 1940 when it was almost dismantled for scrap. After the war, the pier reopened, but led rather an uneventful life until it was declared unsafe in 1966 and closed. For six years it was left to deteriorate and in autumn 1972 the council advertised for tenders for the pier's disposal. Work began on dismantling it in March 1973 and within a few months the structure was no more. The last remnant of the pier, the old Pier Amphitheatre on the shore, later known as the Gaiety Theatre, was demolished in September 1991.

PIERS THAT NEVER WERE

Barry Island/Ynys-y-Barri – On 11 August 1893, the *Western Mail* reported, 'PROPOSED NEW PIER FOR BARRY. Barry has been visited this week by a gentleman representing a well-known firm from the Midlands, who have a scheme afoot for the construction of a fine new pier off Barry Island. If the work is proceeded with it will involve the expenditure of several thousand pounds.'

Presumably the well-known Midlands firm must have changed their minds as nothing further was heard of their scheme.

Porthcawl – The Porthcawl Improvements Syndicate announced plans to build a pier for the resort in November 1911. The pier, to be located between the Seabank House Hotel and Caroline Street, was to be 600 ft long and 30 ft wide with a pavilion and landing stage. The estimated cost of the pier was £18,640 and an open-air swimming pool was also envisaged.

However, there were many initial objections to the pier. Owners of the properties 'Mainda', 'Heathlands' and 'Brynymer' claimed the pier would destroy the value of their properties. The Porthcawl Chamber of Trade and the Ratepayer's Association both opposed and Porthcawl Urban District Council claimed the pier would interfere with their plans to extend out the sea wall. The pleasure steamer company P. & A. Campbell objected, as their business calling at the existing harbour pier during the summer would be injured. The syndicate countered by claiming the harbour was derelict.

A Public Inquiry was called for 27 March 1912, which was then put back until 3 April. However, the enquiry failed to take place as, one by one, the objectors withdrew their objections, including P. & A. Campbell and the council, who were to be given land by the syndicate to widen the promenade.

The Provisional Order to build the pier was granted on 3 June 1912 but the finance could not be raised and so the scheme never got off the drawing board.

Langland Bay – In 1893, the New Langland Bay Company applied to the Board of Trade to construct a pier for the use of both visitors staying at the Langland Bay Hotel (opened on 29 May 1893) and pleasure craft. The local landowner, the Duke of Beaufort, gave his consent for the pier to be built. It was envisaged the structure would be 300 ft long, later to be extended to 600 ft, possibly built of concrete and iron. Notices were posted in *The Cambrian* on 22 and 29 September 1893 and *Cambria Daily Leader* on 13 and 20 October 1893 but the pier was not built.

Llansteffan – On 12 December 1876, the Llanstephan Pier & Steam Ferry Company was incorporated with a capital of £6,000 (1,200 shares of £5) to provide 'communications and conveyances for passengers, goods and cattle between Llanstephan and Ferryside'. No support was forthcoming however and only twenty-one shares were ever taken up, leading to the company being dissolved on 22 January 1886.

The site of the proposed pier at Porthcawl in 1911-12, which would have been 600 ft long and housed a pavilion and landing stage. (Marlinova Collection)

Tenby/Dinbych-y-pysgod –The first proposal for a pleasure pier for Tenby was in 1868 when a Bill authorising the building of an iron pier received the Royal Assent on 25 June that year. However, the plan soon foundered.

A second attempt to build a pier was made in 1880 when the Quay Committee suggested building a 700-ft structure out from the south-eastern corner of Castle Hill, but the scheme was abandoned when it was decided that the location was too exposed.

In 1892, an application was made for a landing pier in the harbour extending 120 ft seawards from the western end of the sluice. The pier was to have been financed by the Mayor of Tenby, Clement Williams, and was to be free for landing passengers from small boats when the main harbour was unavailable. At the same time a pier was proposed for the more sheltered north-easterly corner of Castle Hill. This was promoted by the Tenby Pier and Promenade Company, whose prospectus proclaimed,

The steamboat service from Bristol and other ports has been carried on for many years under great disadvantage and inconvenience, as there is only sufficient depth of water for a short space of time at high tide to enable vessels to come alongside the present harbour jetty, and passengers have to be landed in small boats and the vessel will remain until the following tide in order to discharge her cargo. It may, therefore, be reasonably anticipated that a greater passenger and goods traffic must result with such perfect accommodation as the company's pier will afford.

The company had been registered on 15 December 1892 with a capital of £30,000 in 6,000 shares of £5 and a Provisional Order to build the pier, granted by the Board of Trade on 25 April 1893. Richard St George Moore (also responsible for Brighton Palace, St Leonards and Swanage piers) designed the pier and a contract for its construction at a cost of £22,000 had been given to H. B. Price, who commenced work in March. The pier plans were submitted to and approved by the Mayor and Borough of Tenby in July 1893 (not surprising since the company included council members) and the Bill for its erection received the Royal Assent. However, the company quickly realised that their plans were too ambitious and, on 20 September 1893, a special resolution was passed that it should be voluntarily wound up and reformed with a capital of £20,000 in £1 shares. Price's contract price was reduced to £15,000 (of which £10,000 would be raised by cash, the remainder by debenture shares) but, on 5 October 1893, he was declared bankrupt and the work stopped after three abutment arches had been built. The arches were utilised in the building of a lifeboat station on the site in 1895.

In May 1895, the Board of Trade was informed that Tenby Corporation was planning to take on the building of a pier and landing stage (which opened as the Royal Victoria Pier in 1897) and that the Tenby Pier & Promenade Company had been wound up. The company was dissolved on 15 September 1896.

South Barmouth (Fairbourne) – A proposal was made to build a pier for this small resort, but got no further than that.

Pwllheli – Pwllheli is one of the main seaside resorts of the Llŷn Peninsula of north-west Wales and during the 1890s there were two separate pier proposals for the resort. The town's initial seafront development was undertaken by three local men – David Evan Davies (a Calvinistic Methodist minister and chartered accountant), Edward Jones (a grocery businessman who was mayor for four consecutive years) and Robert Jones (a bank manager and town mayor on a number of occasions). Davies and Robert Jones had been trying to raise capital to develop the sea front since 1880 but had been largely unsuccessful until Edward Jones became involved in 1886-87. An agreement was reached with the Churton Estate, whereby the latter would build a sea wall, esplanade and roads while the partnership purchased the land and built houses. The foundation stones of the new houses were laid on 6 December 1888 when the whole town had a public holiday and a grand procession took

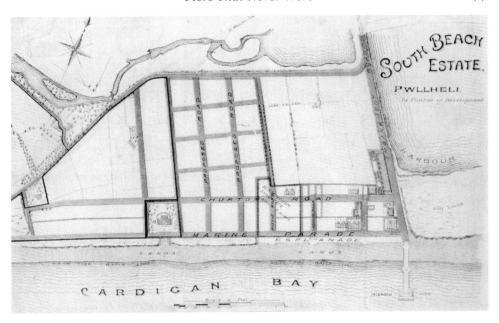

The South Beach area of Pwllheli was also earmarked for a pier, as this plan from *c.* 1890 shows. However, like its counterpart in the West End district of the town, it was never built. (Marlinova Collection)

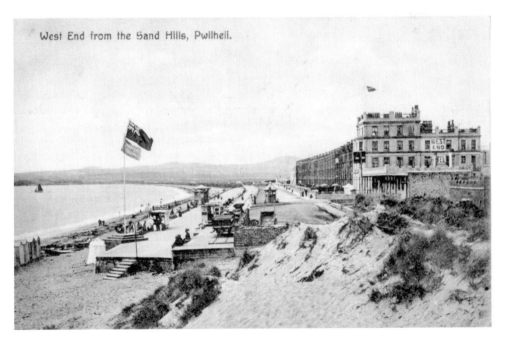

A pier was proposed for the West End area of Pwllheli in 1899 and if built would have extended out opposite the West End Hotel where the kiosk fronts the beach. (Marlinova Collection)

place. By Easter Monday 1890, the sea wall promenade and five of the houses of the South Beach Estate were ready for occupation. Unfortunately, during the opening ceremony the wooden platform collapsed and some took this as an ill omen.

Nevertheless, the development continued and, by the summer of 1893, there were two hotels and twenty-six houses comfortably full of visitors. In that year, a successful Cardiff businessman named Solomon Andrews purchased land to the west of the South Beach development, which was christened the West End Estate. The West End Hotel was the first building to be erected by Andrews, followed by a terrace of houses facing the sea, a parade and a road to the town (Cardiff Road). A tramway was laid to the Carreg-y-defaid quarry, which supplied stone for the development, and this was adapted in 1896 to carry passengers. The tramway was extended to Llanbedrog in 1897, where Andrews converted the Glyn-y-weddw mansion into an art gallery and concert room.

Whilst Andrews' development appears to have had a sound financial footing, the South Beach development was in trouble by 1893 owing to difficulties in raising additional capital and a deteriorating relationship between Davies and Robert Jones on the one hand and Edward Jones on the other (the latter's attempt to become mayor for the fifth consecutive year in 1891 was not supported by the other two). The South Beach Temperance Hotel was failing to attract customers and attempts to build a sanatorium and pier foundered. A pier was shown on maps and plans of the South Beach in the early 1890s, but it appears that a company was never formed nor was Board of Trade sanction sought. In 1895, Edward Jones was declared bankrupt: one of his liabilities being £500 owed to David Davies. The partnership split.

A pier was also part of Solomon Andrews' plans for the West End Estate and, on 1 December 1899, the Pwllheli Pier Company was incorporated with a capital of £10,000 in 1,000 shares of £10 pounds each. The directors were Andrews and his son Emile, who held fifty shares each. The pier was designed by John Hughes, architect, surveyor and civil engineer, of Pwllheli and Colwyn Bay. Alas, as with the South Beach pier, the plan came to nothing and the company soon foundered, although it was not dissolved until 20 March 1923.

The council, often in association with Solomon Andrews, began to take an active role in the promotion of the resort following the failure of the South Beach partnership and, in 1899, they established a tramway between the South Beach and Pen-y-cob. However, this proved to be less reliable than its West End counterpart and was closed in 1920. The West End tram was severely damaged by a storm in October 1927 and was closed the following year. In 1916, the council had finally united the rival South Beach and West End parades by the construction of a new promenade.

Red Wharf Bay, Llanbedrgoch – Thomas Evans wished to build a small pier in 1894 at Red Wharf Bay in the parish of Llanbedrgoch on Anglesey. This failed to happen, although the London & North Western Railway did open a branch to the bay from Holland Arms on 24 May 1909. However, this closed to passengers on 22 September 1930 and to goods on 4 August 1952.

Penmaenmawr – The pier was proposed by the Penmaenmawr Pier Company, incorporated on 29 November 1881 with a capital of £10,000 in £10 shares. The main subscribers to the company were

> Henry Kneeshaw, of Penmaenmawr, quarry proprietor, twenty-five shares
> Captain Octavius La Touche, of Penmaenmawr, ten shares
> Robert Hughes M.D., of Penmaenmawr, ten shares
> C.H. Darbyshire C.E., of Penmaenmawr, ten shares
> J. Atkinson, of Penmaenmawr, twenty shares
> W.H. Wilson, of Penmaenmawr, general dealer, ten shares
> Hugh Davies of Penmaenmawr, accountant, two shares

A Provisional Order was granted on 23 December 1881 and a design for a 1,200-ft pier was prepared by James H. Lynch at a cost of £7,166. However, there was an objection by the London & North Western Railway regarding the site of the pier, close to McDonald's Bathing House, on the grounds that it would injure their railway works and sea wall. The objection was withdrawn in February 1882 after a clause had been agreed upon for the protection of the railway company.

Unfortunately, there was a further objection in March 1882 from the operators of the commercial pier, used for the shipment of stone from the neighbouring quarries. They claimed that the length of the pier would make it more difficult for craft to approach their commercial pier. Amendments to the design were made to limit its length to no greater than 990 ft and to re-site it opposite McDonald's bathing house. The Penmaenmawr Pier Bill was passed on 5 May 1882, but no pier was ever built.

Llandudno Victoria – The opening of the Victoria Palace in 1894 by a company that included conductor Jules Rivière was, in the original plans, to have been accompanied by a pier.

Rivière had formerly been conductor of the Llandudno Pier Orchestra but had fallen out with the directors of the pier in 1892 and left to form the Victoria Palace Company, incorporated on 3 June 1892 with a capital of £30,000 in 3,000 x £10 shares. Upon the opening of the Victoria Palace (also known as Rivière's Concert Hall) in July 1894, Rivière established a forty-two-piece orchestra at the 1,015-seat venue, which attracted the eminent piano and violin soloists Sir Charles and Lady Hallé in 1895.

An associated company, the Llandudno Victoria Pier Company, was registered on 17 November 1896 by a group of fifteen local men with the intention of building the pier. One of the local directors was William Horton, who had purchased Rhos-on-Sea Pier in May 1896. The original list of shareholders included three grocers, a butcher, an ironmonger, a draper, a builder, an auctioneer, a surveyor, a gentleman, two hotel manager/proprietors and three solicitors. The company had a capital of £20,000, divided into 4,000 shares of £5.

Plans were drawn up in November 1896 by engineer John D. Harker of Manchester. There was considerable opposition to the scheme and so the Board of Trade sent Sir George Nares to hold an inquiry at the Victoria Palace Concert Hall the following April, to assess the nature of opposition which continued despite the approval of the council. Objections came mainly from the 'old' pier company, which envisaged the new one taking its steamers and patrons away; some locals and visitors worried that the bay would be 'mutilated'. Lord Mostyn also objected; the pier would have to cross land which he had given to the town as a grassed area and a roadway. Having weighed the pros and cons, Sir George could find no legal reason why the pier should not be built. The Provisional Order was granted by the Board of Trade in May 1897. A banquet for about fifty guests was held at the Marine Hotel to celebrate. Amongst the guests were Jules Rivière, the architect, the promoters, William Horton of Rhos-on-Sea and many other interested parties.

However, by 29 March 1897, only 139 shares in the company had been taken up and, on 24 February 1898, they divided the £5 shares into five shares of £1 each and increased its capital to £80,000 by the creation of 60,000 shares of £1 each. Negotiations were taking place with the Victoria Palace Company to acquire their undertaking following a poor 1897 season, which saw a loss of £1,670 on the concert hall. The sale had been provisionally agreed and a draft contract prepared.

The sale was not followed through, however, and little seems to have happened (apart from a conveyance of the foreshore to the company) until the company's annual general meeting in May 1899, when it was announced that contractor Messrs Heenan and Froude's tender of £90,000 had been approved. A group of directors and the architect toured the country to collect ideas and styles of seaside architecture. The pier was to be modelled on the best characteristics of the finest piers in the land and was to be 1,305 ft long and 4 ft wide at its narrowest part. The deck area was to cover some 2 ¾ acres. One hundred yards

from the entrance there was to be a Moorish-style pavilion mounted on an 'embankment' to the right of the main promenade deck. The pier head was to measure 200 ft x 180 ft and have a polygonal platform, at the centre of which there would be a circular auditorium with moveable roof and glazed windscreens, working on pivots allowing audiences of 3,000 persons to assemble in comfort. Entertainments of all kinds, in all seasons would be provided in the 3,500-seat pavilion, which would have a concert hall, promenade, refreshment rooms, balcony and smoking rooms. The landing stages to be constructed at the pier head would accommodate two paddle steamers at any state of the tide. The plans showed that the pier would be the prettiest and also the costliest of its kind. The contractor was very experienced in metal structures having been responsible for the erection of Blackpool Tower and other entertainment palaces and was prepared to accept part of the contract price in paid-up shares and debentures of the company. A banquet was held at the Marine Hotel in mid-May 1899 to celebrate the award of the Provisional Order. An article in the *Financial Times* the following month advised local investors to think very carefully before putting their money into the scheme. It said the company's prospectus was highly optimistic and had quoted from the Llandudno Pier Company's profits and dividends without fully explaining the figures.

The Royal Assent to build the pier was granted in 1900 and, at the beginning of January 1901, the first list of directors was registered. Of the three, two were local shareholders and the third was William Horton. However, the shares were slow to attract funds and so, after two years, they were subdivided into £1 shares and their number increased to 80,000. Nevertheless, on 1 October 1901, the secretary of the company, Alfred Pugh, informed the Board of Trade that they had not commenced business, as the application for the shares was not sufficient to warrant an allotment and on 21 April 1902 the Companies Registered Office was informed that the company had failed.

No work on the pier was commenced and the only activity was administrative: the filling in of annual returns to the Registrar of Joint Stock Companies and payment of the company's solicitors, who were two of the major shareholders, in share capital. William

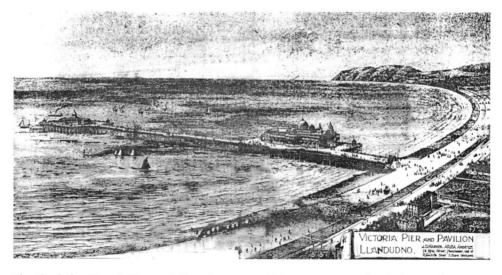

The Llandudno Victoria Pier would have been an ambitious structure with a deck area of 2 ¾ acres, a large Moorish-style pavilion, an auditorium on the pier head and a landing stage that would have accommodated two steamers at a time. Although this pier was never built, its architect, J. D. Harker, saw his pavilion designs built at Blackpool Victoria/South and Morecambe West End piers. (Conwy Archives)

The seal of the Llandudno Victoria Pier Company, formed in 1896 to provide Llandudno with a second pier, to be sited opposite the Victoria Palace. (Marlinova Collection)

Horton had been replaced on the list of directors by December 1907. He was undoubtedly too busy sorting out his problems with the pier at Rhos-on-Sea. By the end of 1910, only one director remained and of the original shareholders, three had died and two had moved away. A letter of early 1912, excused the absence of the usual annual return: the company was not carrying on any business because the pier had not been built owing to the want of capital, and the time for construction defined in the Provisional Order had lapsed. The end came on 29 August 1913 when the company was dissolved.

The shares of the parent company, the Llandudno Victoria Palace Company, were themselves never fully subscribed, with only 826 ordinary shares and 179 preference shares taken up. Following Rivière's defection to the newly formed Colwyn Bay Pier Orchestra in 1900, the decision was taken on 7 March 1901 to wind up the company. Under new management, the Victoria Palace became the Llandudno Opera House and was home to the Carl Rosa Opera Company before it was renamed the Hippodrome. In 1915, it was acquired by the famous pierrot showman Will Catlin and renamed as the Arcadia, and continued as a summer concert venue (under the auspices of Llandudno Borough Council from 1968) until 1993. In 2005, the Arcadia was demolished to make way for an extension of the North Wales Theatre & Conference Centre. Now known as Venue Cymru, entertainment continues to be provided on the site of the Victoria Palace in the shape of orchestral concerts, drama, ballet, pantomime, brass and military bands, musical comedy and ice shows.

Llandrillo-yn-Rhos – In November 1864, a Provisional Order was granted for powers to erect a pier at Llandrillo-yn-Rhos. A consortium had been formed and the Llandrillo-yn-Rhos Pier Company created. The prime mover was a local landowner named John Lewis Parry Evans of Rhos Fynach Farm. He was joined by Thomas Henry Lloyd of Llandudno, John Jones of Colwyn and Augustus Frederick Watts of Pensarn. Also named on some

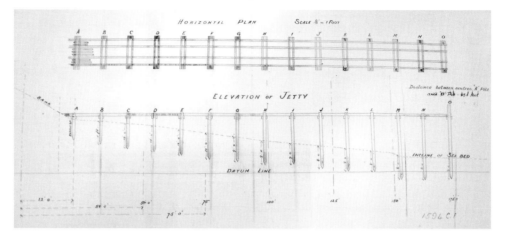

Plan for a pier at Llandrillo-yn-Rhos drawn by H. J. Muzeen, Engineer, in 1864. This was to have been built on a similar footprint to that actually erected in the 1890s. (Gwynedd Record Office XD35/208 file 19)

documents was John Richards, a wine merchant from Abergele. The solicitor for the company was Thomas Knowles, who was also involved in abortive pier schemes at Foryd and Pensarn.

At the time, Llandrillo-yn-Rhos was a tiny, scattered village at the edge of a large and ancient parish and Colwyn Bay itself did not exist: it was only in 1865 that the first house in Colwyn Bay was built. The growth of what was to become Colwyn Bay followed the sale of the Pwllycrochan Estate, by the Erskine family, in September 1865. In the sale particulars only a few farms and the small railway halt were shown, but mention was made of the proposed pier at Llandrillo to which 'steamers could ply at all times of the tide.' The Colwyn Bay Hotel, named after the new town, was not built for another eight years.

John Parry Evans owned the land adjacent to the beach where the proposed pier was to be built but application had to be made to lease the foreshore from the Crown. It was a lengthy process involving a Provisional Order with detailed plans put to the Board of Trade. If these were deemed satisfactory, a lease would be drawn up and royalty rights agreed between the Board of Trade and the Promoters, then an Act of Parliament and Royal Assent were required before construction could begin. The first correspondence was a Memorial dated 23 December 1864. It set the scene:

* The village of Llandrillo-yn-Rhos and its neighbours, has during the last few years become a favourite place of resort for visitors to the seaside.
* It would greatly add to the natural advantages of Llandrillo-yn-Rhos and its neighbours, if proper convenience for the landing and embarking of Passengers, Goods and Merchandise carried by steamers and other vessels were afforded by the constructing of the pier.
* The construction of such a Pier, Jetty and landing place would be of public advantage to the inhabitants of Llandrillo-yn-Rhos and its neighbours and be the means of affording an agreeable place of resort and recreation for visitors to Llandrillo-yn-Rhos.
* The Memorialists and others are prepared, at their own expense, to construct the proposed pier.

Two plans were drawn up; one by H. J. Muzeen and another by James Brunlees. The original plan, for which the Provisional Order had been granted in November 1864, was submitted by Muzeen. Attempts to trace Muzeen in the Institute of Civil Engineers

records have failed. It seems that the designation 'engineer' may not have been an accurate description of his main occupation. On the 1871 census, Henry J. Muzeen was recorded as a forty-four-year-old surveyor, living in West Derby, Liverpool. Subsequent censuses record him as a surveyor/inspector of nuisances (1881) and retired land surveyor (1891). His estimate for the cost of the wooden structure was £6,000. Its length was to be 1 furlong 80 yards (900 ft), which would take it out beyond the spring tide low-water mark. Costs were kept down by setting the pier into the slope so that the start of the deck would be less than 10 ft above the level of water at a high spring tide. In fact, it was described by the engineer on the plan as a 'jetty', with no railings shown and not even a tollbooth was included in Muzeen's plans.

Muzeen's pier was soon rejected in favour of a more elaborate 1,200-ft iron pier submitted by James Brunlees. Brunlees was a highly respected railway engineer who had also built piers and docks and was involved in the abortive channel tunnel scheme of the 1870s. He was president of the Institute of Civil Engineers in 1882-83 and was knighted for his services to industry. He had designed Southport Pier, opened in 1860, and was actively engaged in 1864-65 in submitting designs for piers along the North Wales coast, of which only Rhyl went ahead at this time.

The Provisional Order for the Brunlees pier was granted in March 1865 and the Llandrillo-yn-Rhos Pier Act was passed on 5 July 1865. The conditions of the approval given by the Board of Trade and the Act required the Promoters to agree to an eighty-year lease commencing 10 October 1865 at an annual rental of £5. They were also to pay a royalty of half a penny for every ton of stone or minerals shipped from the pier. Construction of the pier had to be completed within two years of the commencement of the lease. Accounts of tolls received and of stone shipped were also to be submitted at regular intervals.

Lack of finance ensured that work on the pier was never started. However, a pier was later built on the site in 1895 (see Rhos-on-Sea Pier).

Pensarn (Abergele) – A Provisional Order for the construction of a pier was applied for in 1864 by the Pensarn (Abergele) Pier Company. This was another pier company (see Voryd and Llandrillo-yn-Rhos) overseen by Thomas Knowles with a pier designed by noted pier engineer James Brunlees. They proposed 'a pier or jetty (with a landing stage) commencing opposite to and below the railings on the roadside against the bridge over the Chester and Holyhead section of the London and North Western Railway near Abergele station on that railway and extending in a northerly or north-westerly direction towards and beyond the low-water mark, a distance of six hundred yards (1,800ft) or thereabouts'. Notice was given in the *London Gazette* on 29 November 1864 for the application of the Provisional Order, which was granted early the following year. However, the finance for the project was not forthcoming.

In 1893, there was a further proposal to build a pier, for both the landing of goods and passengers. During a meeting held on 4 November that year, chaired by J. P. Earwaker, Chairman of Abergele and Pensarn Local Board, Mr John J. Hammond of Rhyl presented a plan of the pier. It showed that it was to be 750 ft in length and 12 ft wide with a toll house on the shore and a landing jetty with crane at the seaward extremity. At 15-ft tides there would be ten feet of water at the pier head. The estimated cost of the pier was £1,423 14s 6d, and the cost of the formation of the company about £500, but it was suggested that a company be formed with a capital of £10,000. It was claimed the pier would enable local traders to receive and ship their goods at half the cost charged by the railway company.

The Abergele & Pensarn Pier Company was formed following the meeting and, in December 1893, directors went to view the 1,000-ft Iron Pier for sale at Douglas, Isle of Man, which was available for £1,200. To re-erect the pier at Pensarn would have cost a further £1,300, so the company declined to buy it. The company soon foundered and Abergele and Pensarn never did acquire their pier.

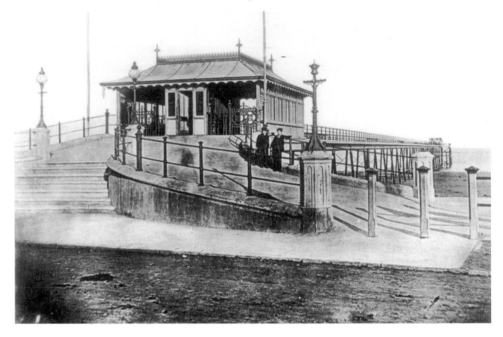

This is the Iron Pier at Douglas that was offered to the Abergele & Pensarn Pier Company in December 1893 but not taken up by them. The pier was long thought to have been re-erected at Rhos-on-Sea in 1895 but this book disproves that theory and it was actually dismantled for scrap in 1894. (Marlinova Collection)

Voryd (Foryd) – The third of the three piers in 1864-65 involving solicitor Thomas Knowles, none of which were ever started.

Knowles had been previously involved with the Rhyl Promenade Pier Company but had left following a dispute. He founded the Foryd Pier Company and the Board of Trade were informed on 23 December 1865 that the pier was to be 1,800 ft long and designed by James Brunlees at an estimated cost of £10,000. It was to be sited at Foryd, in the parish of Abergele, 100 yards westward of a house formerly used as a telegraph house by the Liverpool Dock Trust, but which was now in the hands of Hugh Robert Hughes of Kinmel Park, near to the terminus of the existing branch of the Vale of Clwyd Railway. Hughes was prepared to grant the land for the pier as long as it was built within eighteen months of the confirmation of the Pier Order and he was paid £150 per acre.

The application for the Provisional Order was announced in the *London Gazette* and *Denbighshire & Flintshire Telegraph* in January 1866 but was opposed by the Rhyl Promenade Pier Company, whose pier was under construction only 1 ¼ miles away from the Foryd pier site. Nevertheless, the Provisional Order was granted in March 1866, although just three months later, the Board of Trade was informed that the Foryd Pier Company had decided not to proceed with the Bill for the confirming of the Provisional Order.

SOURCES

General

Past and Present Steamers of North Wales by F. C. Thornley (T. Stephenson and Sons 1952)

West Coast Steamers by C. L. D. Duckworth and G. E. Langmuir (T. Stephenson and Sons 1953)

Seaside Piers by Simon H. Adamson (The Batsford Press 1977)

Seaside Entertainment: 100 Years of Nostalgia by Bill Ellis (Countryside Publications 1985)

Pavilions on the Sea by Cyril Bainbridge (Robert Hale 1986)

Entertainment in Rhyl and North Wales by Bill Ellis (Chalford Publishing 1997)

Guide to British Piers, 3rd Edition by Timothy J. Mickleburgh (National Piers Society 1998)

Piers and Other Seaside Architecture by Lynn Pearson (Shire Publications 2002)

The Liverpool & North Wales Steamship Company by John Shepherd (Ships in Focus Publications 2006)

Lancashire's Seaside Piers by Martin Easdown (Wharncliffe Books 2009)

Penarth

National Archives BT31/15335/39495

National Archives BT31/4242/27494

National Archives MT10/583

Penarth – Piers Information Sheet No. 37 by Tim Mickleburgh (Piers Information Bureau 1990)

Penarth Pier 1894-1994 by Phil Carradice (Baron Birch for Quotes 1994)

Penarth: the Garden by the Sea by Barry A. Thomas (author 1997)

Penarth – The Story, Volume 1 by Phil Carradice (Penarth Press 2004)

Victorian and Edwardian Penarth by Barry A. Thomas (author 2007)

Barry Island/Ynys-y-Barri

National Archives MT10/196

Barry Herald (various editions)

Western Mail 11/8/1893

Old Barry in Photographs by Brian C. Luxton (Stewart Williams 1977)

Old Barry in Photographs, Volume II by Brian C. Luxton (Stewart Williams 1978)

Barry in Old Picture Postcards by Tom Clemett (European Library 1998)

Aberavon/Aberafan

National Archives MT10/946

Glamorgan Gazette (various editions)

Port Talbot Guardian 13/12/1957, 14/9/1962, 9/10/1964

Port Talbot and Aberavon by Keith E. Morgan (Tempus Publishing 1997)

Porthcawl
National Archives MT10/1437

Mumbles
National Archives BT297/675
National Archives MT10/604
National Archives MT81/240-1
Bristol Mercury and Daily Post (various issues)
Western Mail (various issues)
Daily News 31/7/1885
The Story of the Village of Mumbles by Gerald Gabb (D. Brown and Sons 1986)
The Life and Times of the Swansea & Mumbles Railway by Gerald Gabb (D. Brown and
 Sons 1987)

Langland Bay
National Archives MT10/622

Llansteffan
National Archives BT31/2292/11048

Tenby/Dinbych-y-pysgod
National Archives BT31/5462/37782
National Archives BT31/5703/39864
National Archives MT10/604
National Archives MT10/619
National Archives MT10/651
Tenby Observer (various editions)
Western Mail (various editions)
The Era (various editions)
Liverpool Mercury 6/2/1882
Bristol Mercury and Daily Post 30/3/1893
Illustrated London News 13/5/1899
The Royal Victoria Pier, Tenby (Tenby Museum and Art Gallery Fact Sheet 6 1995)
Tenby in Old Picture Postcards by Evelyn Skone (European Library 1985)
Fair and Fashionable Tenby: Two Hundred Years as a Seaside Resort (Tenby Museum
 1987)

Abertsytwyth
National Archives BD11/1718-20
National Archives BT31/751/293c
National Archives BT31/15075/31455
National Archives BT31/1717/6251
National Archives CRES 58/1423
National Archives MT10/1301
Cambrian News (various editions)
Aberystwyth Today by Howard C. Jones (Stewart Williams 1980)
Born on a Perilous Rock: Aberystwyth Past and Present by W. J. Lewis (*Cambrian News*
 1980)
A Fashionable Watering Place by W. J. Lewis (*Cambrian News* n/d)

Aberdovey/Aberdyfi
A Riverside Story: the History of Aberdyfi Wharf and Jetty by Hugh M. Lewis (author
 1972)

Tywyn
National Archives BT31/2289/11025
National Archives MT10/230
Cambrian News (various editions)
North Wales Chronicle 15/8/1868
Daily News 8/11/1879
Tywyn Pier by Jeremy S. Wilkinson (Journal Of the Merioneth Historical and Record
 Society Volume IX 1984)
John Corbett: Pillar of Salt 1817-1901 by Barbara Middlemass and Joe Hunt (Saltway Press
 1985)
The Tal-y-llyn Railway by J. I. C. Boyd (Wild Swan Publications 1988)
Aberdyfi: The Past Recalled by Hugh M. Lewis (Y Lolfa 2001)

Pwllheli
National Archives BT31/16306/64379
Y Genedi Cymreig 24/4/1900
Old Pwllheli: A Collection of Pictures, Volume 1 by W. Alister Williams (Bridge Books
 1990)
Pwllheli: A Collection of Pictures, Volume 2 by W. Alister Williams (Bridge Books 1991)
Pwllheli: An old Welsh Town and its history by D. G. Lloyd Hughes (Gomer Press 1991)

Red Wharf Bay, Anglesey
National Archives MT10/410

Menai Bridge/Porthaethwy
National Archives MT10/407
National Archives MT10/673
National Archives MT10/1497
Menai Bridge and District Civic Society Newsletters
Menai Bridge (St George's) Pier – Piers Information Sheet No. 7 by Robert L. Eastleigh
 (Piers Information Bureau 1989)
Liverpool Mercury 14/6/1850, 9/4/1887, 17/11/1897, 7/6/1900
North Wales Chronicle (various editions)

Beaumaris
National Archives MT10/796
Beaumaris and Anglesey Papers [B&A] 1-6 Section VI 222-226 held at Bangor University
Beaumaris Town Council minutes held at Bangor University
Beaumaris Pier – Piers Information Sheet No. 10 by Robert L. Eastleigh (Piers
 Information Bureau 1989)
North Wales Chronicle (various editions)
Y Gened Cymreig 7/4/1896, 8/9/1896
Liverpool Mercury 23/2/1891
Daily Post 26/3/2010
www.penmon.org.uk
www.beaumarislifeboat.com
www.anglesey.gov.uk

Bangor
National Archives CRES 58/1358
National Archives MT10/1228
Bangor Pier – Piers Information Sheet No. 18 by Robert L. Eastleigh (Piers Information
 Bureau 1989)

North Wales Chronicle (various editions)
North Wales Observer and Express
Mate's Illustrated Guide to Bangor 1901
Williams' Sixpenny Guide to Bangor and Neighbourhood c. 1902
Bangor 1883-1983: A Study in Municipal Government by Peter Ellis Jones (University of
 Wales Press, Cardiff 1986)
A Seaside Restoration (*Contract Journal* 7/4/1988)
Bangor Souvenir Programme 7 May 1988
Bangor Pier 1896-1988 by Ian Skidmore (Community Task Force 1988)
Bangor: A Pictorial History, Volume 2 by John Cowell (author 1997)

Penmaenmawr
National Archives MT10/346
National Archives MT10/372
Liverpool Mercury 7/11/1881
Y Genedi Cymreig 24/11/1881
Liverpool Mercury 5/5/1882

Deganwy
www.wikipedia.org/wiki/trefriw

Llandudno
National Archives ADM 326/488
National Archives BT31/1440/4254
National Archives CRES 49/1654
National Archives CRES 49/1977
National Archives CRES 58/906
National Archives MT10/1247
National Archives MT10/1584
Ivor Wynne Jones Archive, Conwy Archives
Conwy Archives XBT Marine Maps 55/3/1
Conwy Archives XBT Marine Maps 573
Conwy Archives XBT Marine Plans 2172
Conwy Archives XBT Marine Plans 4998
Liverpool Mercury 5/1/1863
Llandudno Advertiser 8/3/1884, 11/1/1908, 25/1/1908
North Wales Chronicle 23/1/1869, 23/9/1876, 11/8/1877, 22/12/1877, 14/7/1891
Llandudno, Queen of the Welsh Resorts by Ivor Wynne Jones (John Jones Cardiff Ltd
 1975)
Llandudno's Story by Michael Senior (Gwarg Carred Gwalch 1986)
Llandudno and the Mostyn Influence 1861–1939 by F. Ron Williams (Mostyn Estate and
 Llandudno & District Historical Society 2002)

Llandudno Victoria
National Archives BT31/5337/36570
National Archives BT31/7116/50196
Llandudno Advertiser 4/12/1897, 20/5/1899, 7/6/1899
Freeman's Journal and Daily Commercial Advertiser, Dublin 16/5/1899

Rhos-on-Sea/Llandrillo-yn-Rhos
National Archives BT 31/5247/35686
National Archives BT31/10293/77319
National Archives BT31/11387

National Archives CRES 37/1705
National Archives J13/1360
National Archives LRR01/3452/114063
National Archives MT10/10
Gwynedd Archives (GwRO) XD35/208 File 19
Conwy Archives Marine Plans Reference 6369
Conwy Archives census records 1861, 1871, 1881 and 1891
Denbighshire Record Office Porter Paper Archives DD/PO
Denbighshire Record Office UDD/A/1/1929
Denbighshire Record Office QSD/DU/2/14 Rhos-on-Sea Pier Accounts 1920-30
Weekly News and Visitors Chronicle (various editions)
Isle of Man News 16/6/1894
The Times 5/6/1908
North Wales Weekly News (various editions)

Colwyn Bay/Bae Colwyn
National Archives BT31/15863/54760
Colwyn Bay Victoria Pier – Piers Information Sheet No. 57 by Lester A. Kitching (Piers
 Information Bureau 1990)
North Wales Weekly News (various editions)
Colwyn Bay: Its origins and Growth by Norman Tucker (Colwyn Bay Borough Council
 1953)
Colwyn Bay 1934-1974 by Geoffrey Edwards (Colwyn Bay Borough Council 1984)
Colwyn Bay and District, Volume 1 by Graham Roberts (Bridge Books 1991)
Colwyn Bay: Its History Across the Years by Norman Tucker and Ivor Wynne Jones
 (Lansdowne Publishing 2001)
The Spirit of Colwyn Bay 1 by Eunice Roberts and Helen Morley (Landmark Publishing
 2002)
www.victoriapier.com

Pensarn (Abergele)
National Archives MT10/10
North Wales Chronicle 11/11/1893

Voryd
National Archives MT10/22
Liverpool Mercury 18/1/1866

Rhyl
National Archives BT31/780/434c
National Archives BT31/4467/29126
National Archives BT31/5053/33937
National Archives CRES 37/1598
National Archives CRES 37/1731
National Archives CRES 37/1832
National Archives CRES 37/1956
National Archives CRES 37/1959
National Archives CRES 37/1960
National Archives CRES 37/1961
National Archives CRES 37/1962
National Archives CRES 37/1966
National Archives CRES 37/1967
National Archives CRES 37/1968

National Archives LRR01/3518-21
National Archives MT10/3
National Archives MT10/140
National Archives MT10/238
National Archives MT10/580
National Archives MT10/1258
National Archives MT10/1434
National Archives MT10/1441
National Archives MT10/1567
National Archives T1/12387
Rhyl Guardian (various editions)
Liverpool Mercury (various editions)
North Wales Chronicle (various editions)
Leeds Mercury 26/3/1864
Rhyl Daily Post 28/3/1973
Rhyl: the Town and its People by W. Jones (author 1970)
Rhyl and Round About by W. Jones (author 1976)
Rhyl: A Portrait in Old Photographs and Picture Postcards by Harry Thomas (S.B. Publications 1991)
The Maritime History of Rhyl and Rhuddlan by D. W. Harris (Books, Prints and Pictures 1991)
The Springtime of Rhyl by Colin Jones (author 1999)
The Summertime of Rhyl by Colin Jones (author 1999)
The Fall of Sunny Rhyl? by Colin Jones (author 1999)
Old Rhyl from 1850s to 1910 by Marjorie Howe (Gwas Helygain Ltd 2000)
Glorious Rhyl: A Peep at its Past by Philip Lloyd (author 2002)
Rhyl's Grand Pavilion 1891-1901 by Colin Jones (author 2002)
The Spirit of Rhyl by Bill Ellis (Landmark Collectors Library 2004)

ACKNOWLEDGEMENTS

National Archives, Kew
British Library Newspapers, Colindale
Anglesey Archives Service, Llangefni
Bangor University Archives
Conwy Archives Service, Llandudno
Denbighshire Archives, Ruthin
Gwynedd Archives Service, Caernarfon
Tenby Museum and Art Gallery
Isle of Man Public Record Office
Linda Sage
Steve Thomas
Campbell McCutcheon
Chris Wyatt
Anthony Wills
Richard Riding
Neil Fairlamb

Also Available from Amberley Publishing

Golf in Wales A Pictorial History
Phil & Trudy Carradice

ISBN: 978 1 84868 836 0
£14.99

Wales A Historical Companion
Terry Breverton

ISBN: 978 1 84868 326 6
£17.99

Wales In the Golden Age of Picture Postcards
David Gwynn

ISBN: 978 1 84868 303 7
£12.99